IMAGES
*of America*

LOST FARMS OF
MCHENRY COUNTY

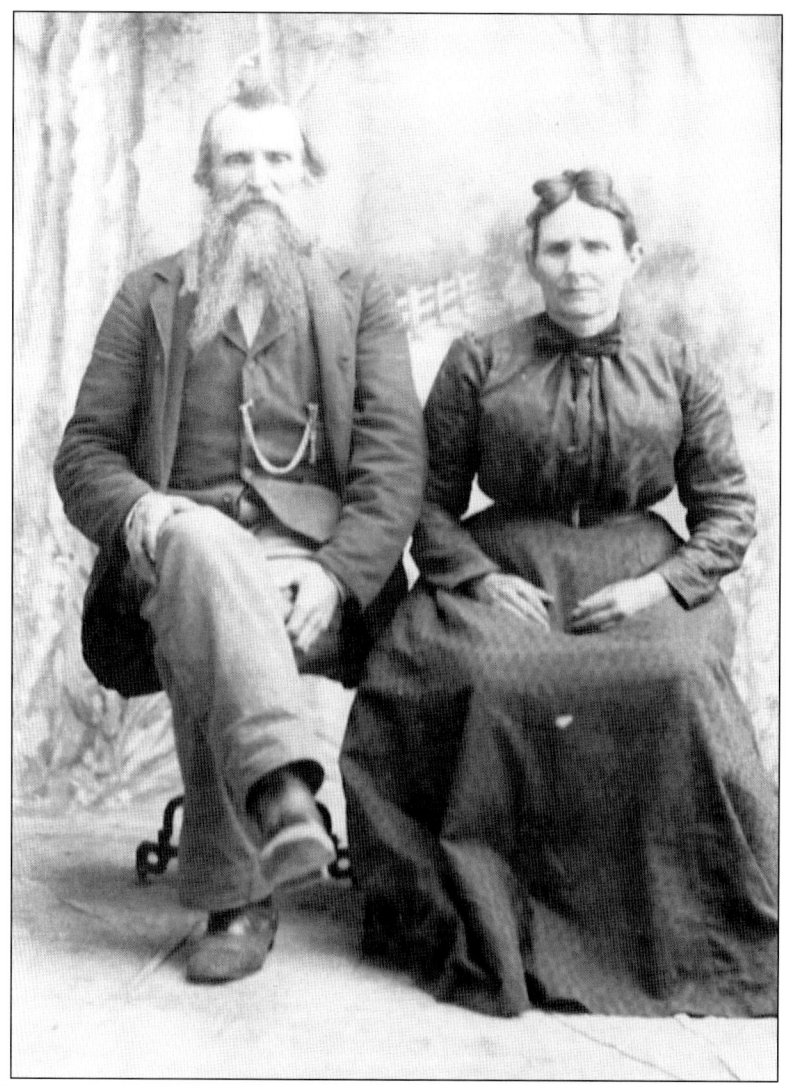

McHenry County is named after Maj. William McHenry (1771–1835). The county is comprised of 17 townships and was created on January 16, 1836, out of parts of Cook and LaSalle Counties. It originally stretched all the way east to Lake Michigan. By an act of the legislature in the winter of 1839–1840, the eastern townships of the county were carved out to form Lake County. McHenry's eulogy, printed in the *Illinois Advocate*, was prescient. In part, it reads, "He was among the first to scatter far and wide the seeds of civilization over this fair portion of the fairest of the earth . . . that the present inhabitants of Illinois may plant their farms in peace, and garner up their bountiful inhabitants in safety." The words of the eulogy proved true indeed. In the decades that followed, while attracting hardy farmers like those pictured above, McHenry County became one of the most productive and wealthy agricultural areas in the world. (Courtesy of the McHenry County Historical Society.)

ON THE COVER: Sixty local farmers and their families came in buggies and wagons for a corn cutting and shocking bee at the Charles Pope farm in Greenwood Township in 1913. They were able to cut and shock 55 acres of corn in one day. At noon, the ladies served a fine dinner to the grateful hands. (Courtesy of the McHenry County Historical Society.)

# IMAGES of America
# LOST FARMS OF McHENRY COUNTY

Glynnis Walker and Arabella Anderson

Copyright © 2010 by Glynnis Walker and Arabella Anderson
ISBN 978-0-7385-7798-2

Published by Arcadia Publishing
Charleston, South Carolina

Printed in the United States of America

Library of Congress Control Number: 2009935499

For all general information contact Arcadia Publishing at:
Telephone 843-853-2070
Fax 843-853-0044
E-mail sales@arcadiapublishing.com
For customer service and orders:
Toll-Free 1-888-313-2665

Visit us on the Internet at www.arcadiapublishing.com

*This book is dedicated to family farms. May we never forget their importance to our past, our present, and our future.*

# Contents

Acknowledgments 6

Introduction 7

1. First Came the Farmers 9
2. Then Came the Merchants 61
3. Then Came the Dairymen 73
4. Then Came the Developers 105

# Acknowledgments

The authors would like to thank the McHenry County Historical Society, especially Nancy J. Fike and Grace Moline; the Richardson family; the Kattner family; Helen Marlowe; the Gunther family; the Cox family; Carol Manke; Mr. and Mrs. Bo McConnell; the Tinkler family; the McHenry County Farm Bureau; Sandy Price of the Crystal Lake Historical Society; our editor, Jeff Reutsche; and all those who continue to believe in the future of the American family farm.

# INTRODUCTION

After the Black Hawk War of 1832, farmers from the East Coast, hearing of the fertile farmland available in the Midwest, travelled along the Native American trails that radiated away from Chicago in search of farm sites. The rich soil of the high rolling prairies, abundant water and game, groves of oak and other hardwoods, and the proximity to the growing city of Chicago made the area northwest of the city extremely appealing for those willing to take on the task of carving out new lives in the wilderness.

The first settlers began arriving in the area in 1834. In prairie schooners and wagons loaded with possessions and families, they headed west from Virginia, New York, and New England. Later farmers came from England, France, Germany, and Ireland, braving the cold and the heat, to carve their part of the American dream out of the wilderness.

The bold and industrious people who first settled in McHenry County brought with them more than just their meager possessions and a determination to create a better life for their families—they brought their imagination. It is not surprising to find out that McHenry County has produced advancements in agriculture that have been instrumental in farming all over the world. The first grain silo was developed here by local farmer Fred Hatch of Spring Grove. The construction of these silos allowed the dairy industry to flourish because it meant that the silage could be stored and kept fresh throughout the winter months to feed the cows and maintain milk production. Because of their development, milk, butter, and cheese from McHenry County were shipped not only to the city of Chicago but also around the world.

Among the original settlers who came to this fertile prairie, recently home to the Potawatomi Indians and Chief Big Foot, was George Stickney, the first settler of Nunda Township. He was born in New Hampshire in 1809 and headed west in 1835. He set out on foot for Michigan and sailed on the "St. Jo" River to Chicago. From there, he trekked west on foot to the Fox River country. He staked his first claim near Elgin, but after a few months traveled north to Nunda. He made his claim there on December 10, 1835, in the area now known as Bull Valley. The yellow brick "spirit house" that he and his wife, Sylvia, shared with their 10 children still stands today.

His close neighbor was Samuel Terwilliger, who arrived in June 1836. Together, with a four-horse team, they ploughed the first 10 acres of Nunda. Terwilliger's son Jerome, born on June 30, 1837, was the first white child born in the township.

Henry Weston is thought to have been the first white man to settle permanently in what is now Greenwood Township. He came in 1833 and named Queen Ann Prairie in honor of his wife, who was the first white woman in the township. She was also the first person to die in Greenwood Township. Soon after her death, Weston was married for a second time to a Miss Watson. Theirs was the first marriage in the township, although the first recorded marriage is that between Charles Frame and Mary Dufield on February 1, 1838, in a ceremony performed by Rev. Joel Wheeler.

One by one, the farmers came, and the county of McHenry began to grow. Towns were built and roads were cut through the prairie, but the introduction of railroads brought the greatest change. The Chicago and North Western Railway blanketed the county. One line pushed west through Marengo by early 1851. Two other lines were established in 1854. One ran diagonally across the county from the Fox River at Cary, reaching Harvard by 1855. The other ran north from Algonquin through eastern McHenry County beyond Richmond. A fourth line graced the northern tier of townships by 1861.

The years between 1840 and 1850 saw great change in McHenry County. The census of 1850 showed a drastic increase in population from around 2,000 to 14,978 inhabitants. This mass migration caused a demand for better commerce, which, in turn, lured men other than farmers, such as Benjamin Douglas and Col. William Hoffman, to build McHenry County's first sawmill in 1839 in Crystal Lake. Others built the first creameries, shops, hotels, and newspapers.

The railroads also made the development of icehouses possible. In the early 1860s, a wealthy Chicagoan named Charles S. Dole purchased 1,000 acres in sparsely settled Crystal Lake and began harvesting ice from the lake. He and his brother James built 12 icehouses with the combined storage capacity for 100,000 tons of the frozen lake water. Employing idle McHenry County farmhands in the winter, Dole shipped ice via rail to demanding customers in Chicago, St. Louis, and as far off as New Orleans.

From the beginning, McHenry County was an area of great promise. Anyone who had an idea and was not afraid of hard work could turn their efforts into wealth. A century and half after the first settlers arrived, McHenry County was the 11th richest county in the nation, and it all began with the farmers.

# One

# First Came the Farmers

The first farmer came to McHenry County in 1834. On November 18 in that year, Samuel and Margaret Gillian and their children, who had travelled from Virginia seeking unsettled land to farm, crossed the Fox River at what is now Algonquin. They became the first white settlers in what was soon to become McHenry County. Technically speaking, the land still belonged to the Native Americans—the treaty that ceded the land did not go into effect until 1836—but no one was about to enforce it. Samuel's brother John Gillian followed in 1835. Also by 1835, the Virginia settlement in Nunda and Dorr Townships was populated by families. James Dufield, Christopher Walkup, William Hartman, John Gibson, and John McClure made their claims in the new land. The Pleasant Grove Colony was located in what is now Marengo. Settlers there included Oliver Chatfield, Calvin Spencer, Porter Chatfield, Russell Diggins, Richard Simpkins, and Moody B. Bailey.

The Gillians arrived with two canvas-covered wagons, with one drawn by horses and the other by oxen. They also brought several cows, a harbinger of what was to become the thriving dairy industry. Even though the Blackhawk War of 1832 was over and the Native Americans had been forced to relinquish their land, there were still many who were displaced and still living in the area. One day, a Native American party came to the Gilliam camp and asked for food. Strong pioneer woman that she was, Margaret refused, and one of them spit into her soup pot and the party stole one of the family's horses. The Gillian's later retrieved their horse. History does not record what happened to the soup. William Wire, who later became one of the preeminent citizens of Greenwood Township, was kidnapped by a Native American raiding party that came to his family's farm when he was just three years old. Wire's older sister, who, although still a young girl was an excellent horsewoman, took to her steed and chased after them. She recovered her little brother and brought him back home.

The settlers who first came to McHenry County did not expect an easy life, but they did intend to make a better one. Through their efforts, they made a better life for all those who followed.

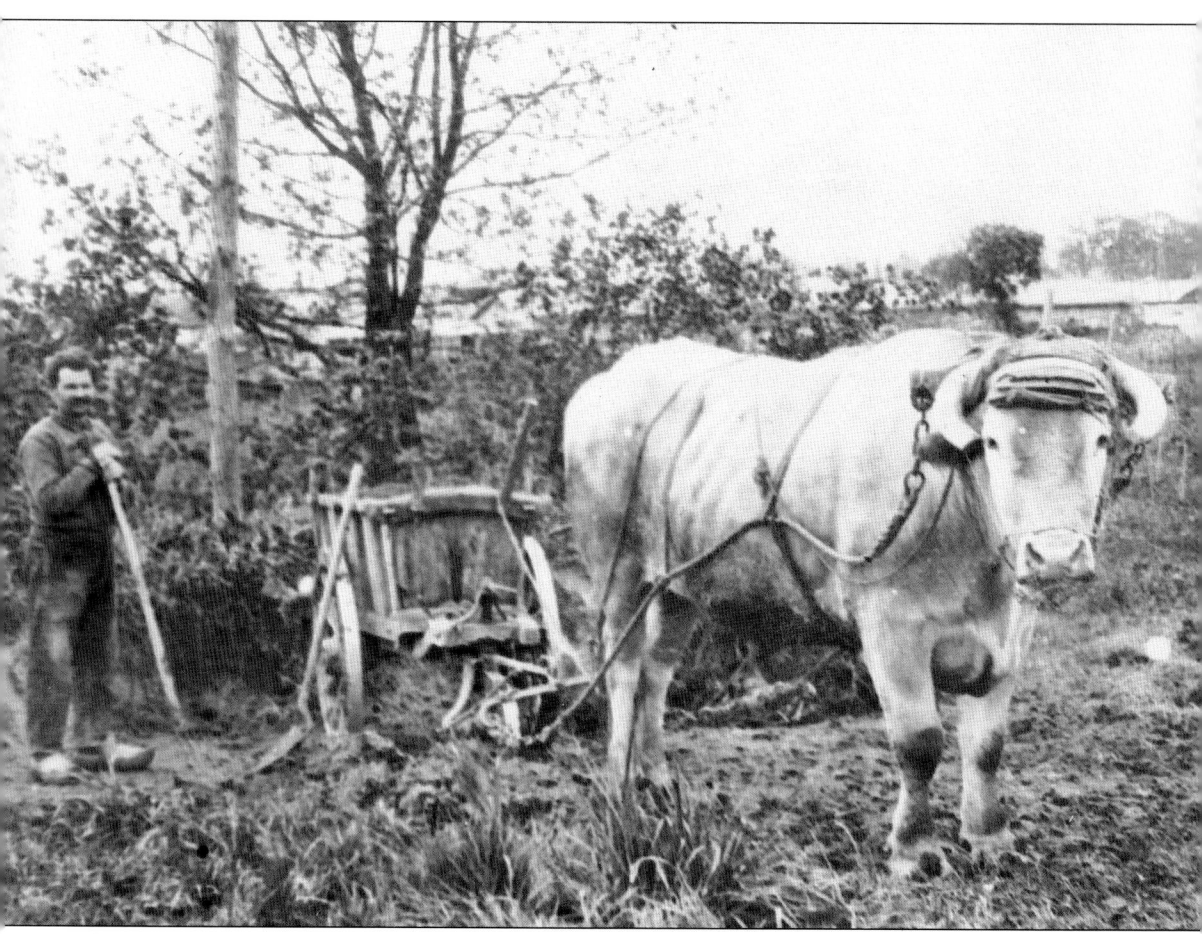

Since McHenry County was a combination of open prairie and oak and other hardwood forests, sometimes farmers had to clear their land of the trees before beginning to plant crops. In the 19th century, oxen were still the most frequently used draught animals. Although slower than horses, they were also stronger, less expensive to feed, and did not have such a delicate constitution, something that proved handy in the cold Illinois winters. Oxen served the early settlers in many capacities and were the preferred choice when it came to pulling the heavy prairie schooners that carried the worldly possessions of the settlers over such great distances. It is not surprising then that oxen also came in handy when it was time to clear the new land for farming. (Courtesy of the McHenry County Historical Society.)

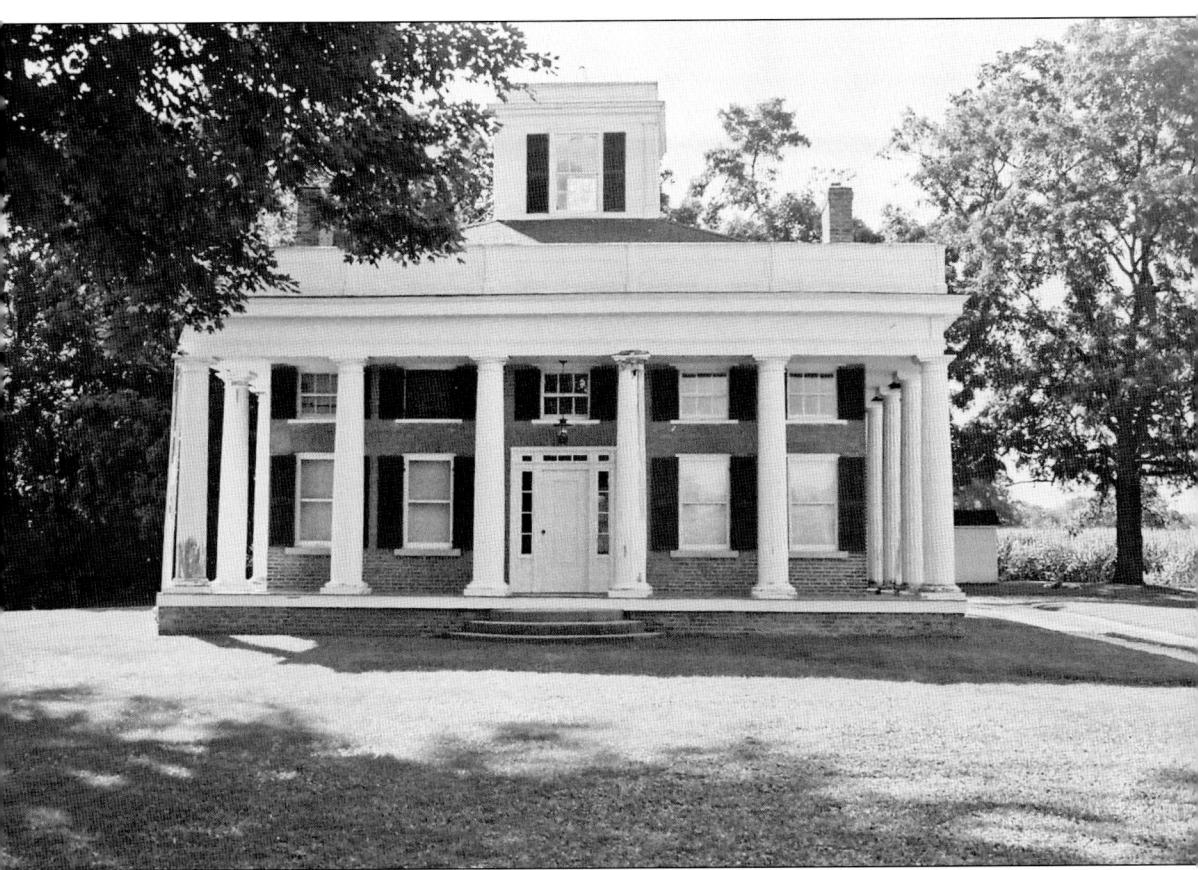

In 1836, Samuel Terwilliger came to Nunda Township. He received 160 acres from the government for serving in the militia and later added 200 more to his property. He was the first man to plow any soil and was known as one of the best stock raisers in the area. He and his wife, Laura, had seven children, including son Jerome, the first white child born in Nunda. In 1849, he built the Colonial House, a square, redbrick Greek Revival–style home that still stands in Bull Valley. The second floor featured a ballroom that stretched across the front of the house, which was surrounded on three sides by a porch with 17 fluted Doric columns. In the ballroom, the Terwilligers threw parties for dignitaries visiting the area. The house is listed on the National Register of Historic Places. Laura died in 1869. In 1879, when he was 81, Samuel proposed to Maggie Conley, who was only 17. He promised her the farm if she would accept his proposal, which she did. The farm has never been sold, remaining in the family since 1836. (Photograph by Arabella Anderson.)

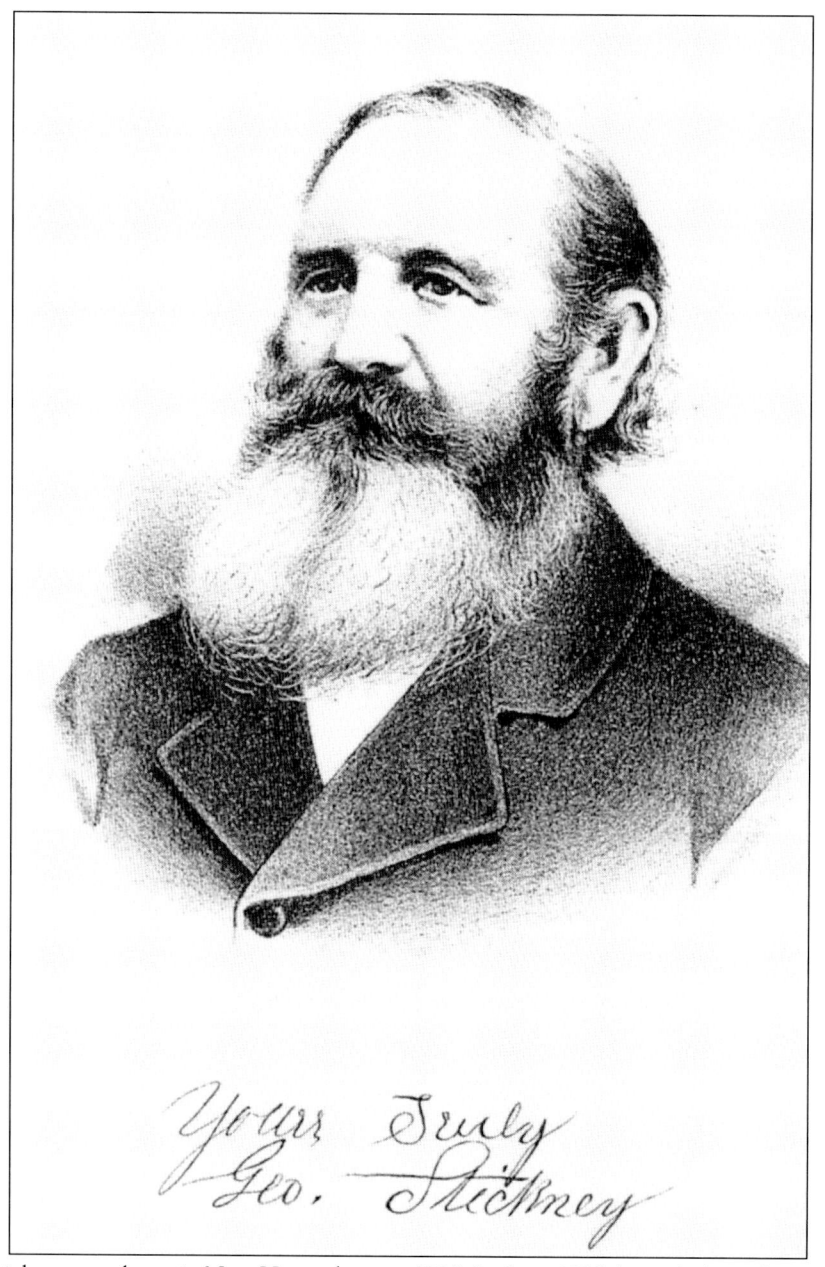

George Stickney was born in New Hampshire in 1809. In June 1835, he sailed to Chicago, bought a compass, strapped his homemade trunk that contained all of his belongings on his back, and following the Native American trails west. On December 10, he made his claim in Nunda, before the area had been surveyed by the state, and he built the first house, a log cabin, there. He organized the township government, was its first supervisor, and served as road supervisor and school director. With the other two school directors, G. L. Beckley, his future father-in-law, and William Holcombe, he built the first schoolhouse in Nunda. The first teacher, Armenda McOmber, was paid $1.25 a week. In 1839, Stickney married Sylvia Beckley, whose family had migrated to McHenry County from Connecticut. (Courtesy of *The History of McHenry County*, Chicago Interstate Publishing Company, 1885.)

George and Sylvia Stickney were married for 40 years. Only 1 of their 10 children survived to adulthood. Their infant son was the first to die in the new settlement, and his burial marked the first religious ceremony in the township. Held at his graveside, the service was presided over by the Reverend VanAlstine. It also marked the beginning of the Holcombville Cemetery. George was buried near his first-born son and other family members on the eastern side of this cemetery. George and Sylvia were both spiritualists, a fashionable pastime in the 1800s. She was a talented medium, and the couple held many séances in their Bull Valley home, dubbed the "spirit house." The yellow brick home was built between 1849 and 1865. Italianate in style, its most outstanding features were its rounded corners, both inside and out. It is believed that the Stickneys favored this design feature because it allowed the summoned spirits to float freely in the corners. George's funeral, attended by his many friends, was held in the ballroom. Today the house is the property of the Village of Bull Valley, housing the police department and the clerk. Like the Terwillger house, it was placed on the National Register of Historic Places. (Photograph by Arabella Anderson.)

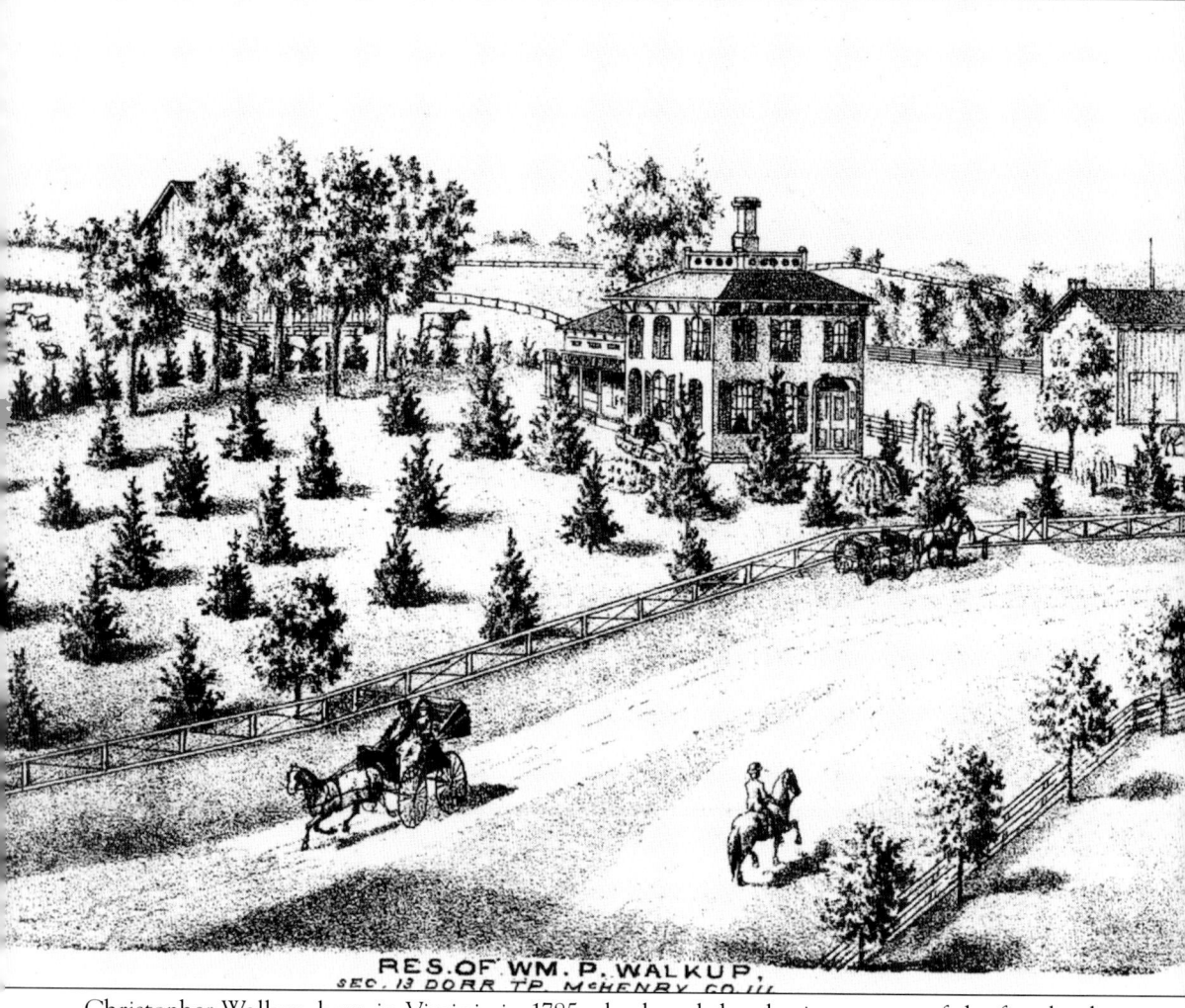

RES. OF WM. P. WALKUP,
SEC. 13 DORR TP. McHENRY CO. ILL

Christopher Walkup, born in Virginia in 1785, also heard the glowing reports of the fine land to be had in McHenry County. He and his wife, Sabina Beard, who was descended from Sir William Wallace, the Scottish knight known for leading a resistance against the English in the Wars of Scottish Independence, headed one of the first settling parties to McHenry. They packed their belongings in a prairie schooner and went north. The journey took six weeks, and Sabina rode her horse the entire way. The Walkups' group included James Dufield, John McClure, Christopher McClure, William Hartman, John L. Gibson, and John Gillian. They arrived in what was then called the Virginia settlement on October 1, 1835. (Courtesy of the McHenry County Historical Society.)

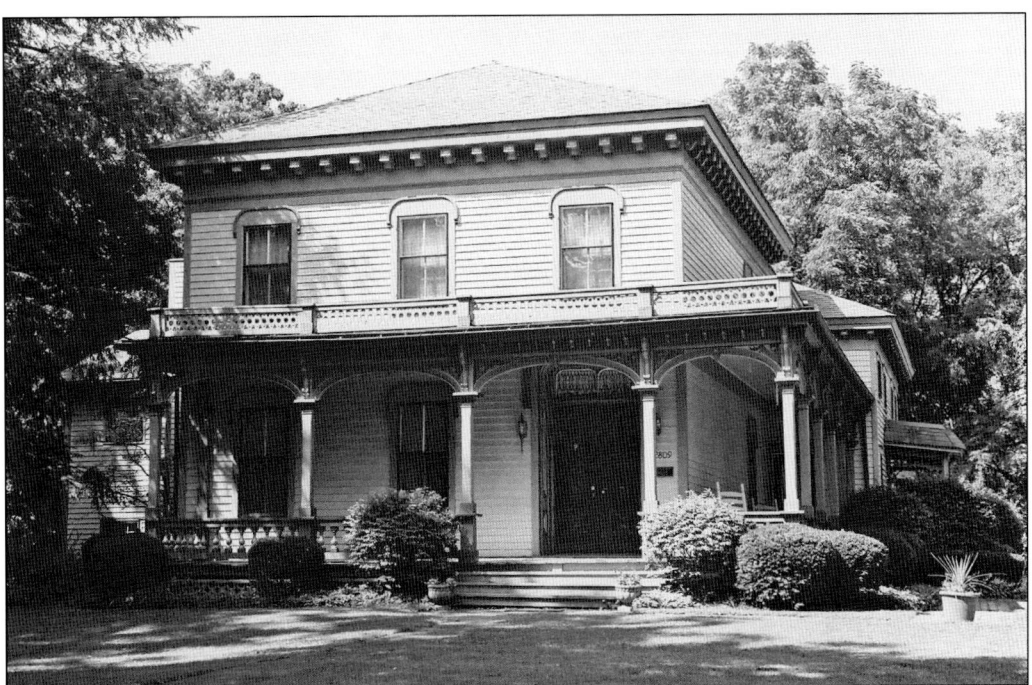

Walkup secured 400 acres at a $1.25 each and built a log cabin with a stick and clay chimney and a loft where the family slept. In 1869, the grand house, which still stands at the corner of Country Club and McConnell Roads, was built. The Walkups developed a schoolhouse, a church, a gristmill, and a general store. Records from the time indicate that eggs could be had for 10¢ a dozen, and five pounds of coffee cost 50¢. The house was also the stagecoach stop on the Elgin-Lake Geneva route. (Photograph by Arabella Anderson.)

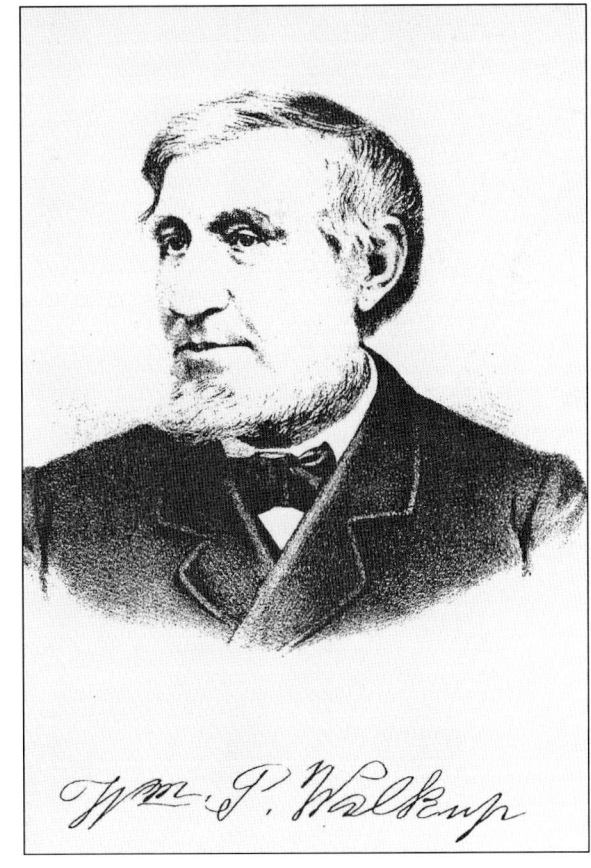

The Walkups had six children, John B., Margaret, Josiah, William Price, Janet, and Sarah. William Price, who was 17 when he came with his parents to McHenry County, inherited the family home, which still stands on Country Club Road. Christopher and Sabina are buried in Ridgefield Cemetery. This photograph was found in *The History of McHenry County*. (Courtesy of *The History of McHenry County*, Chicago Interstate Publishing Company, 1885.)

Two of Christopher and Sabina Walkup's sons settled in Nunda Township and built houses on the west side of Walkup Avenue. In 1856, John B. Walkup, born August 11, 1811, built his house across from what used to be called Walkup Woods. It is now known as Veterans Acres Park. The foundation of this Greek Revival house is made of over 70,000 cobblestones that were gathered from the shores of Lake Michigan and hauled to the present site by oxen. John B. died on June 9, 1856, shortly after the house was finished, some say from the effort of building it. Following his death, it was home to his widow and children, two of whom still lived in the house at the dawn of the 20th century. The house, which is still occupied, was the second building designated a county historic landmark. John B.'s brother Josiah, born February 22, 1815, was a partner in the Chrystal Lake Pickling and Preserving Works located at the corner of Walkup and Woodstock Avenues. He was also a trainman for the Chicago and North Western Railway, whose terminus, Walkup's Crossing, was on his property. His house, which was located at the corner of Walkup Avenue and Route 176, no longer stands. Michael Walkup, the current owner of the property, is hoping to rebuild. (Photograph by Arabella Anderson.)

John B. Walkup and Mary White Walkup had three children, Leonidas W. Walkup, born on May 16, 1842, in McHenry County; Eva M. Walkup, born on November 17, 1844, in McHenry County; and Alfred C. Walkup, born on May 18, 1849, in McHenry County. In 1880, at the age of age 31, Alfred became a missionary in Micronesia. As a captain, he cruised among the islands of Micronesia for many years on the sailing ship *Morning Star* and later on the *Hiriam Binghams* I and II. In 1888, his wife died, and he returned to McHenry County with his three small children, who went to live with their aunt and uncle in the house that their grandfather John Walkup had built. Alfred returned to Micronesia and continued his mission. On May 1, 1909, he set out on his last voyage. A squall struck the ship on May 4 and it sank. For 11 days, the survivors rowed in a small boat, attempting to reach land. Alfred died from exposure shortly after they reached the mission station in Ebon. Alfred and his children John M. (first row), William, and Eleanor are pictured above. (Courtesy of the McHenry County Historical Society.)

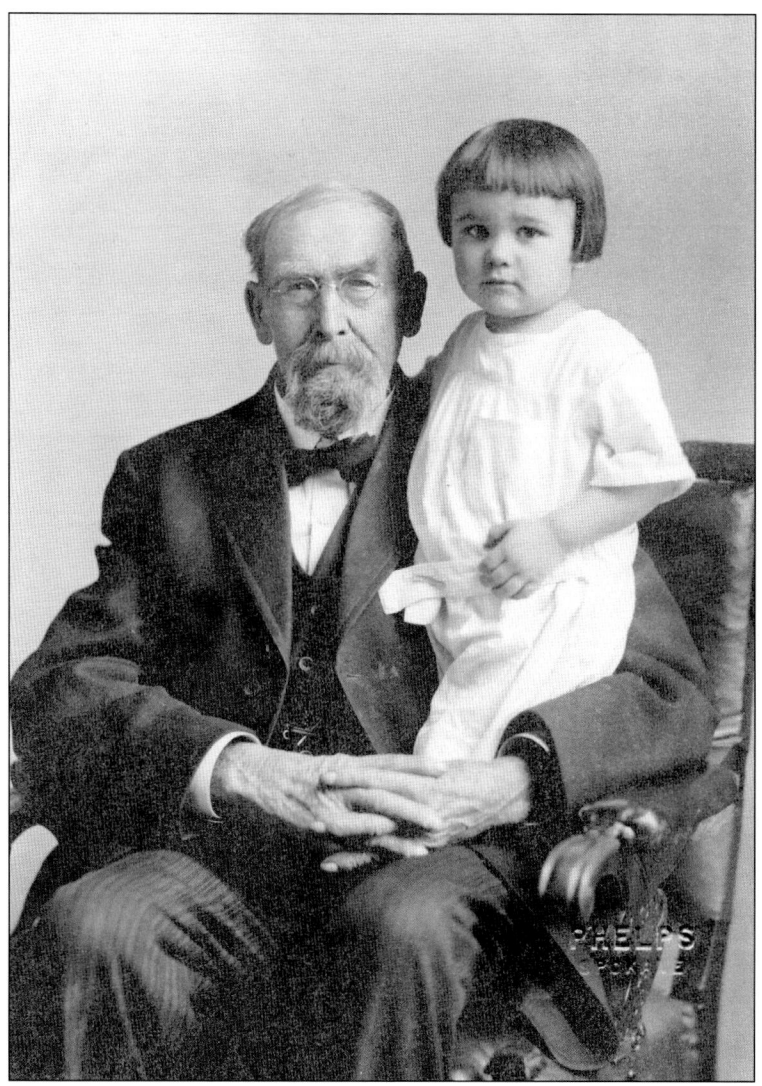

Maj. Najah Beardsley was a soldier in the War of 1812. A native of New England, he set out for Chicago on board the *Queen Charlotte*, a vessel that had been captured from the British during that war. The Beardsley brothers, Najah, William, Orsmus, and John, were the second family to settle in Crystal Lake. Beman Crandall and his wife, Polly, who arrived in 1836 and settled their claim on Virginia Street, were the first. Crandall, along with Christopher Walkup, laid out the village of Crystal Lake in 1840. Beardsley staked his claim on 75 acres near Terra Cotta Avenue. His son Ziba is credited with giving the town its name, declaring upon viewing the lake for the first time, "The water is clear as crystal." For a short while, the town on the shores of the lake was called Crystalville, but it was later changed to Crystal Lake. Ziba staked his claim on the southeast shore of the lake. Beardsley Street in Crystal Lake is named after the family. Ziba's brother Abner was a merchant in the town for 23 years. In 1837, Abner and his wife, Mary, became the parents of the first white child born in Crystal Lake, a son named William (pictured above with his grandfather Najah), and built the first house on Crystal Lake prairie. Ziba and Abner's sister Hannah was the first bride in town, marrying Franklin Wallace on March 10, 1839. The service was performed by justice of the peace Crandall. (Courtesy of the McHenry County Historical Society.)

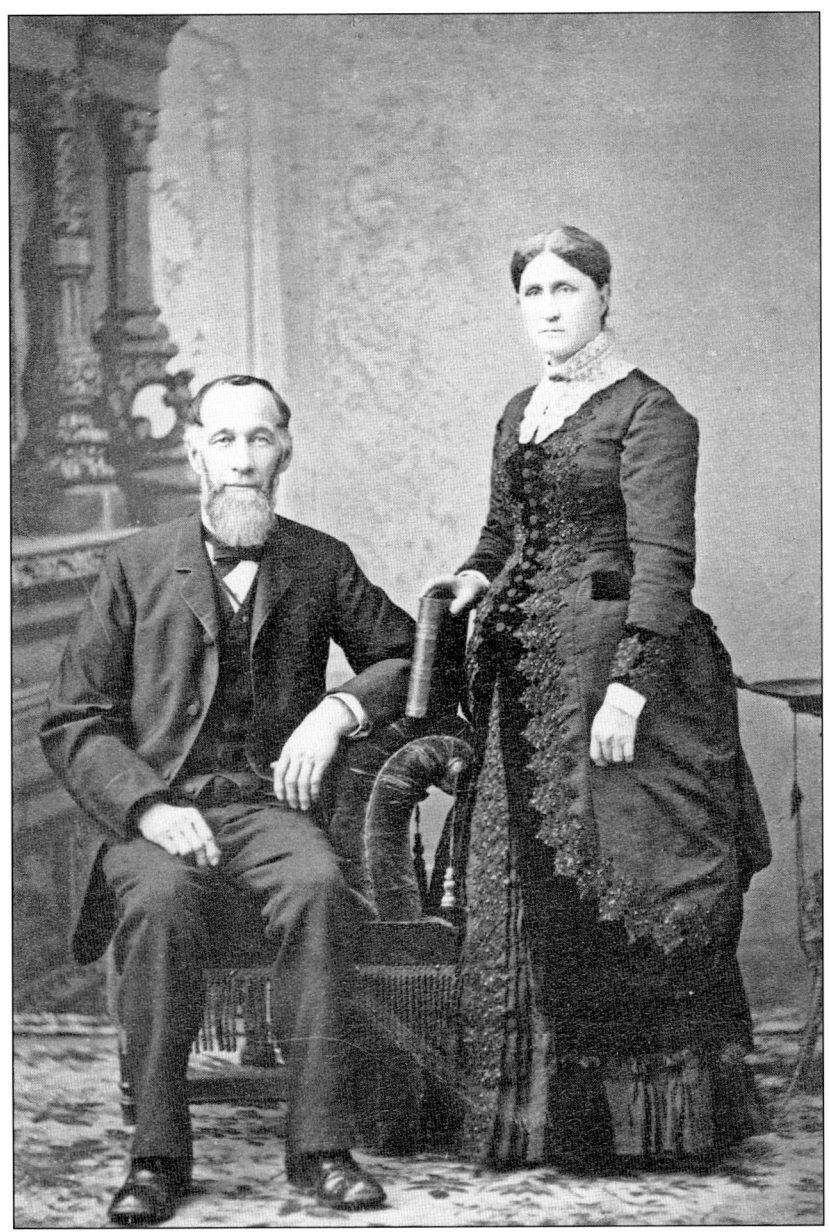

The Beardsley brothers, Najah, William, Orsmus, and John, were very influential in the development of the town of Crystal Lake. William and John came to Crystal Lake in the fall of 1837 with two yoke of oxen, some bedding, and a plan to spend the winter there to cut down logs for the house they were planning on building in the spring. They came in a covered wagon and camped on the spot where the Crystal Lake Country Club is now located. The early settlers were hardy people. In a letter he wrote in 1906, Orsmus described that journey: "We steered directly across the prairie toward the lake [Crystal Lake] as there were no roads. It was snowing so hard we lost our bearings and had to stay out there all night, an experience I shall never forget. It was so cold and they made me go afoot to Beman Crandall's. We were pretty played out after tramping through a foot of snow for five or six miles after laying out all night with nothing to eat." John is pictured above with his wife. (Courtesy of the McHenry County Historical Society.)

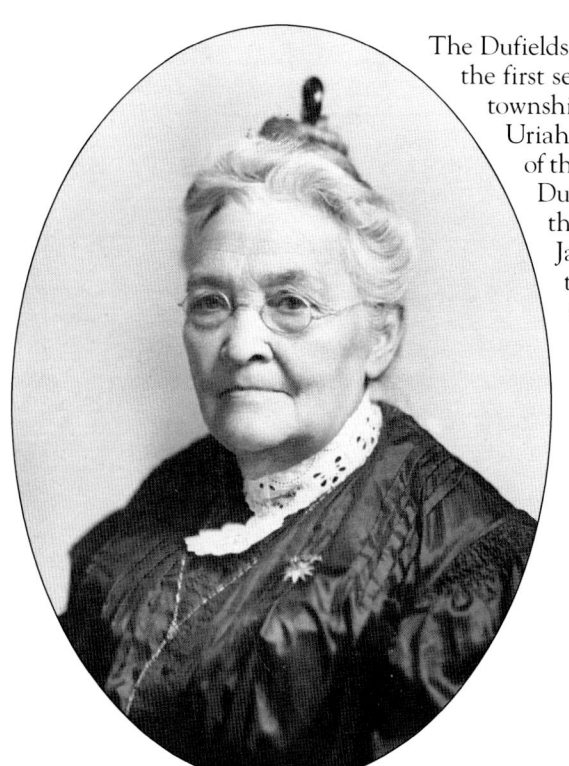

The Dufields, a large and prosperous family, were among the first settlers in the county. The first death in this township was that of the three-year-old daughter of Uriah Cattle in September 1836. Later in the fall of that same year, the young daughter of James A. Dufield, who was born in 1801 and was part of the original Virginia settlement, also died. Mrs. James A. DuField is pictured in a photograph taken in 1854. (Courtesy of the McHenry County Historical Society.)

John A. Dufield was born 1851 in Woodstock. In 1865, he apprenticed as a printer. In 1877, he and his brother M. C. Dufield founded the *Woodstock Democrat*. M. C. retired, but John continued to publish the newspaper until 1902. On Christmas Day in 1877, John married Ada Jewett. They had two children, Opal and Allan. John also served as postmaster from 1896 to 1900. After selling the newspaper, he worked in the printing and stationary business for several years. He died on September 9, 1908. Ada died on April 6, 1926. (Courtesy of the McHenry County Historical Society.)

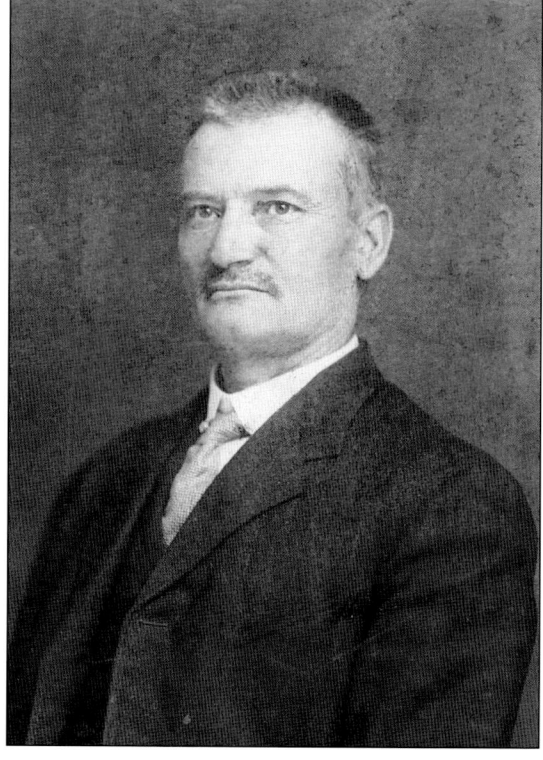

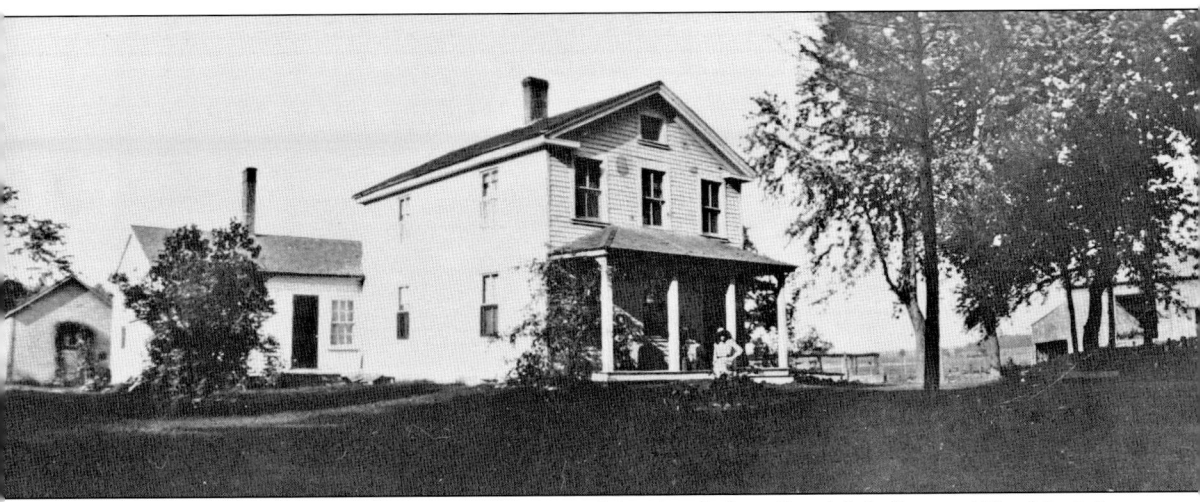

When John Frame came to McHenry County with his family from Randolph County, West Virginia, he persuaded his recently widowed friend, Henry Dufield, to bring his children and come along. In 1839, Henry bought land a mile east of Woodstock. He chose it for its flat grassland, stand of woods, and his beloved bottomless pond—the only lake in Woodstock. Like most of the settlers, he first built a small log cabin consisting of two rooms. The first school taught in the county was in that log cabin. As his prosperity increased, he began to build a large and comfortable home in 1847. He added to the home in 1852 and again in 1882. The house still stands on Country Club Road in Woodstock near Dufield Pond. In 1863, his son Oscar married Francesca Frame. The Dufield farm was sold to Oscar and later went to Henry's granddaughter Gertrude Dufield Matheny. On October 2, 1895, Henry died on the farm that he so loved. (Courtesy of the McHenry County Historical Society.)

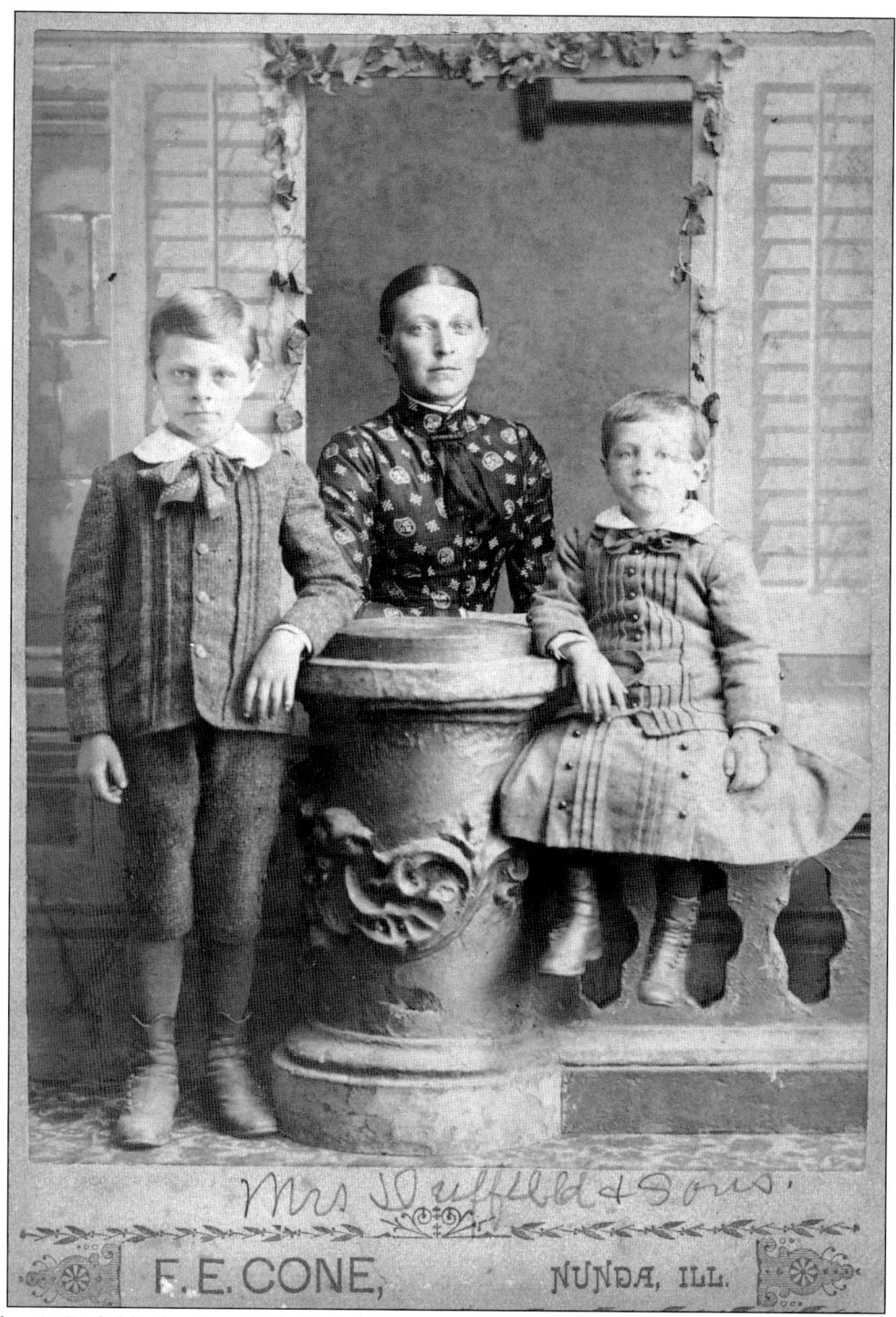

John A. Dufield's daughter Belle Dufield Skinner and her two sons, Leroy and Arthur Skinner, are pictured above. Belle, who was born in 1835, was the daughter of James (b. 1801) and Margaret McClure Dufield. James later married Sarah Benson Black and had three children, Sarah, Edson, and Mary. (Courtesy of the McHenry County Historical Society).

Pictured here are, from left to right, Belle; an unidentified child; Belle's mother-in-law, Almira Cadwallader; and Belle's son Roy Skinner. (Courtesy of the McHenry County Historical Society.)

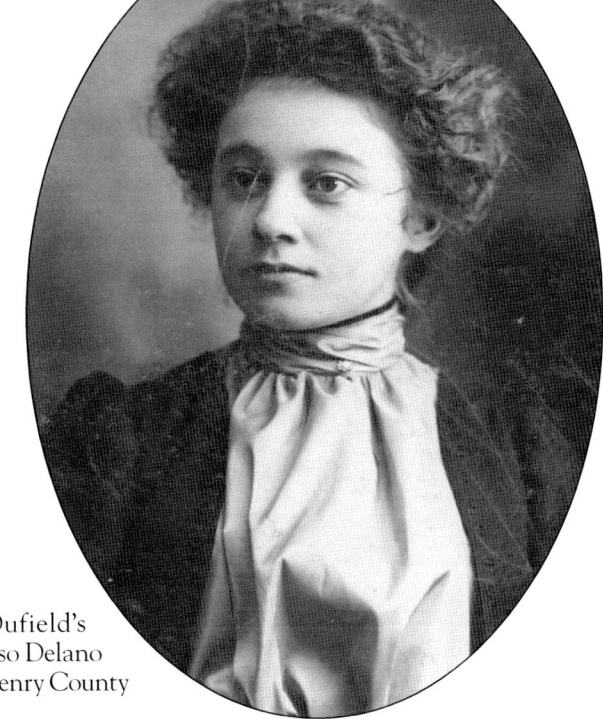

This photograph is of James A. Dufield's granddaughter Pearl Dufield, who was also Delano Dufield's daughter. (Courtesy of the McHenry County Historical Society.)

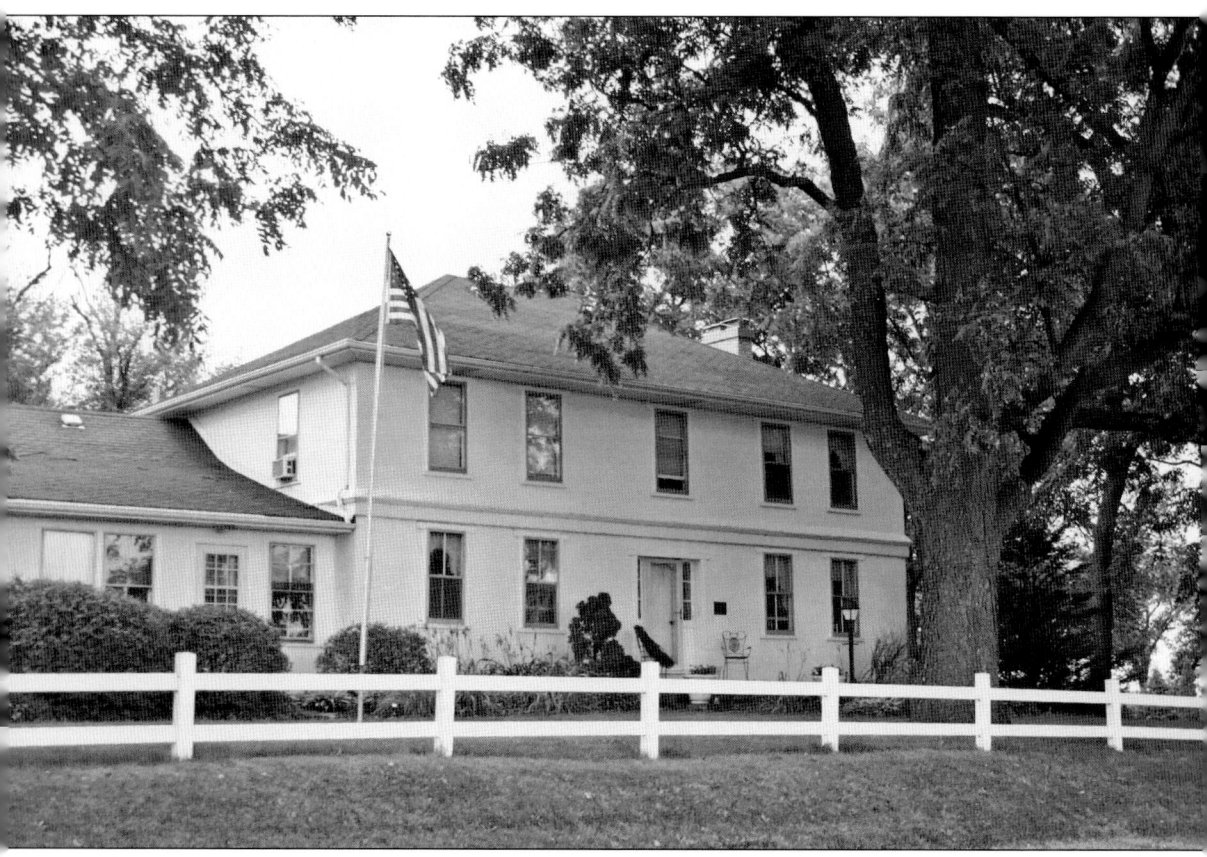

John James, a farmer from New Hampshire, received his land grant in McHenry County in 1842. He also purchased an additional 120 acres. According to the 1850 census records, he later increased his holdings to 320 acres. Located on Greenwood Road in Woodstock, James's house on Windhill Farm was built in 1848. The eight-room home that he shared with his wife, Mary, and their children, Abigail and George, had two natural rock fireplaces and three kitchen pantries. All the external walls were 12 inches thick. James was a devout Baptist, active in town politics, and between 1861 and 1864 was overseer of the poor. He was also an abolitionist. His house had three stairways, one of which was hidden and led to a basement room through a trapdoor directly beneath the kitchen. No existing plans show the presence of this secret room. During and immediately prior to the Civil War, it is thought that Windhill Farm was a stop on the Underground Railroad. (Photograph by Glynnis Walker.)

In 1838, Rudolphus A. Hutchinson came to Harvard and purchased 292 acres of land. On this farm, he built "the house of seven gables." Set into the bricks at various locations are stones arranged in a diamond pattern. It is thought that these designs were to ward off evil spirits. Seven gables highlighted the steep pitched roof. Each has a uniquely designed finial at its peak, representing the sun, the moon, the universe, the stars, prosperity, health, and love. (Courtesy of the McHenry County Historical Society.)

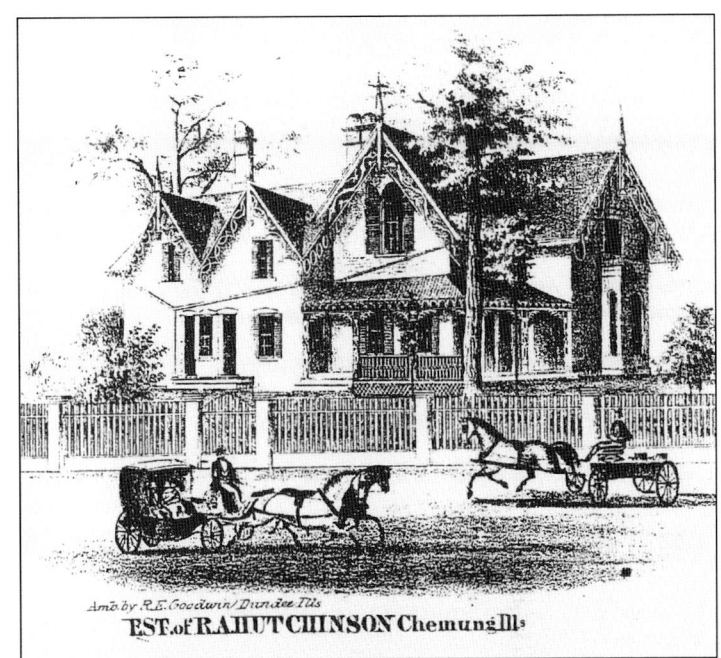

Hutchinson, who served as justice of the peace in McHenry County, planned his house in two parts, with a courtroom and jail cell separated from the family rooms by a solid brick wall. From time to time, he entertained Chief Big Foot for tea and also hid escaping slaves. In 1997, the house of seven gables was painstakingly restored by David and Susan Netherton and plaqued by the National Register of Historic Places. (Courtesy of the McHenry County Historical Society.)

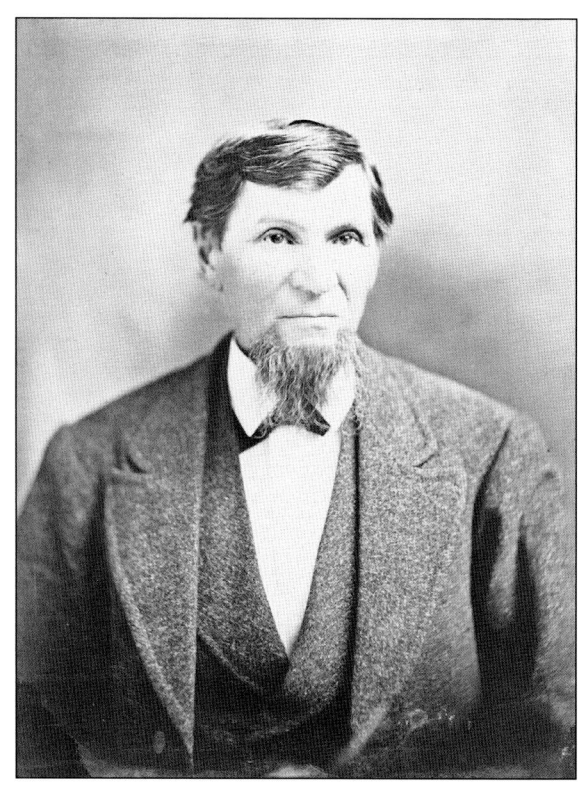

After the Napoleonic Wars, many German families immigrated to America to avoid persecution by the French. In 1844, George and Michael Schaff, sons of George Schaff and Anne Marie Kuhn, embarked on a ship called the *Pontiac*. They left Le Havre, France, and spent 36 days crossing the Atlantic. They arrived in New York City in June 1845. Their journey brought them eventually to Queen Anne Prairie in Seneca Township. Working as farmhands brought them the funds to purchase a farm together on Kishwaukee Prairie, and they were able to bring their parents to America. In 1859, Michael Schaff married Kate Eppel. Pictured are George Schaff Sr. and his wife, Magdalena. (Both courtesy of Carole Manke.)

In 1860, Michael bought a 160-acre farm in Hartland Township. Michael and Kate had four children, Charles, Josephine, Minnie, and Emma. Later the family moved to Clay Street in Woodstock and Michael became a most esteemed citizen. His stately figure and kind face were familiar around the city. He later bought a beautiful home on south Jefferson Street, where he died at the age of 95. (Courtesy of the McHenry County Historical Society.)

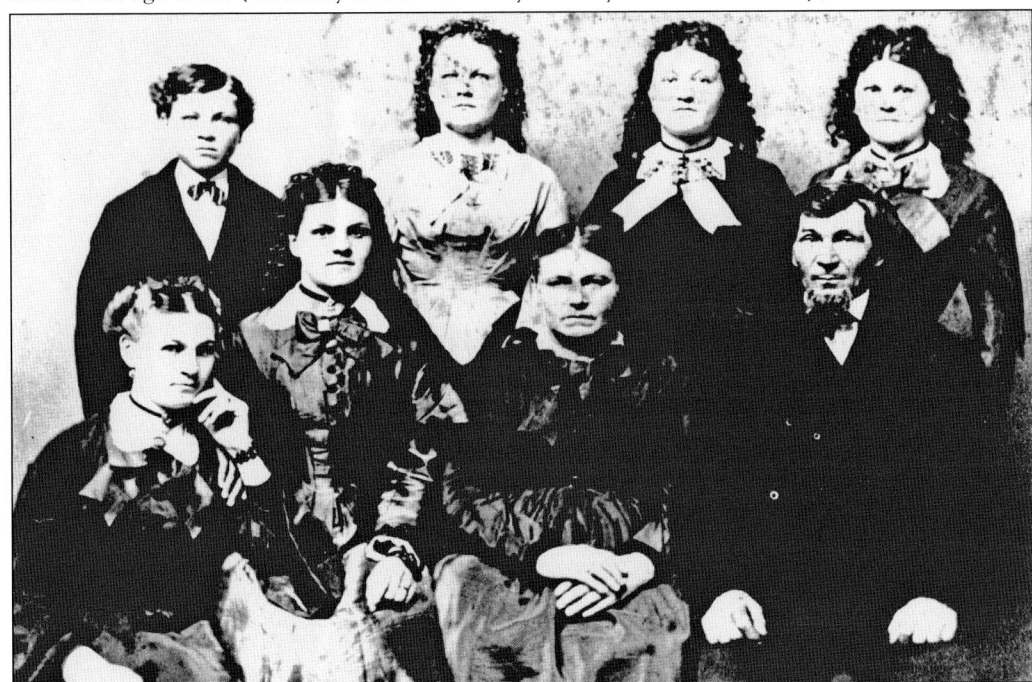

In 1847, George Schaff married Magdalena Sondereneckerl. They had five daughters, Maria, Lena, Caroline, Elizabeth, and Katherine. One son, George, died at 15 of a horse kick to the head, thus ending the family name through that line. In 1888, George Sr. sold his farm and moved to Woodstock. Pictured from left to right in 1854 are (first row) Lena, Elizabeth, Magdalena, and George Sr.; (second row) George Jr., Katherine, Caroline, and Maria. (Courtesy of the McHenry County Historical Society.)

When any of the early farmers needed a hand in plowing a field; building a barn or a house; or bringing in their crops, they turned to each other for support and assistance. The old saying, "few hands make light work," was especially true for these hardy pioneers. Pictured here is Clyde Trow's barn raising on Kishwaukee Valley Road. (Courtesy of the McHenry County Historical Society.)

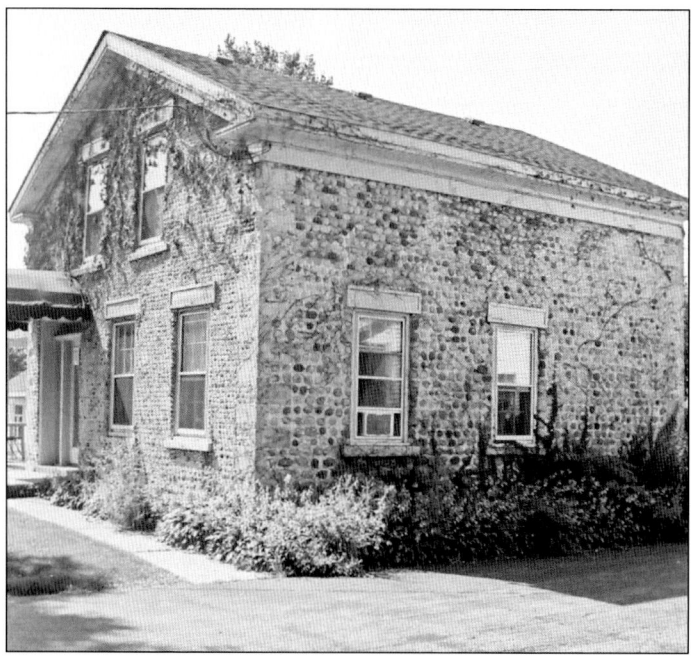

The Wallace house, the oldest house in Crystal Lake, built in 1851, still stands on Virginia Street. It was the home of Hannah Beardsley and Columbus Wallace. The yellow cobblestone structure was built by stonemason Andrew Simmons. The Wallace house is notable in that it does not have a fireplace. This was Hannah's decision. She said that after cooking over an open fire so long, she had no desire to cook that way again. Instead, the house was furnished with a wood stove. (Photograph by Arabella Anderson.)

Ziba and Abner Beardsley's sister Hannah was the first bride in Crystal Lake, marrying Franklin Wallace on March 10, 1839. The service was performed by justice of the peace Beman Crandall, who, like the Stickneys, had a great interest in spiritualism. In a letter written by John Beardsley in 1907, he recalls the building of the first schoolhouse. There was a meeting, and "the school question was brought up. It was decided that a school must be built and so we sharpened our axes and went to the woods to cut logs and soon had them on the spot located for the building." There were 20 pupils and Hannah was the first teacher. After Wallace died on February 22, 1845, Hannah married his brother Columbus in 1849. William Wallace, pictured above, is her son. (Courtesy of the McHenry County Historical Society.)

Thomas Stillwell Huntley, the only early settler of McHenry County to have a town named after him, was born in Cortland County, New York, on March 27, 1807. At the age of 39, he migrated west to Illinois with his wife, Eliza, and their three children, Charles, Harriet, and William. He bought 640 acres of land at what became Conley Road and Rt. 47 for $1.25 an acre. Being a man of considerable vision, he purchased an additional 80 acres. From these holdings, he provided a site for a train station and a general store, set aside three lots for churches, sold lots for other businesses, saved a site for a town square park, and donated land for a cemetery, thus establishing Huntley Station. On September 5, 1851, the first train came through, and Huntley became the shipping center for dairy products from the region. When his first wife died in 1873, he married Emma Annette Brinkerhoff. He was 69, she was thirty-four. Two years later, she presented him with his youngest son, Thomas S. Huntley Jr. In 1894, Thomas Sr. died at the age of 87. In his obituary, it stated that his "kindness and generosity will be remembered as long as this town remains." (Courtesy of the McHenry County Historical Society.)

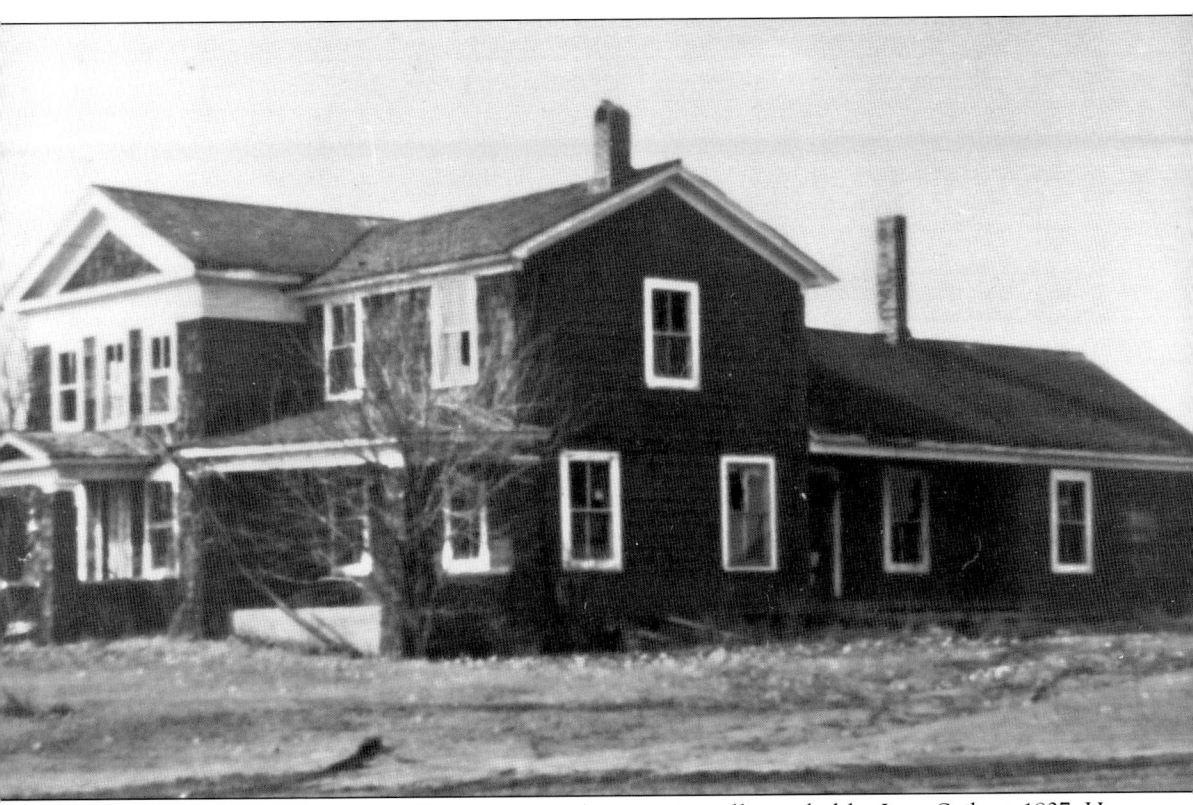

The area where the town of Cary now stands was originally settled by Levi Seibert 1837. He married Electa Gillian, daughter of Samuel and Margaret Gillian, McHenry County's first settlers. The house, designed in the Victorian Gothic style, was built in 1847. Located at 312 West Main Street, it was plaqued by the McHenry County Historical Society in July 1994. In spite of the fact that the Seiberts were the first settlers of Cary, the town got its name from Elma D. Cary, who laid out the first plat. It was incorporated on January 9, 1895. (Courtesy of the McHenry County Historical Society.)

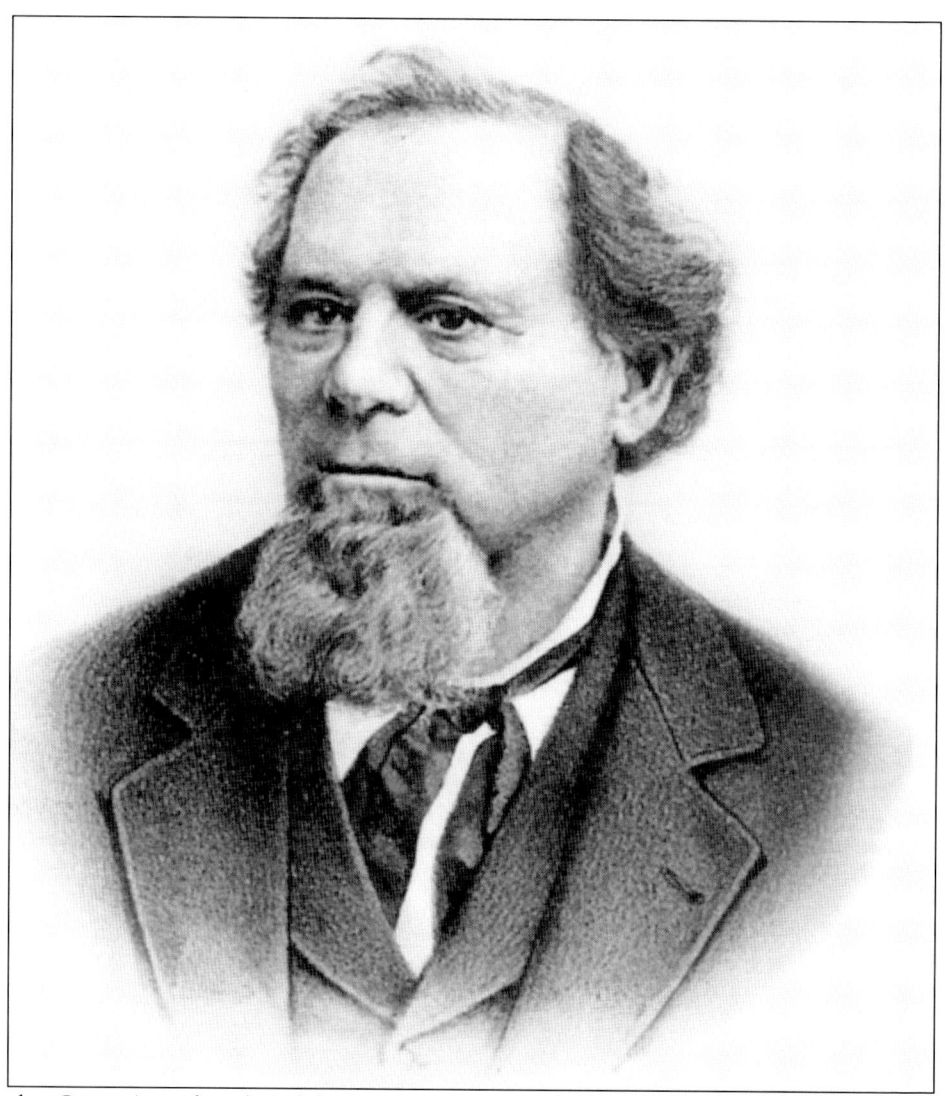

Eldridge Gerry Ayer, founder of the town of Harvard, was born on July 25, 1813, in Haverhill, Massachusetts. He was one of four sons and four daughters of Samuel and Aquilla Chase Ayer. On October 29, 1835, Eldridge Ayer married Mary Dean Titcomb, and soon the two moved to Kenosha, Wisconsin, where he went into the dry goods business. In 1847, hearing about the excellent farmland available in McHenry County, he bought 200 acres on Big Foot Prairie. There he opened a general store and retained the services of a blacksmith. Ayer bought an additional 400 acres five miles farther south, with the intention of wooing the railroad owners to consider Harvard for their new depot. When the railroad representatives came to Chemung, which already had a main street, they were forced to pay extra for their accommodations and supplies. When they tried to negotiate a price for the land needed to build the roundhouse, machine, and switchyard, they felt that the price was too high. They then paid a visit to Eldridge Ayer, who wisely told them to take all the land they needed. In return, they promised him that he could build a hotel to feed and care for the railroad employees and the passengers. They also promised that they would furnish the Ayer family with free freight and free water as long as they ran the hotel. With that, the town of Harvard was born, and the town of Chemung all but disappeared. (Courtesy of *The History of McHenry County*, Chicago Interstate Publishing Company, 1885.)

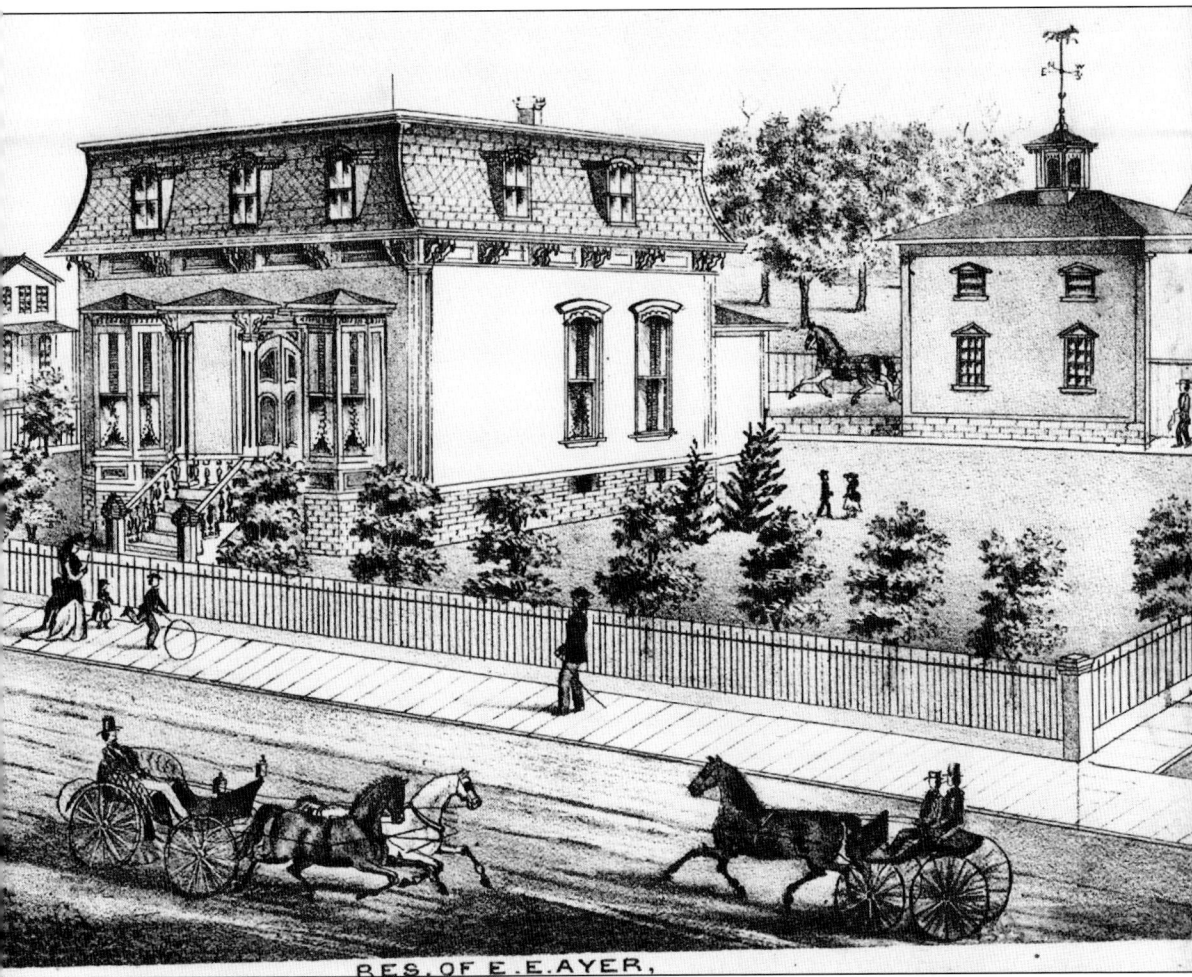

RES. OF E. E. AYER,

Eldridge Ayer's son Col. Edward E. Ayer was born in Kenosha, Wisconsin, in 1841. He had all of his formal schooling in a little log schoolhouse. When he was a young boy, his family moved to Harvard. At the age of 19, he joined a group of pioneers in a covered wagon on their way to California and arrived just in time for the beginning of the Civil War. He retuned to Harvard at the age of 22 with $1.80 in his pocket and made his wealth as a farmer in Harvard and also became a manufacturer of railroad ties. He was a lover of antiquities, and with his wife, Emma Burbank, he made more than 50 trips to Europe to expand his collection. He became the first curator of the Field Museum and gave it its first $8 million, encouraging his friend Marshall Field I to donate also. He was also the director of the art institute, supported the Chicago Symphony, and gave extensively to the Newberry Library, lifting it to unique importance because of his donation of manuscripts about America's aboriginal peoples. The E. E. Ayer house pictured above was built in Harvard, but its actual location remains a mystery today. (Courtesy of the McHenry County Historical Society.)

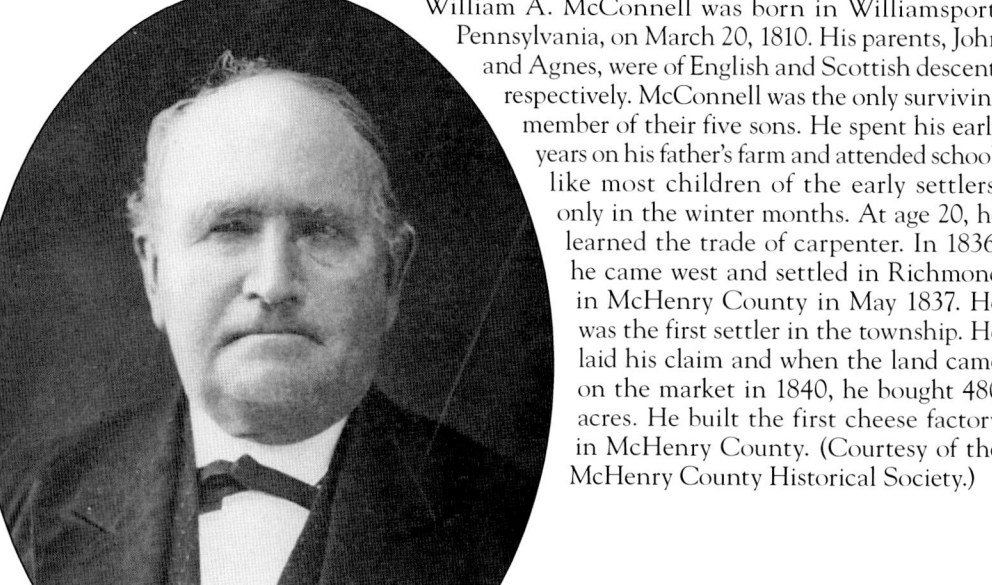

William A. McConnell was born in Williamsport, Pennsylvania, on March 20, 1810. His parents, John and Agnes, were of English and Scottish descent, respectively. McConnell was the only surviving member of their five sons. He spent his early years on his father's farm and attended school, like most children of the early settlers, only in the winter months. At age 20, he learned the trade of carpenter. In 1836, he came west and settled in Richmond in McHenry County in May 1837. He was the first settler in the township. He laid his claim and when the land came on the market in 1840, he bought 480 acres. He built the first cheese factory in McHenry County. (Courtesy of the McHenry County Historical Society.)

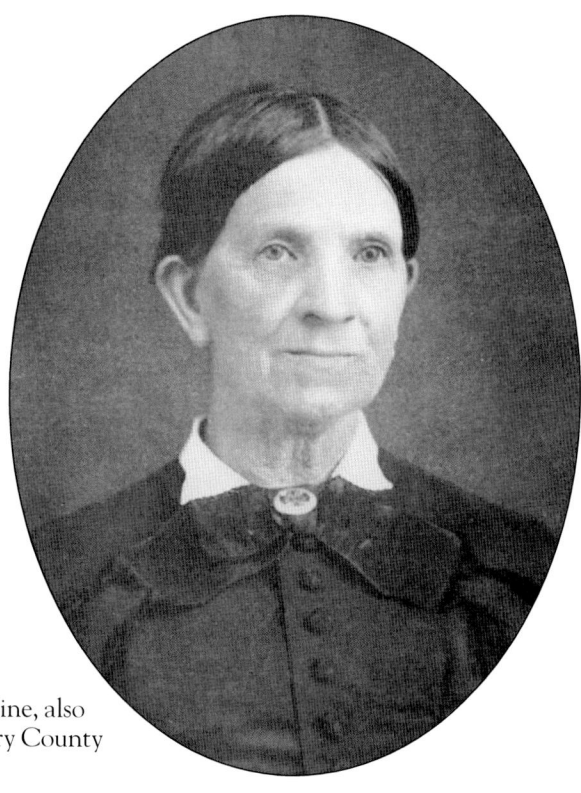

In 1838, McConnell married Elizabeth Bodine, also of Pennsylvania. (Courtesy of the McHenry County Historical Society.)

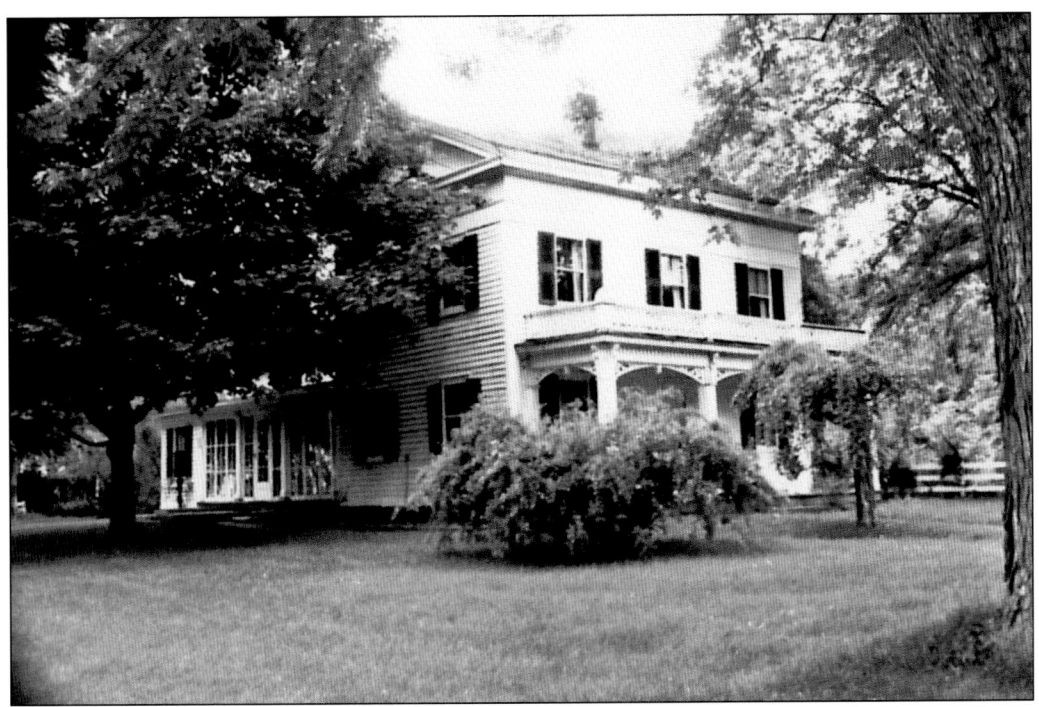

Over the years, McConnell added to his land until he owned 1,400 acres and built a fine residence half a mile west of the center of Richmond. He was the first postmaster of the town and also the first justice of the peace, a position he held for 36 years. Like many of the wealth farmers in the county, he was also a Mason. (Courtesy of the McHenry County Historical Society.)

In 1872, the McConnells gave each of their three sons a fine farm with buildings, stock, and feed for one year. One son, Abram Bodine McConnell, had a farm on what is now McConnell Road in Dorr Township. William McConnell is pictured on the right. (Courtesy of the McHenry County Historical Society.)

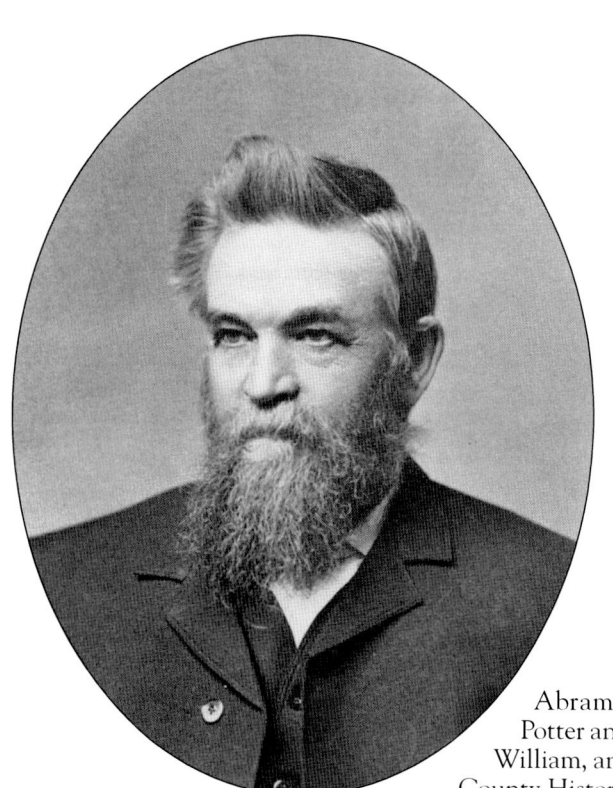

Abram Bodine McConnell married Hattie Potter and had five children, Elizabeth, Ida Lena, William, and Fred. (Both courtesy of the McHenry County Historical Society.)

Pictured here are two of the McConnells' daughters, Elizabeth (left) and Lena. (Courtesy of the McHenry County Historical Society.)

McConnell and his wife built a fine house in Woodstock, which still stands on the corner of South and Jefferson Streets. (Courtesy of the McHenry County Historical Society.)

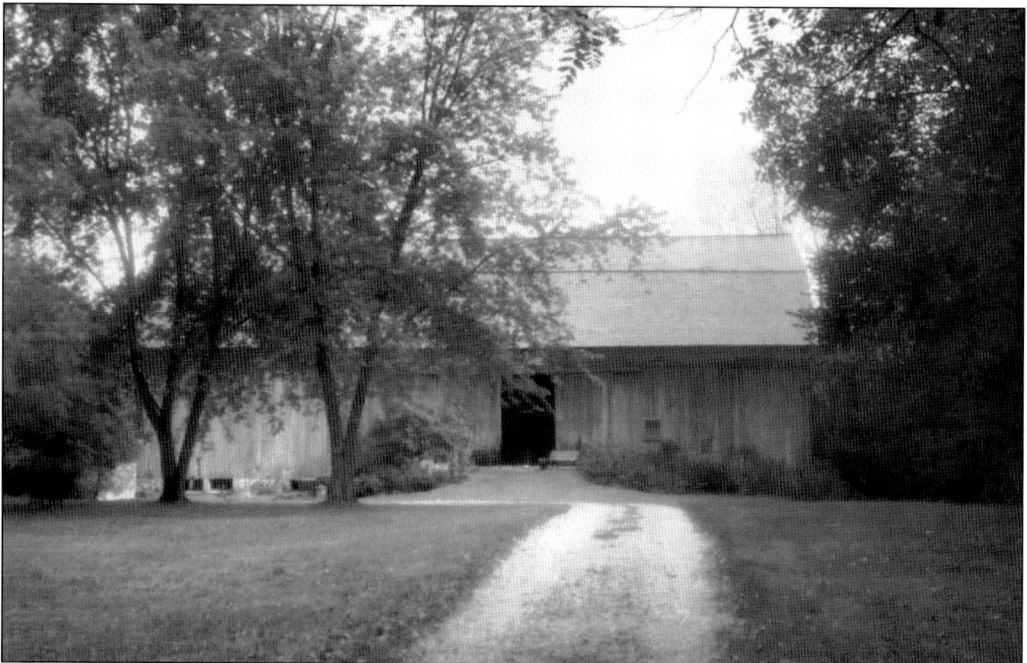

Abram Bodine McConnell's farm, located just outside of Woodstock in Dorr Township on McConnell Road, was large and prosperous. It had three barns, one of which is still standing and is now owned by the Tinkler family. (Photograph by Arabella Anderson.)

The barn that was part of the McConnell farm outside of Woodstock is still standing and is currently owned by the Tinkler family. (Photograph by Arabella Anderson.)

William and Elizabeth McConnell's second son, John, was born in Richmond Township on July 8, 1842. He was the first white child born there. In 1864, he went to Sacramento, California, and started working in the lumber business. Four years later, he returned to settle down and farm his 365 well-cultivated acres. He also had dairy cows, milking 20 and 35 cows a day. In 1868, John married Mary Frothingham. They had two children, Bertha and Charles. He was connected with the Richmond Cheese Factory, where he became sole proprietor in 1877. In 1882, he established the Richmond Pickle Factory, the only establishment of its kind in the town. He also served as a township trustee for 10 years. Bertha is pictured right with her son Lyman. The photograph below is of her husband, Charles A. Mather. (Both courtesy of the McHenry County Historical Society.)

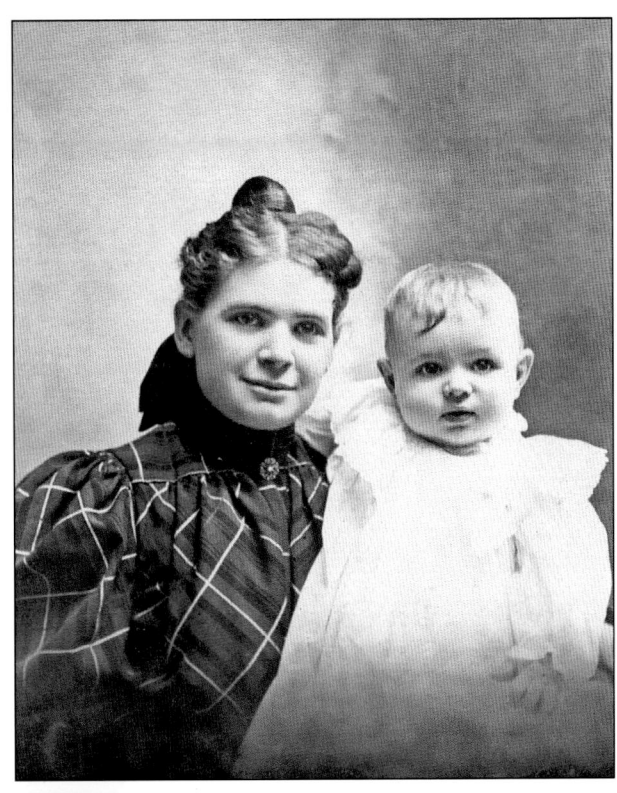

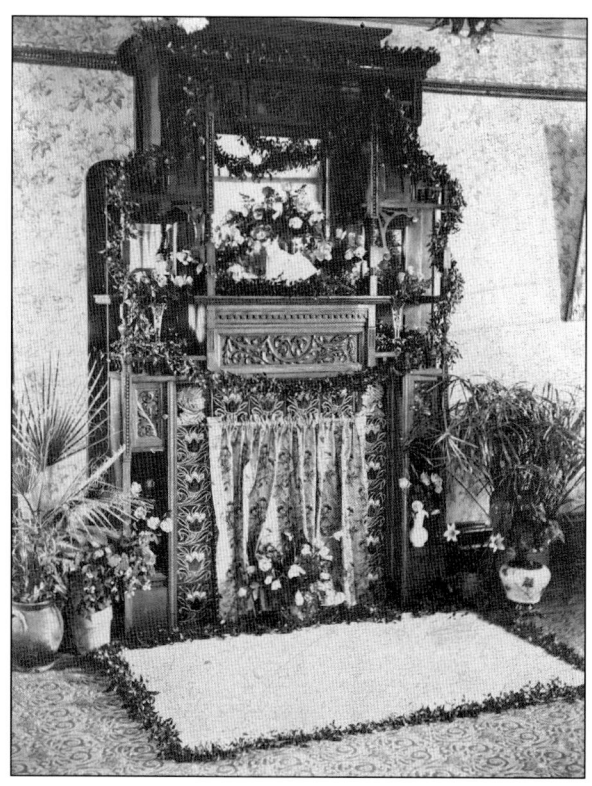

John McConnell's daughter Bertha married Charles A. Mather. This fireplace was in the Richmond house and was decorated for their wedding day, June 3, 1896. The house appears to have been grand and, for its time, was very modern. It speaks to the success of the family's farm and to McHenry County's dairy business in general, a harbinger of things to come. (Courtesy of the McHenry County Historical Society.)

Horace Capron became the second U.S. commissioner of agriculture, appointed by Pres. Andrew Johnson. He established a system of plant and seed exchanges with other countries; made a large collection of native grasses, forage, and fiber plants; organized the division of botany; completed and occupied the first department of agriculture; and recommended the establishment of a division of veterinary surgery. Four years later, he accepted the invitation from the Japanese government to become their agricultural advisor. He also introduced beer brewing to Japan. In 1967, a life-sized bronze statue of Capron was erected in the city of Sapporo, Japan. (Courtesy of the McHenry County Historical Society.)

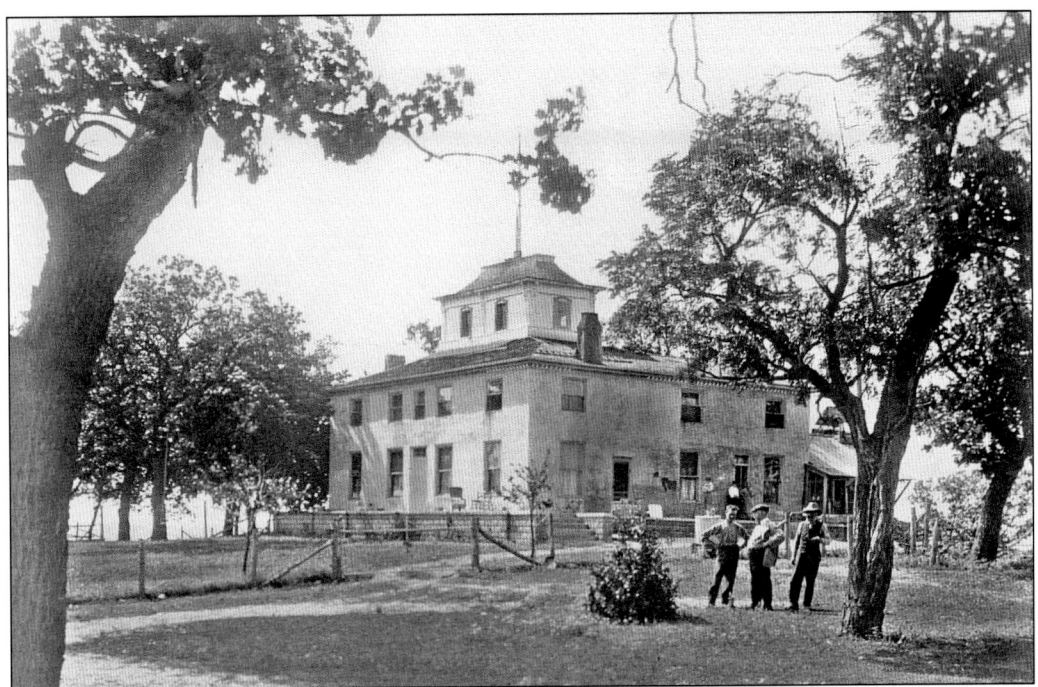

Capron commissioned the building of the Mansion House on his 1,000-acre spread in 1850. It was designed after the grand, old square mansions of the south. Made of redbrick brought from Milwaukee by ox cart, it still stands on Route 173 between Alden and Hebron. Capron did not occupy the house until 1854, when he brought his second wife, Margaret Baker, of New York, to live there. The large belvedere lookout on top of the house made it possible to see for miles. The Mansion House—like the Terwillger house, the Cupola House in Marengo, the House of Seven Gables, and Windhill Farm—was also a stop on the Underground Railroad. (Courtesy of the McHenry County Historical Society.)

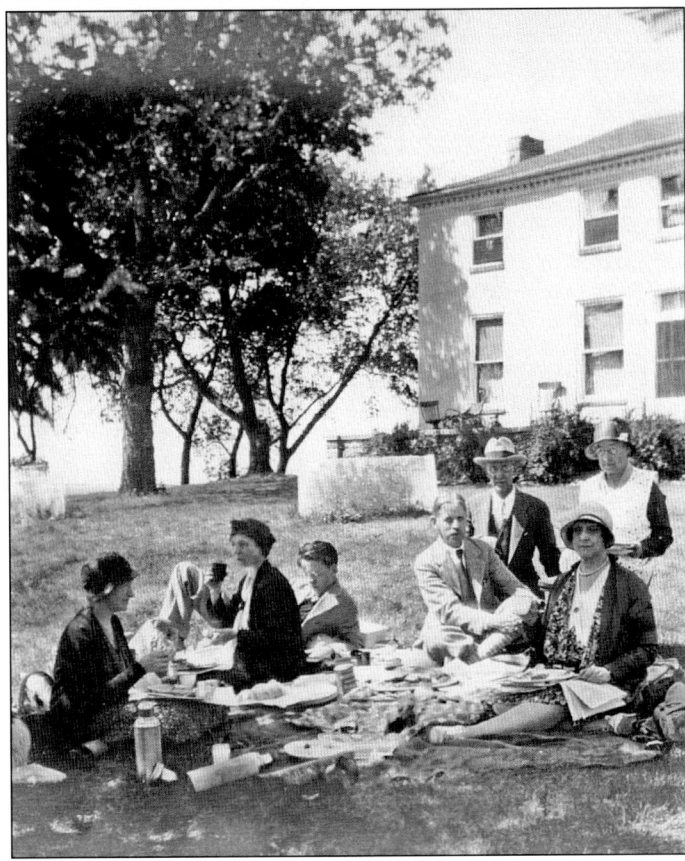

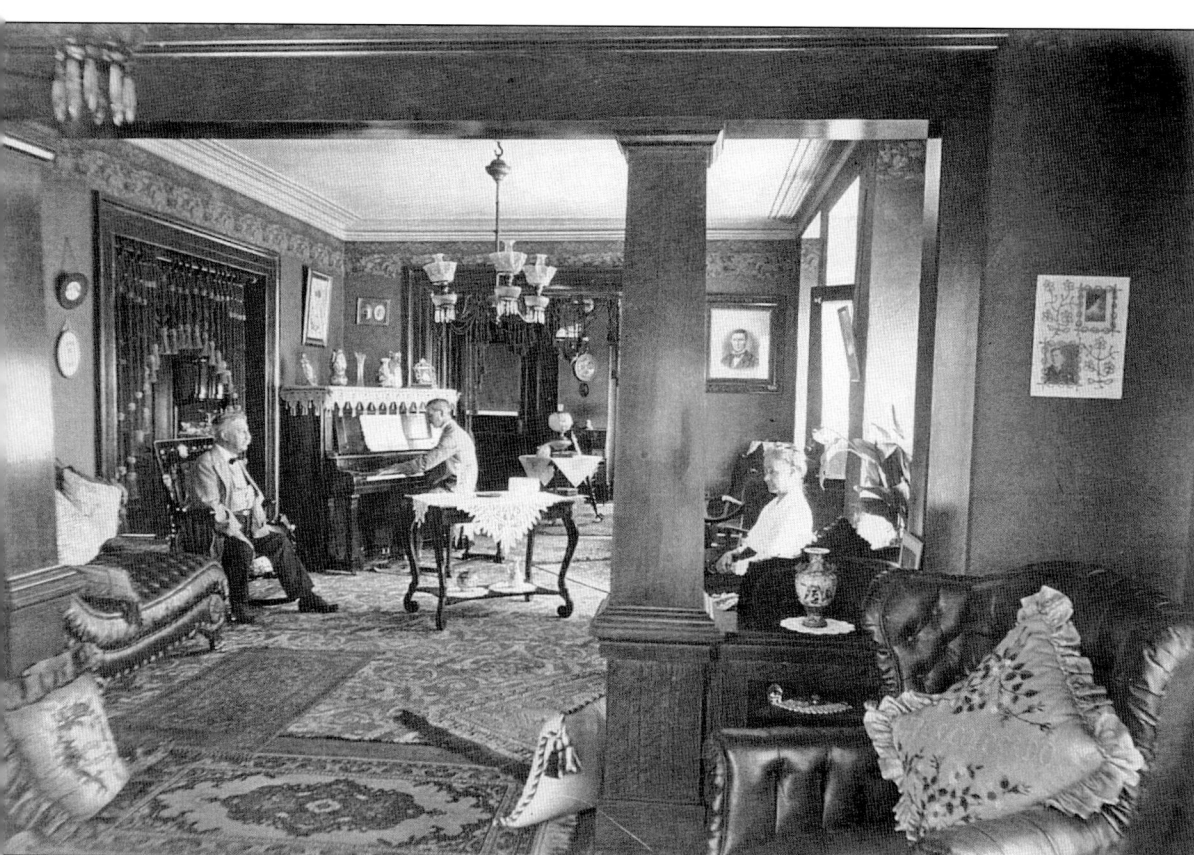
The Italianate exterior of the mansion house was impressive, and the size of the home dwarfed the local log cabins and small Greek Revival homes of the area. The interior of the house was very grand, with high ceilings; plaster moldings; crystal; gas chandeliers; an elegant, curving staircase; and expensive woodwork. After the Civil War, Horace Capron, a general, invited many important guests to visit the house, including Gen. Ulysses Grant. When Capron left the house and moved to Washington, D.C., and later to Japan, the house was occupied by his brothers Newton and John. Since they died, the mansion has belonged to a succession of owners, including the Bates family. Silent film star Granville Bates was born in the house. The Mansion House is still occupied. It stands on Route 173 between Harvard and Alden. (Courtesy of the McHenry County Historical Society.)

Col. Gustavus A. Palmer (b. 1805) and his wife, Henrietta (b. 1812), arrived in McHenry County by covered wagon in 1839 and lived in the Crystal Lake area for over 40 years. They had three children, Charlotte, John, and Emma. Palmer was a founding member of the Nunda Masonic lodge, and meetings were held in his home. He and his wife both died within days of each other from typhoid pneumonia in December 1884. They are buried in the same grave at the Lake Avenue Cemetery in Crystal Lake. Their son, John, pictured right, married Mary Adelline Throop, pictured below, on April 3, 1902. (Both courtesy of the McHenry County Historical Society.)

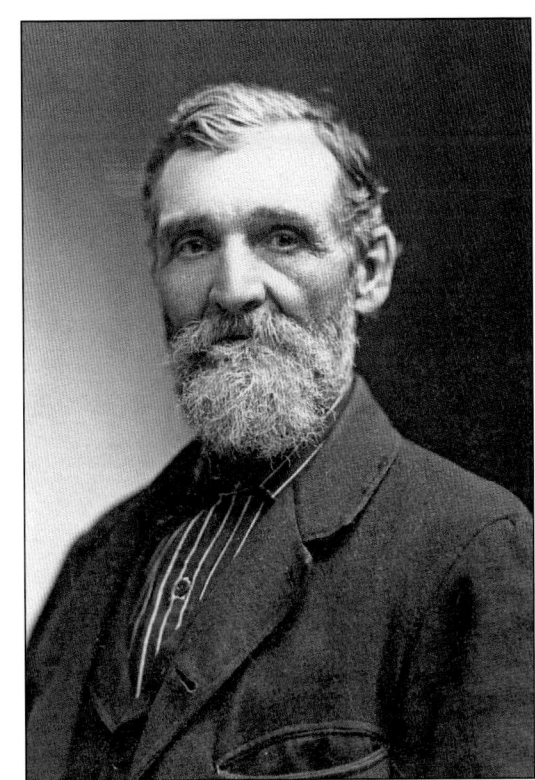

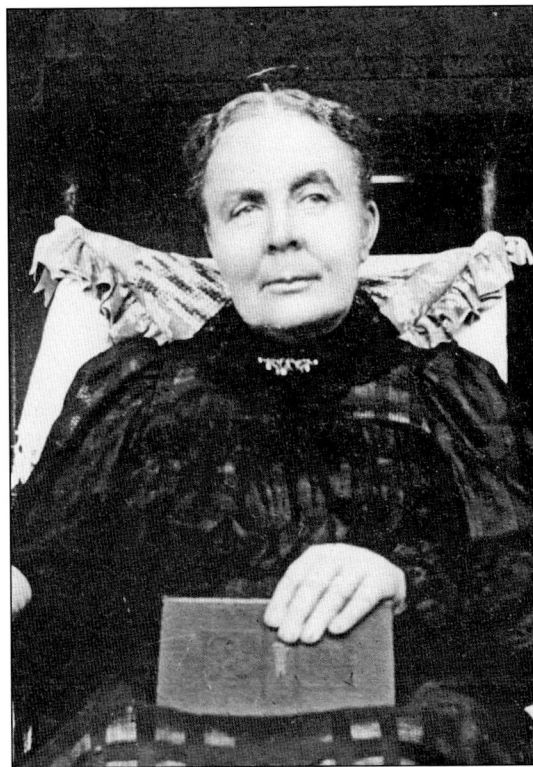

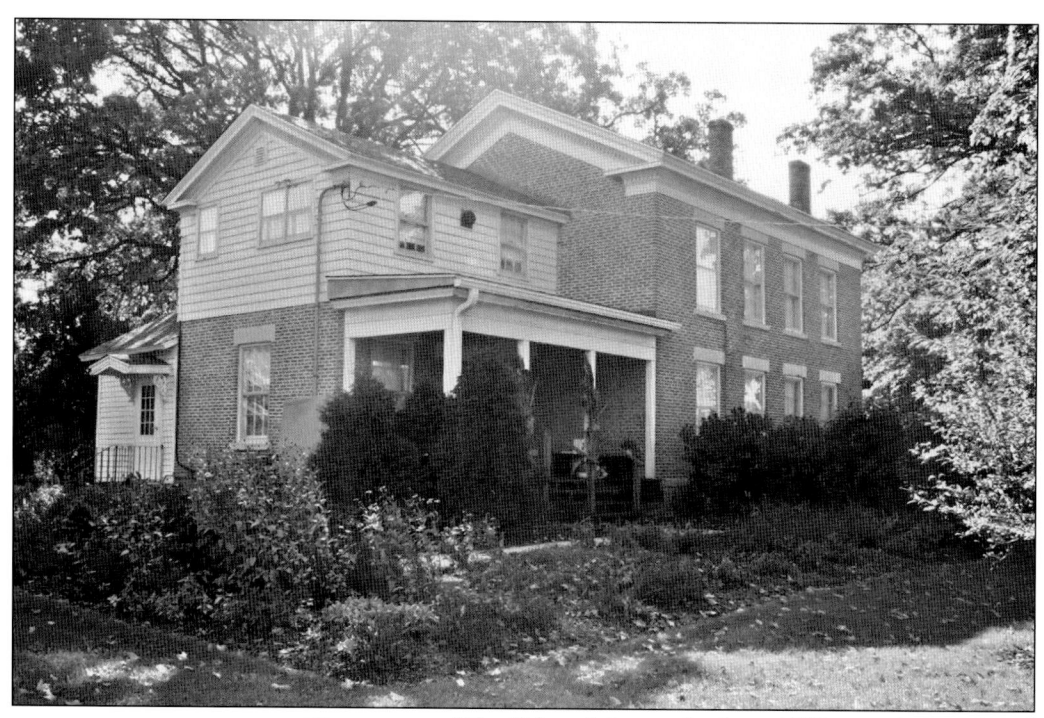

The Palmer's house, built in 1858, was designed and built by Andrew Simons on bounty land that Colonel Palmer earned in the little-known Patriots War of 1837 and 1838. The Palmer house, located at the northeast corner of the intersection of Route 176 and Terra Cotta Road, was known as Palmer's Corners. The house, a combination of Greek Revival and federalist architecture, is the only building in Crystal Lake that is listed on the National Register of Historic Places. (Photograph by Arabella Anderson.)

Page Colby, a native of Vermont, was born in 1820 and headed to McHenry County in 1842, purchasing 80 acres for $130. He eventually added to his holdings until he owned 800 acres. Colby cleared the land, built a road, and began constructing his Greek Revival farmhouse on McCollum Lake Road in McHenry. He married his wife, Mehitabel, in October 1843 and had six children, Charles C., Mary, Ellen, George, Willard, and Ida. (Courtesy of the McHenry County Historical Society.)

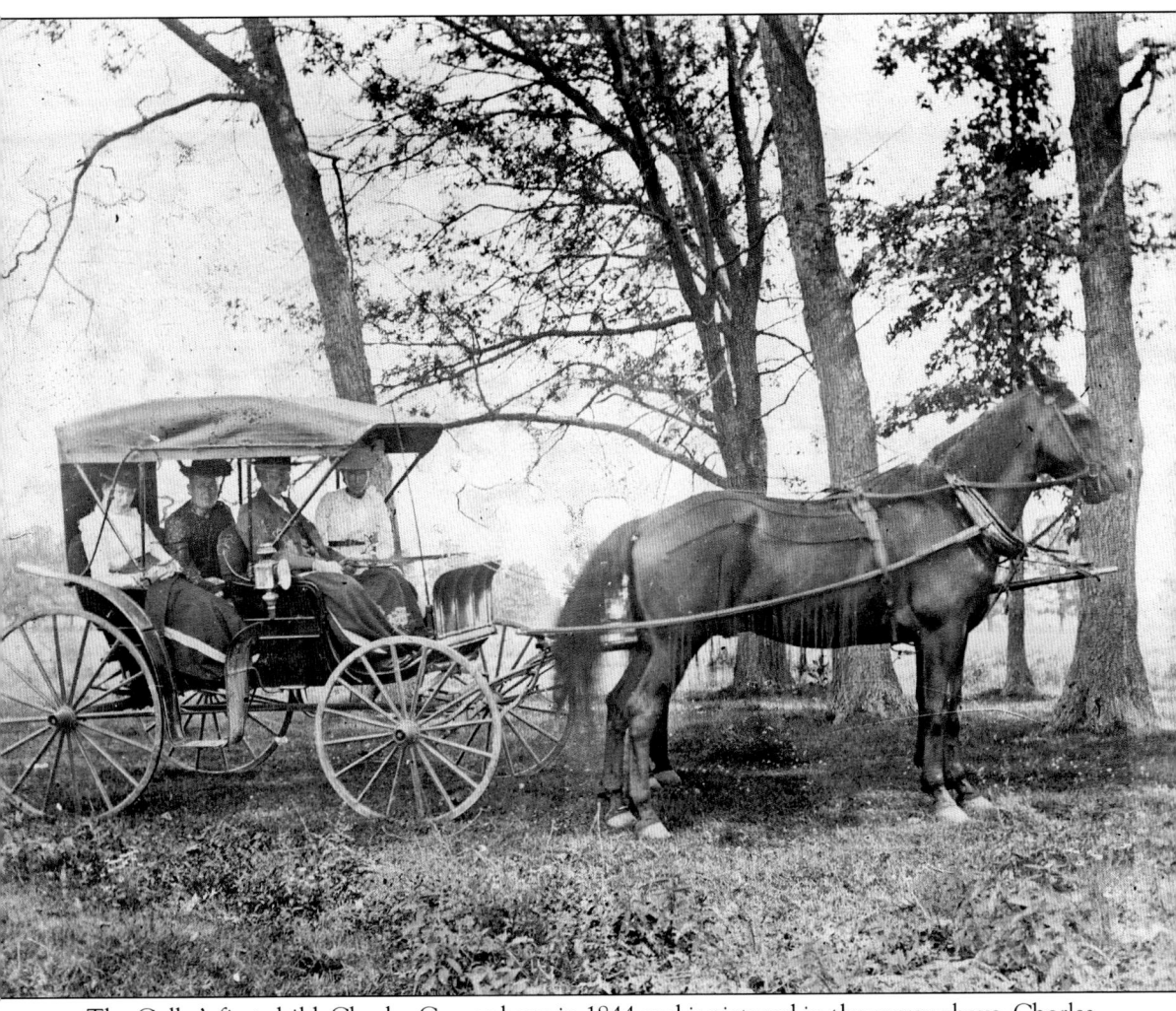

The Colby's first child, Charles C., was born in 1844 and is pictured in the surrey above. Charles married Arminda Talbot on Christmas Day in 1864. He farmed 220 acres and raised milking shorthorn cattle, Merino sheep, and Poland China hogs. He was also a teacher and served on the school board. Charles and Arminda had two children: Fred, born in 1865, and Caroline, born in 1876. (Courtesy of the McHenry County Historical Society.)

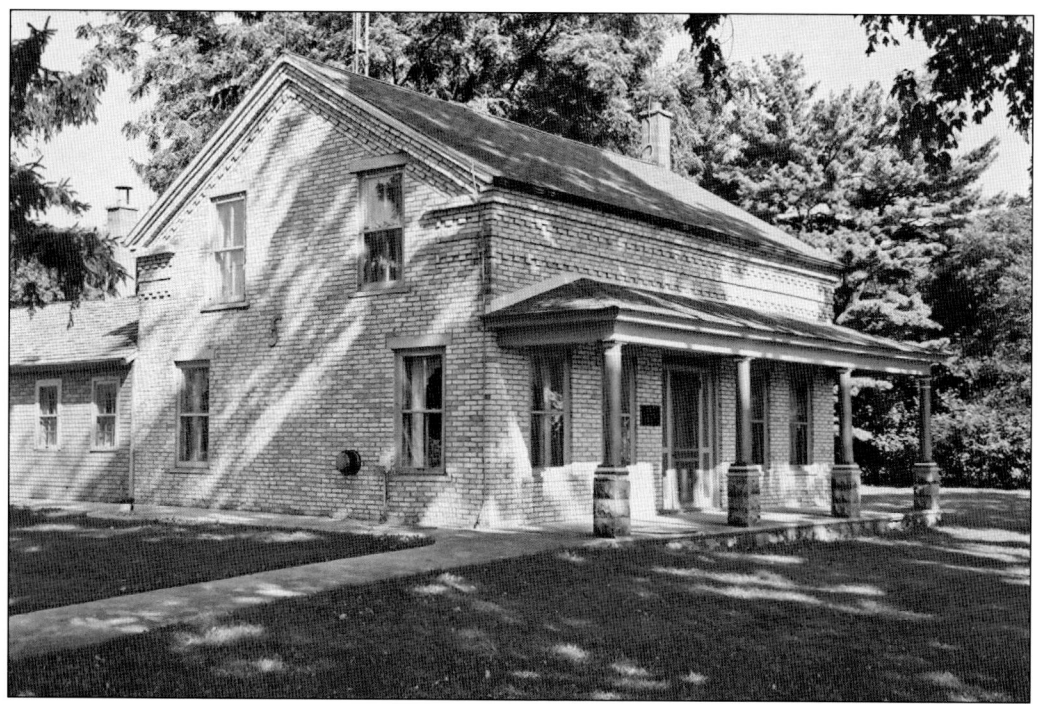

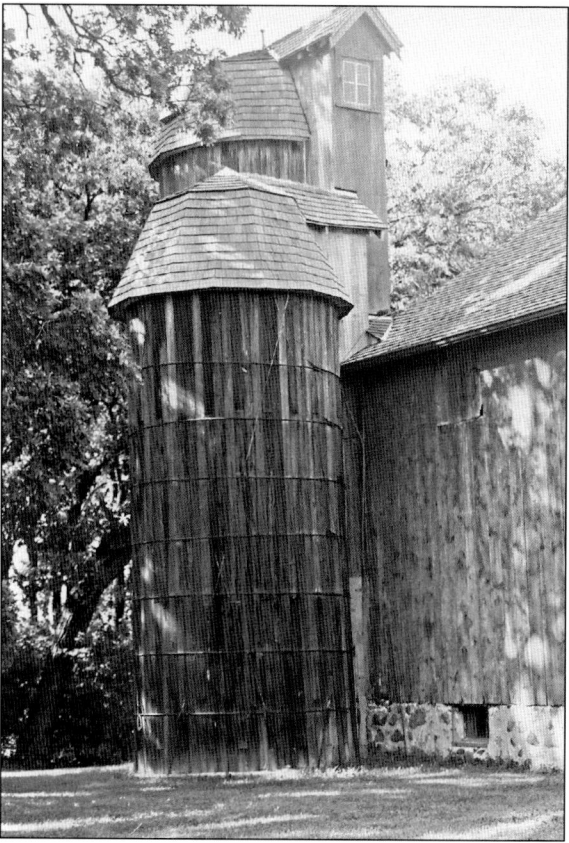

Page Colby raised Holstein cattle, Berkshire hogs, Spanish Merino sheep, and Norman horses. The Colby farm eventually became the Petersen farm but remained in the family for 159 years until the death of the last descendent, Robert Petersen, in 2002. Now considered a historic treasure under the protection of the McHenry Landmark Commission and the City of McHenry, the farmstead is being restored as part of the Petersen family will to create a living museum of 19th- and 20th-century farm life. (Photographs by Arabella Anderson.)

Robert and Frank Richardson homesteaded the Richardson farm in 1840. The brothers, brick masons by trade, rented the farm and in 1842 went to Milwaukee, where they constructed the first brick building in the city. In 1846, they returned to English Prairie, where they built the brick farmhouse still occupied by the Richardson family. The initial farm, which was 240 acres, has grown over the years to include 450 acres and 2 farmsteads. (Courtesy of the Richardson family.)

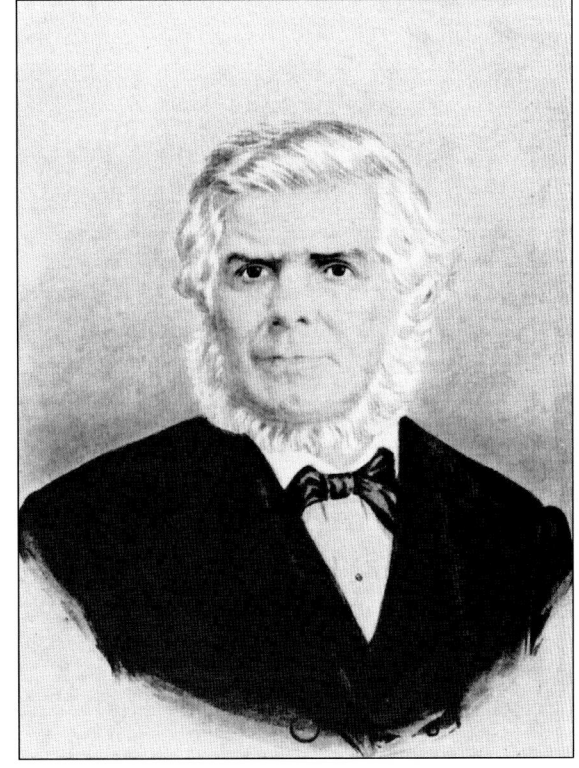

Robert was born in 1811 in Yorkshire, England. He came to America in 1834 and married Eleanor J. James of London in 1843. They had seven boys and six girls. Aside from running their very successful farm, Robert was a supervisor, a justice of the peace, a school trustee, and an assessor and road commissioner. (Courtesy of the McHenry County Historical Society.)

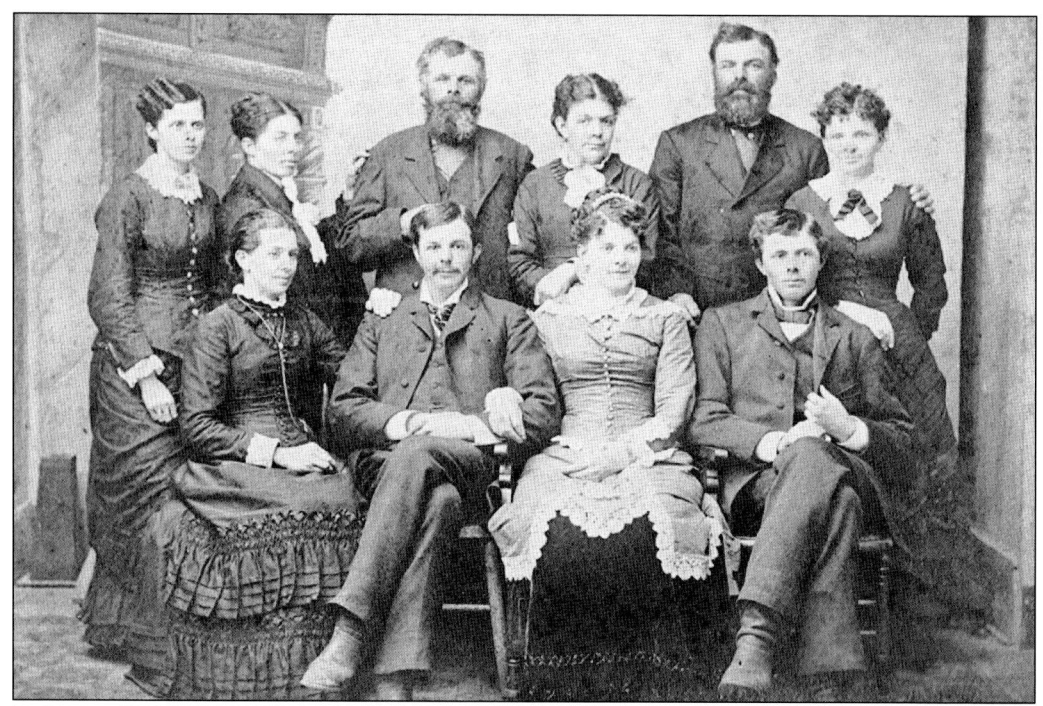

Robert and Eleanor Richardson had 13 children: Francis (b. 1843), Tamar (b. 1845), Joseph (b. 1846), Hannah (b. 1848), Robert T. (b. 1849), Eleanor (b. 1850), Robert E. (b. 1852), Eliza (b. 1854), Sarah (b. 1856), John (b. 1859), Esther (b. 1860), Jesse (b. 1862), and Alfred (b. 1865). Pictured here in 1880 are the 10 children who lived to adulthood. Three of the boys—the two Roberts and John—died during childhood. (Courtesy of the Richardson family.)

Charles L. Teckler, the "dean of real estate," was born in Germany in 1859 and came to McHenry County as an infant. In 1902, he became a realtor, specializing in farms and rural property. He was involved in developing some of the finest farms in the area. He was very popular in Crystal Lake, known as an honest man who did much for the community. He died on August 8, 1946, at the age of 87. Teckler and his family are buried at Union Cemetery in Crystal Lake. (Courtesy of the McHenry County Historical Society.)

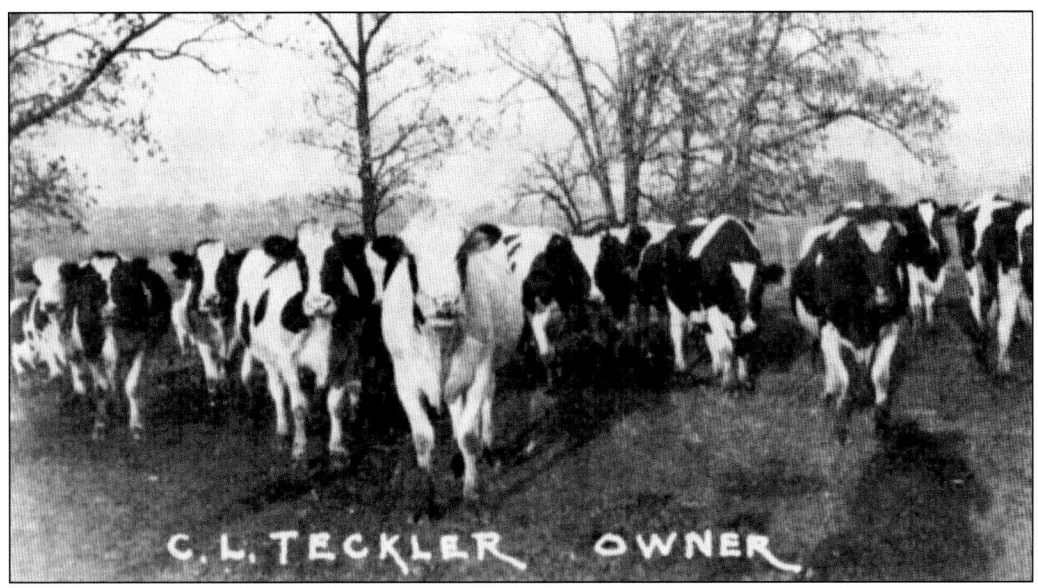

Teckler had a large dairy farm three miles outside of Crystal Lake. Some of his cattle are pictured above; the farm and Teckler family are pictured below. (Both courtesy of the McHenry County Historical Society.)

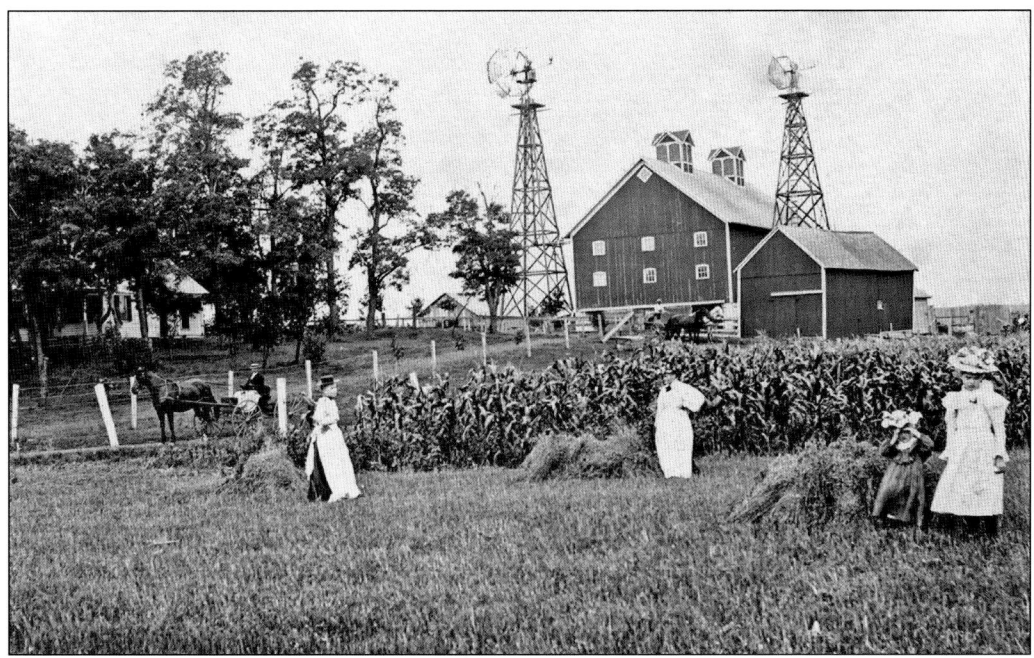

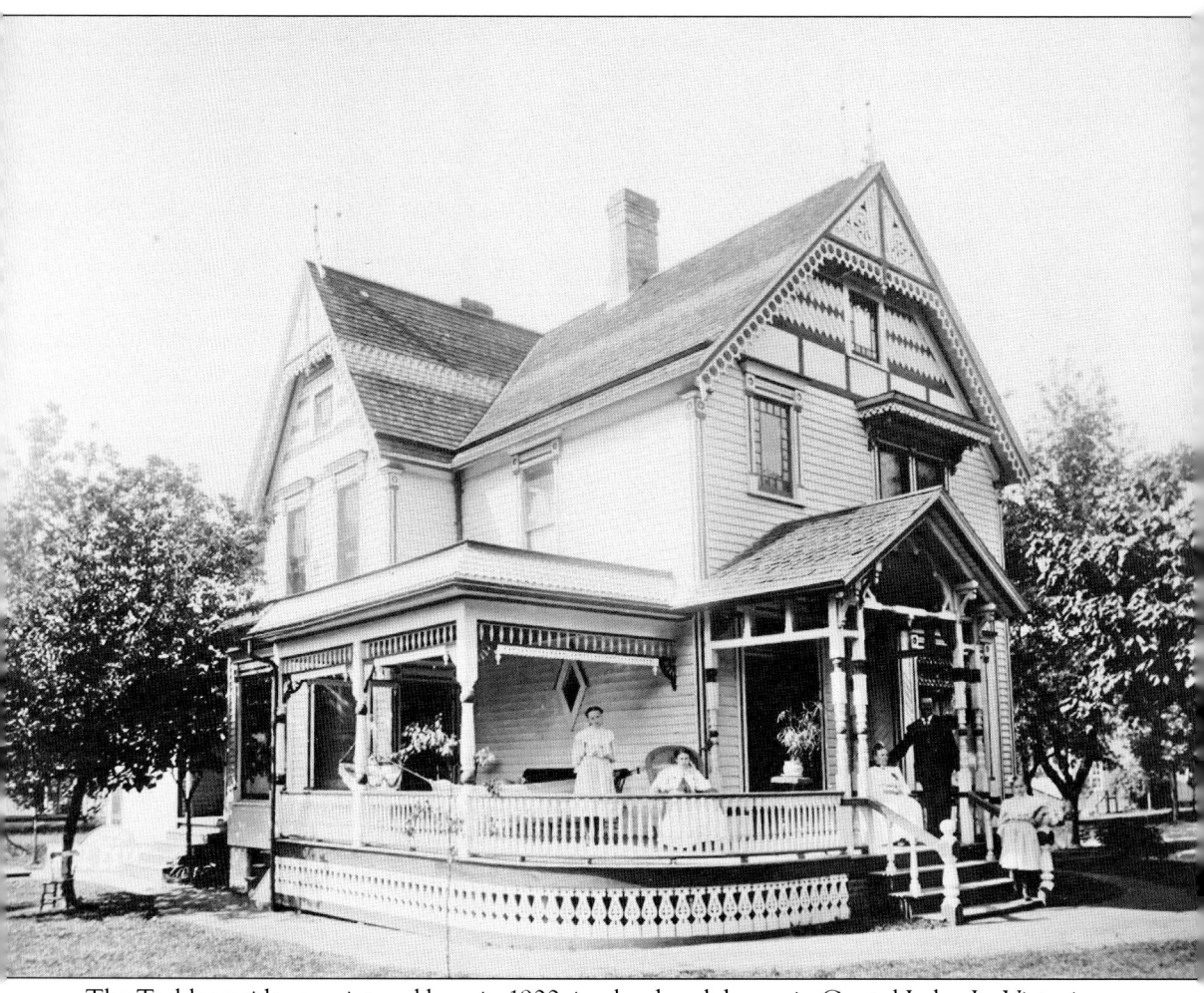

The Teckler residence, pictured here in 1900, is a landmark house in Crystal Lake. Its Victorian elegance has been maintained to the present day. It is situated at 25 Walkup Avenue, near Crystal Lake Avenue. In 1882, Charles L. Teckler married Elsie Hibbard at the First Congregational Church in Crystal Lake. At first, the young couple lived on the Samuel Foster farm, located south of Crystal Lake. In 1902, Teckler started his own real estate business in Crystal Lake and resided in town there thereafter. Charles, Elsie, and their three young daughters lived in this elegant home, with its lovely grounds and wrap-around porch. In 1904, Elsie died from pneumonia. Left alone with three young daughters, Teckler married Carrie Dike in 1905, who moved into the household and raised the young girls as her own. (Courtesy of the McHenry County Historical Society.)

The Teckler family is pictured here, including Teckler, his daughter Alice (standing), younger daughters Nettie (seated) and Ester, and his first wife, Elsie. (Courtesy of the McHenry County Historical Society.)

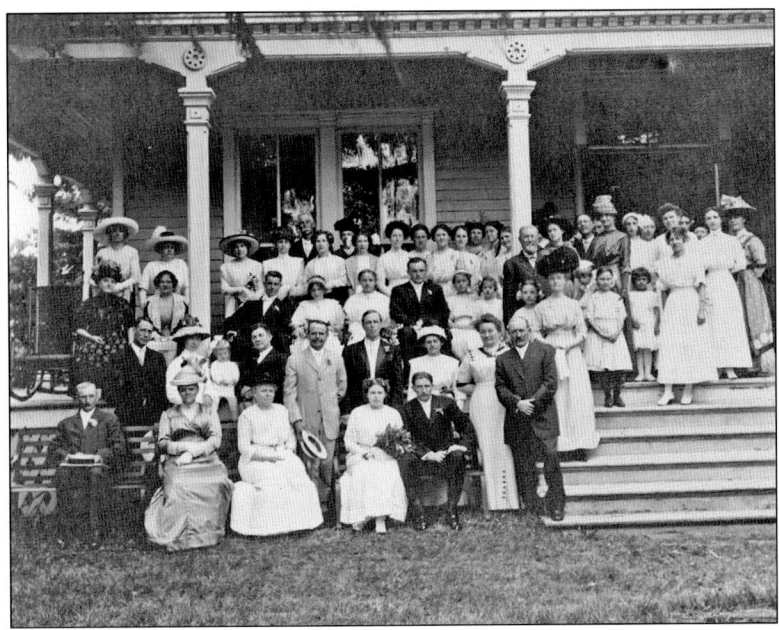

This photograph was taken at the wedding of Alice Teckler and Harold James in front of the Teckler's Crystal Lake house in 1912. Nettie Teckler married Ernest Shroeder of Elgin on June 22, 1922, and Ester Teckler married Donovan Young on May 10, 1928. (Courtesy of the McHenry County Historical Society.)

Alexander Hanley's farm in Crystal Lake looked typical for a farm of its day. There was a barn and several outbuildings, but one thing was missing—a silo. (Both courtesy of the McHenry County Historical Society.)

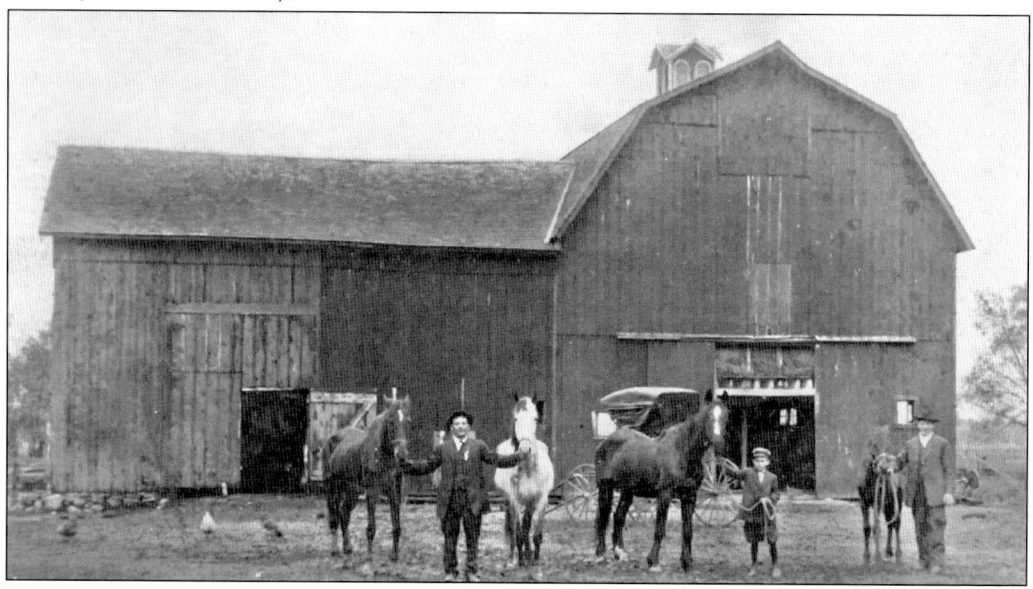

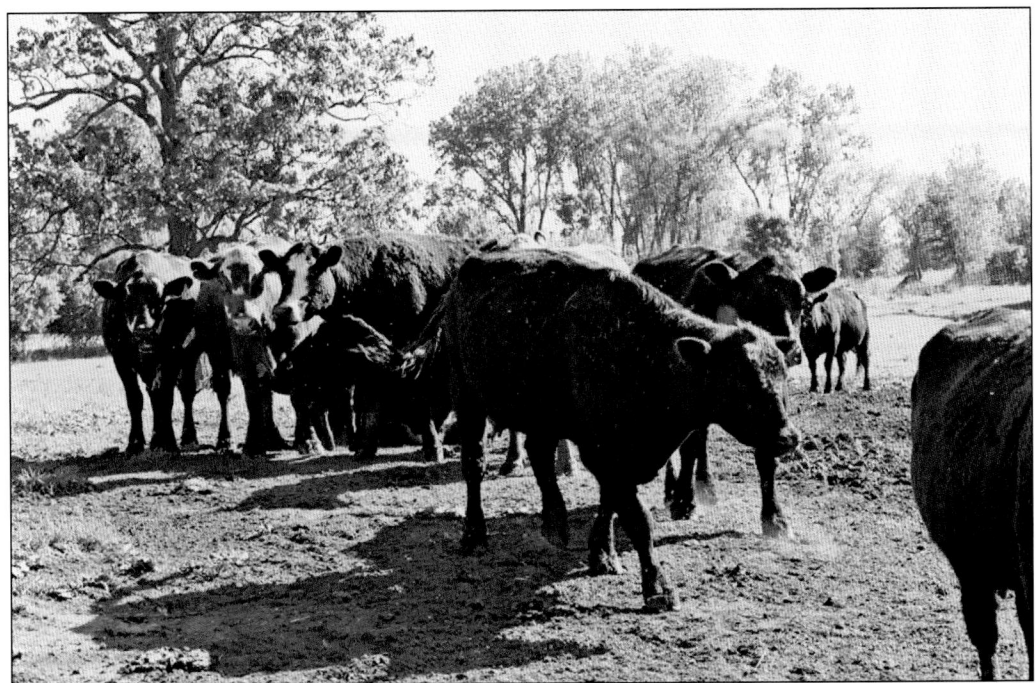

Beef cattle, particularly Aberdeen Angus and Herefords, were popular with early settlers because they could withstand the extreme temperatures of the county. B. R. Pierce brought the first Angus cattle from Scotland to Illinois in 1881. Midwestern farmers were doubly fortunate, as they had both the best farming and grazing land in the country. The problem was how to get the herds through the winter. Although beef cattle were kept in great numbers—at one point, there were 75,000 in Illinois—they were driven or shipped east for slaughter every year because the expense of feeding them through the winter was prohibitive. (Photographs by Arabella Anderson.)

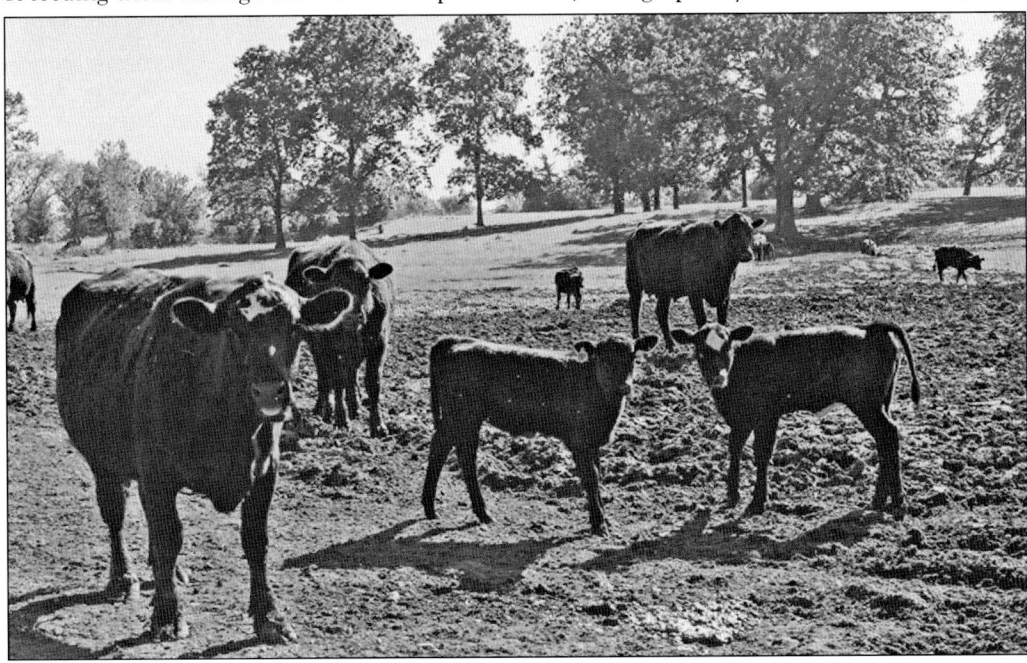

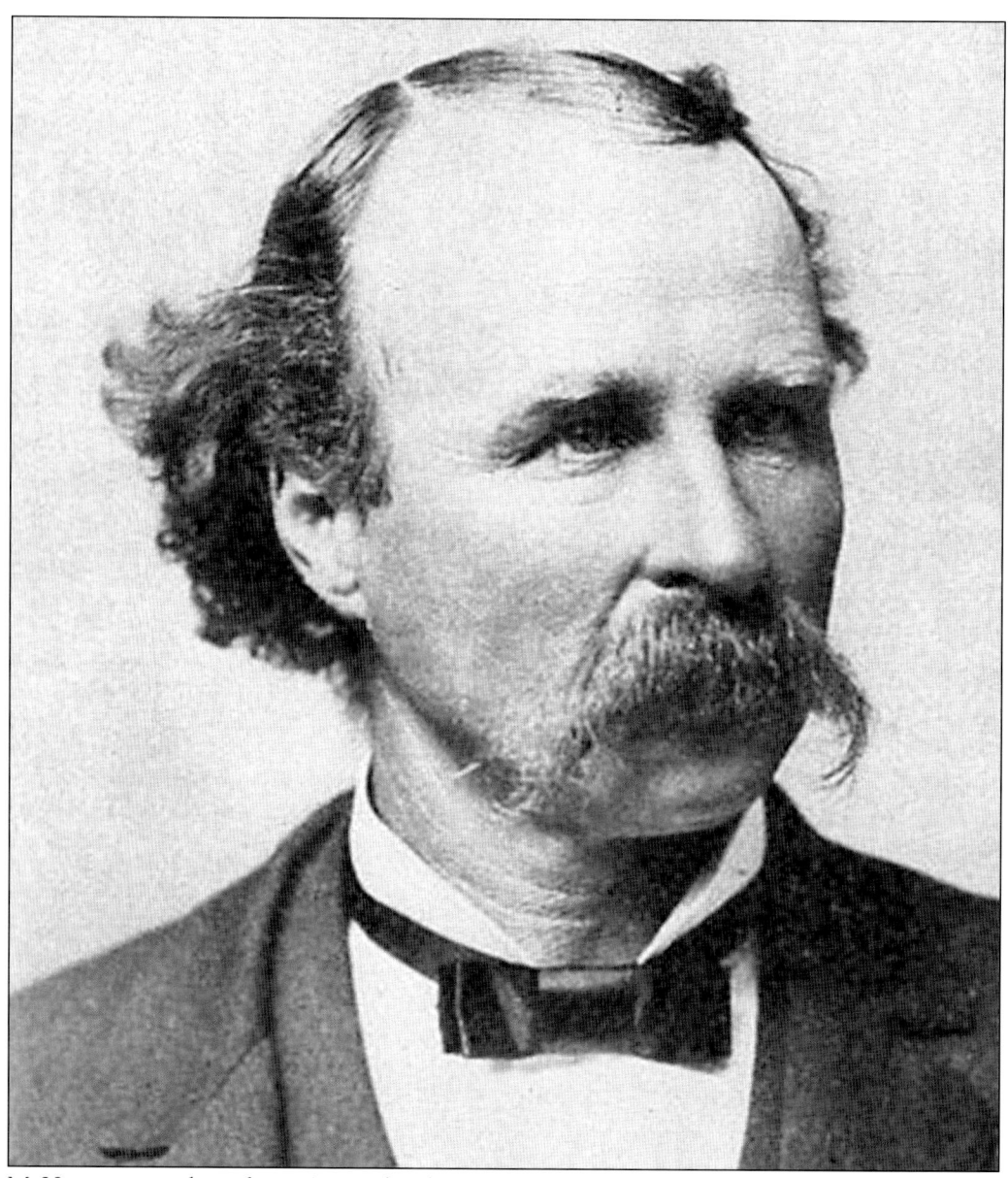

McHenry was a dairy farmer's paradise because the favored blue grass grows naturally and in abundance in this county. The cattle could graze extensively throughout the summer months and make plentiful milk, but what about the winters? Before the 1870s, the problem of how to feed dairy cattle through the winter was a constant one for dairy farmers. Hay, which had been dried, was an obvious choice, although it lost much of its nutritional value in the drying process. Silage, made from stems, stalks, and leaves, although more expensive, was the preferable choice because it provided the nutrients that allowed dairy cows to continue to provide milk. The problem was that storing the silage in a pit in the barn floor often led to spoilage. A farmer from Spring Grove found a solution. Fred Hatch, who had studied at the University of Illinois, returned to the family farm and convinced his father, Lewis Hatch, that they should build a silo to keep the feed fresh over the winter. They built the first square-corner silo, filing it with mature corn. (Courtesy of McHenry County Historical Society.)

Some spoilage was still a problem, however, because moisture and air could get into the corners of the square silos, causing the contents to rot. Fred tinkered with the idea and realized that a round silo would eliminate the problem. Round silos became popular in 1874 and over time increased to 25 feet in diameter and 80 feet in height. Alfalfa and corn became the staple feeding crop of America's dairy cattle. (Photograph by Arabella Anderson.)

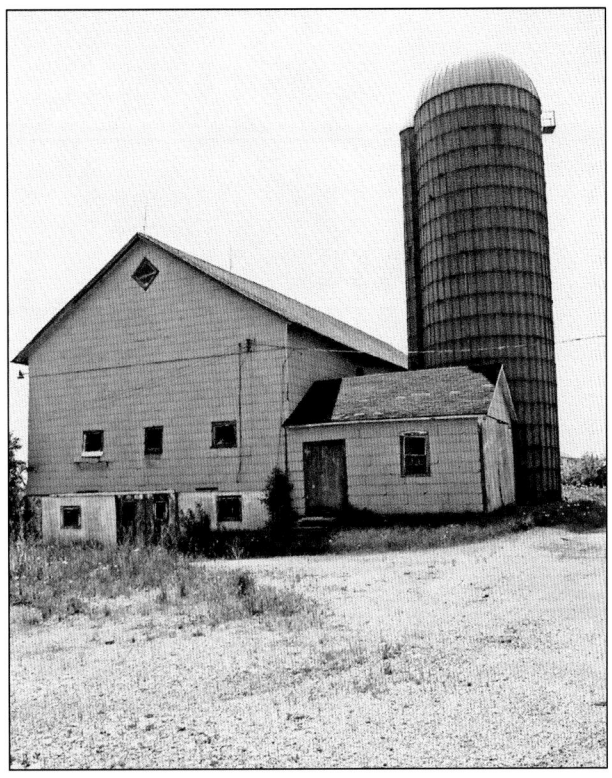

The Hatch silo revolutionized dairy farming. There were 75 shorthorn cows on the Hatch farm during the winter of 1873–1874. They stayed fat and gave more milk than ever before. In 1876, the family built two more silos. In 1891, Fred's alma mater bestowed on him an honorary master's degree, and in 1918, Wisconsin honored him with a place in the dairy hall of fame. (Courtesy of McHenry County Historical Society.)

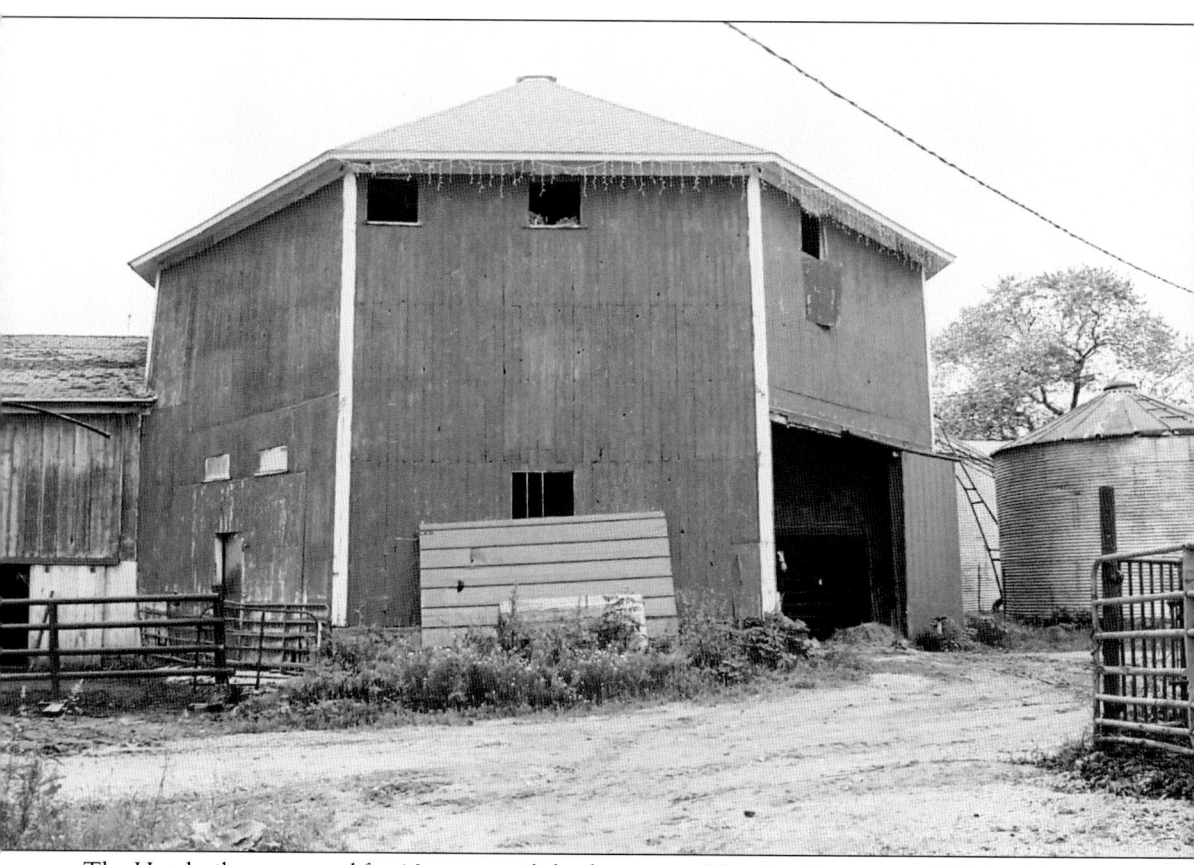

The Hatch silos were used for 46 years until the farm was sold to the Kattners in 1919. Joe Kattner tore down the barn along with the silos. The existing octagonally shaped barn, pictured above, was made from the timbers of the original silo. The Kattner family has farmed this land for three generations now. (Photograph by Arabella Anderson.)

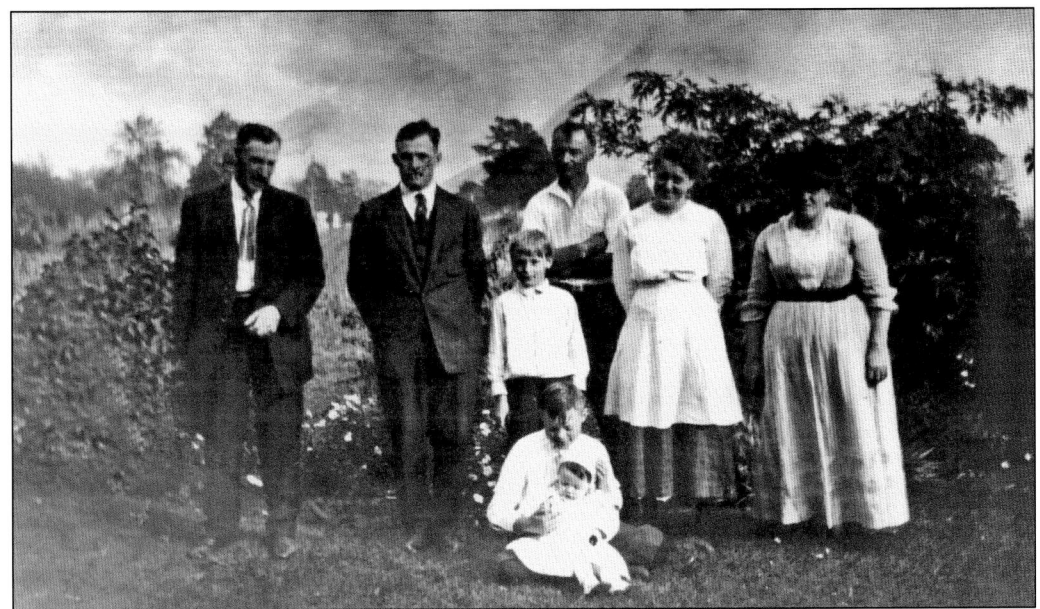

Fred and Meta Bohl were of German extraction. Their young children Paul (standing), William (seated), and baby Florence are pictured on their dairy farm on Route 14 in Crystal Lake in 1914. The Bohls had about 60 head of milking cows. Florence and her brothers worked the dairy farm until her last living brother, William, died in 1979. (Courtesy of the Emmanuel Lutheran Church.)

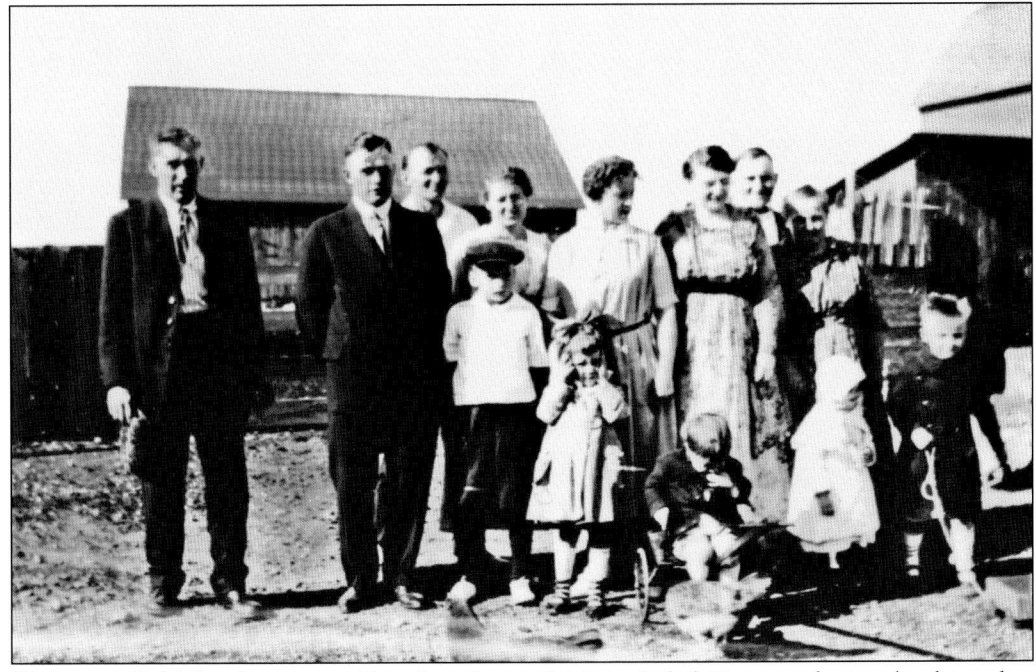

The entire Bohl family is pictured at their farm, which included 62 acres of prime land on what became the main thoroughfare of Crystal Lake. Fred Bohl (1872–1947) is second from left. He and Meta signed the guest book at Charles L. Teckler's funeral. (Courtesy of the Emmanuel Lutheran Church.)

William Bohl, Florence Bohl's brother, is pictured here with the family's minister. (Courtesy of the Emmanuel Lutheran Church.)

The celebration for Fred and Meta Bohl's 50th wedding anniversary was set up in the dining room of the family farmhouse. (Courtesy of the Emmanuel Lutheran Church.)

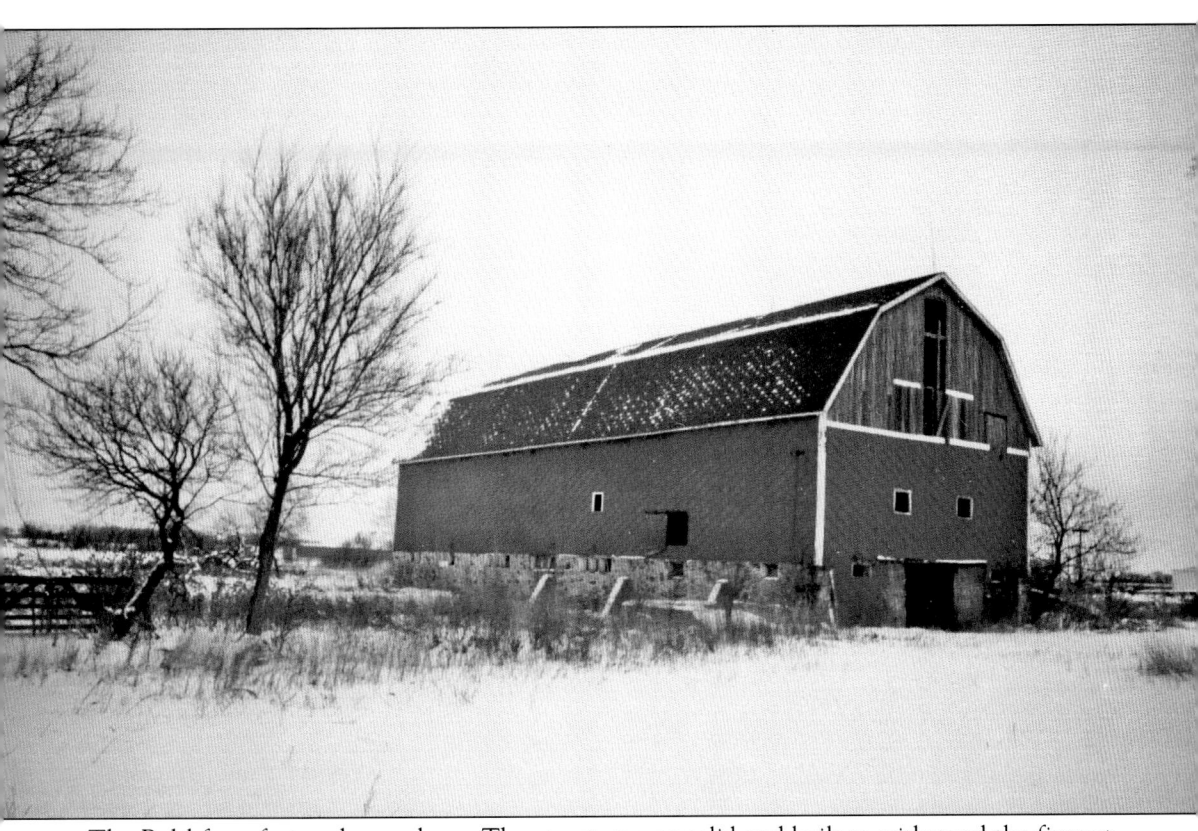

The Bohl farm featured a peg barn. The structure was solid and built to withstand the fiercest weather. The foundation walls were two feet thick and made of field rock and mortar. The wooden support beams were thick as railroad ties and bound together with sturdy wooden pegs. No nails were used in the construction of the barn. Instead, hand tools were used to cut, fit, and create the foundation beams and roof beams. The foundation beams were then notched and hammered into place. The Bohl's barn, pictured above, remained a sturdy structure to the end. Visitors observed license plates from all over the country nailed to the inside walls. Florence, a dairy farmer to the end, kept her last two cows in the barn as pets. (Courtesy of the Emmanuel Lutheran Church.)

Florence Bohl is shown here in a communion photograph. She was born on April 23, 1919, and was Fred and Meta Bohl's third child. Neither Florence nor her brothers married. They lived their entire life on the family dairy farm they loved. In June 1981, two years after William died, Florence gave the farm to the Emmanuel Lutheran Church. A few weeks after putting the land in a trust, she gave the church total control and ownership of the farm. By agreement, she was allowed to live there until shortly before her death, when she was removed by an emergency crew from her home of 74 years. They had to wade through rooms filled with several feet of refuse, junk, and rotting food. Florence slept wherever she fell. In those last years of her life, she was reportedly ill and emaciated. Records indicate she spent only $141 a month on food. Florence spent the remainder of her life in a nursing home on public aid and died on December 13, 1993. She is buried in the Union Cemetery in Crystal Lake in an unmarked grave. The value of the land at the time of her death was estimated at $11 million. (Courtesy of the Emmanuel Lutheran Church.)

# Two

# THEN CAME THE MERCHANTS

Within a few decades of the arrival of the first farmers, other businesses began to appear in McHenry County. One of the most profitable was that of cheese making. The growth of the city of Chicago and the increasing demand for fresh milk products by its citizens spurred the development of McHenry County's dairy industry.

At about the same time that the railroads made it possible to ship milk from McHenry County to Chicago, Gail Borden applied for a patent on a process to condense milk. The New York Condensed Milk Company—later known as the Borden Company—was formed in 1856. Borden's factories soon appeared in Harvard, Alden, and Woodstock, consuming huge amounts of the local milk supply.

Borden's success convinced even more farmers to try dairying. Within two years, three cheese factories sprang up in the county. By 1867, McHenry produced 600,000 pounds of cheese and 5.5 million pounds of milk. At one point, there were more creameries in McHenry County than in any other county in the nation.

Fate also took a hand in the growth of McHenry County's dairy industry. Legend has it that on an October evening in 1871, the great Chicago Fire was started in Catherine O'Leary's barn by a cow. It raged for 36 hours, and O'Leary was used as a scapegoat by *Chicago Tribune* reporter Michael Ahern, who latter admitted to making up the story about the cow. Nevertheless, cows were banned from the city.

This action by the city was not the only thing that increased demand for fresh milk. City milk sellers, who went door to door, were also responsible for the rising demand for fresh milk from the country. The milk they sold was often adulterated with other substances, including flour and plaster and formaldehyde as a preservative. Real milk had to be found elsewhere. Less than a day's travel away, McHenry County was the obvious choice.

By 1884, there were 53 cheese factories in the county. Between 1877 and 1883, the number of cows kept in the county for dairying jumped from 18,378 to 28,179, and McHenry County creameries were providing 757,935 pounds of butter, 2,213,002 pounds of cheese, and 7,917,321 gallons of milk. The increasing wealth of the county literally sprang from the udders of its dairy herds.

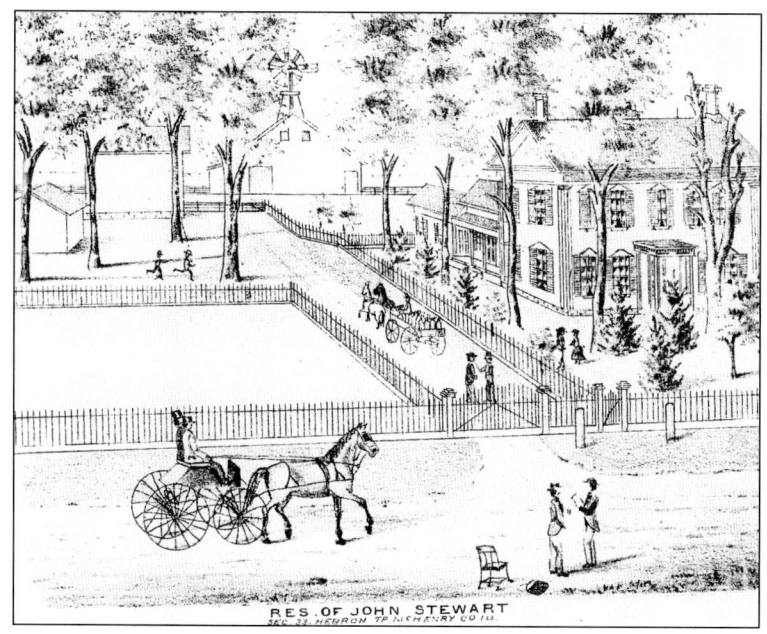
RES. OF JOHN STEWART
SEC 22, HEBRON TP MCHENRY CO ILL

In 1835, Robert W. Stewart and his three brothers came from Onondaga, New York, and settled at Keystone Corners, now Hebron. The brothers built their farms in a row and donated land for a school. Robert, who farmed 900 acres, married Susan Ann Ross and had seven children. In 1866, he and his brother W. H. Stewart built a cheese factory in Hebron. (Courtesy of the McHenry County Historical Society.)

John James Stewart, the fifth child of Robert and Susan Stewart, was born on December 24, 1854, in Hebron and became the eventual owner of the Stewart Cheese Factory, founded by his father and uncle. He was known for owning some of the finest Norman horses in the township and could often be seen driving about the countryside in his horse and buggy. (Courtesy of the McHenry County Historical Society.)

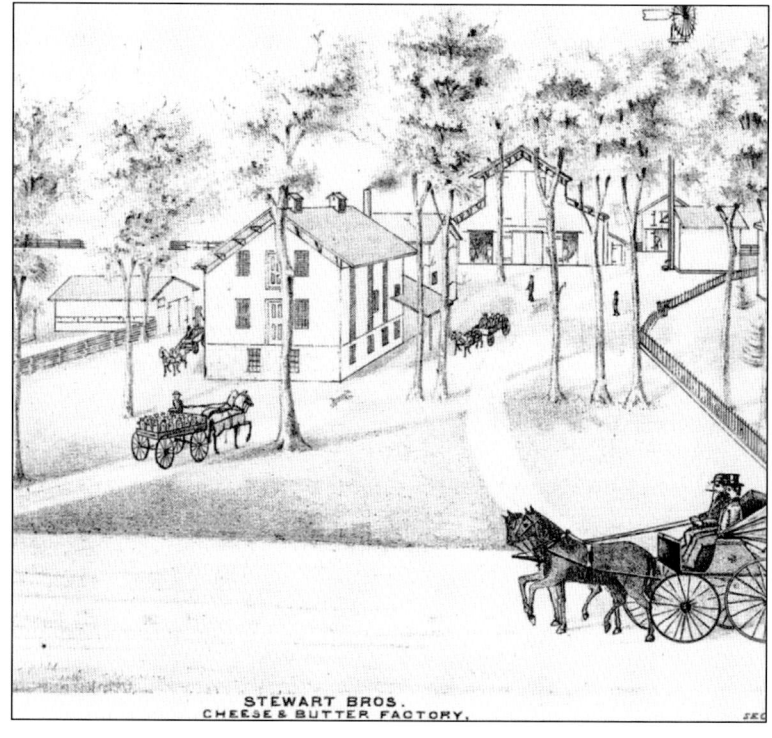
STEWART BROS.
CHEESE & BUTTER FACTORY.

The Alden Creamery was built near Alden village in 1869. In 1885, it was owned by Milo Munger and processed 25,000 pounds of milk and 1,000 pounds of butter each day. H. W. Copeland built another factory southwest of the village in 1883, using 7,000 pounds of milk a day. In 1879, the Ferris family built a third cheese factory nearby. The last Alden factory closed in 1909. The very next day, the Borden plant in Alden opened. It operated from 1909 to 1926, employing up to 30 men. It became a casualty of the tuberculosis war when compulsory testing of cows and their milk for tuberculosis went into effect in 1926. Many farmers refused to test their cows, which created a shortage of milk, and Borden closed the Alden plant. (Courtesy of the McHenry County Historical Society.)

*The Stock Certificates of The Alden Creamery Co. are now ready. We must raise $500 by Oct 1 1896.*

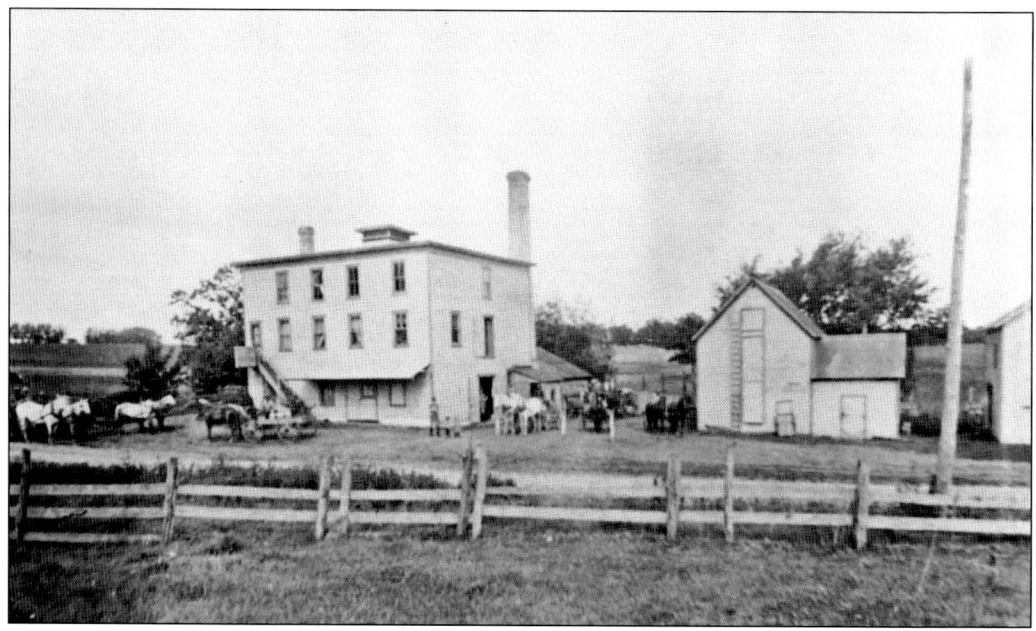

The Greenwood Creamery was built in 1867 by A. C. Thompson and George Abbott. It produced 542,365 pounds of milk and 54,236 pounds of cheese every four months. The products of the McHenry County creameries, which were located about every three miles, were shipped around the world. (Courtesy of the McHenry County Historical Society.)

The south Dunham creamery, also operated by Milo Munger, was built in 1877. In July 1909, records indicated that it received 558,550 pounds of milk and made 24,198 pounds of butter. Revenues for the butter were $5,966.88. In April 1921, John Olbrich bought the Dunham creamery and converted the building into a barn. (Courtesy of the McHenry County Historical Society.)

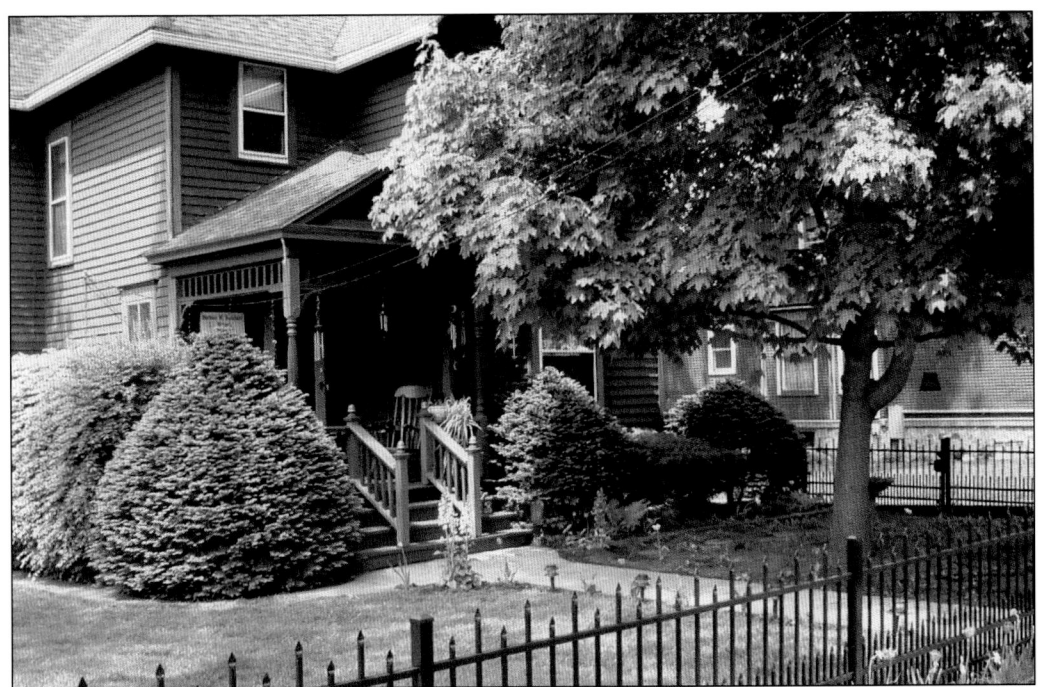

Growth in the dairy industry meant growth in other areas of business in the county as well. In 1902, Herman H. Bosshard built this house on south Madison Street in Woodstock. With its high ceilings, stained glass, and extensive woodwork, it was one of the many new in-town homes that were built with income from local business. Herman Bosshard built his classic Victorian house with the profits accrued from his flour and feed store (advertised at right), which was located on South Jefferson Street. (Above, courtesy of Capt. Leo V. Jean; right, courtesy of the McHenry County Historical Society.)

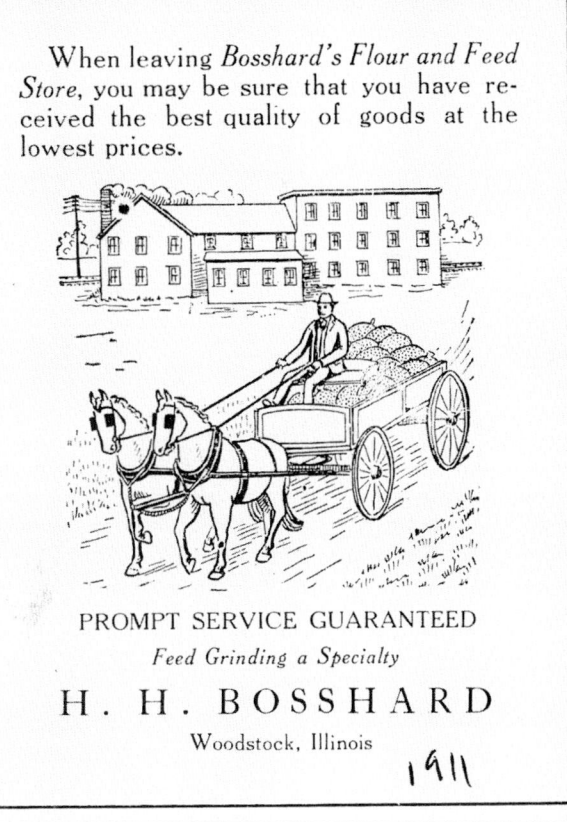

At the southeast corner of the Woodstock square is an 1898 building that still bears the name Church Block. It was there that the Woodstock Dry Goods Company opened its doors in 1902. It required a manager, an assistant, and nine clerks to handle the brisk trade of this thriving business. The store was so busy that in 1904 the owners were forced to expand their premises by adding a second story and a basement. It was one of 13 stores owned by the Potter and McAllister syndicate, which operated similar outfits in Wisconsin and Illinois. Potter and McAllister had the largest retail account with Marshall Field and Company in order to have access to the very latest in fashion for their customers. The Woodstock location was under the direction of W. F. Weaver, one of the managing partners of the syndicate. The Woodstock Dry Goods Company store lasted for 76 years. It was among the city's oldest stores operating in the same location and under the same name. (Both courtesy of the McHenry County Historical Society.)

## Woodstock Dry Goods Co.

### Church Block, Woodstock, Illinois
### FAIR DEALING FAIR WEEK AND EVERY WEEK.

#### DRESS GOODS SPECIAL

Heavy Goods, suitable for school dresses, was 50c, now **39c**

Zephyr Ginghams, good washable colors, was 8c, now ............ **6c**

Scotch Ginghams, suitable for school dresses, all washable colors ............. **10c**

French Gingham for waists, was 25c, while it lasts .. **15c**

Summer goods in Lawns, Batiste, Dimities and Ginghams at very low prices.

One lot of summer wrappers, original prices $1.00, 1.25 and 1.50, while they last.... ...... **50c**

If you are contemplating buying a New Jacket or Suit, give us a fair show. Here are a few prices:

Kersey and Zebiline, all fashionable shades.........................$7.50, 10.75, 15.00
New Skirts, all wool, latest styles, from....$4.00 to 7.50
Special For Fair Week—Last year's suits, broadcloth, basket weaves, that were, $25.00, 15.00 and 12.00......................$12.50, 7.50 and 6.00

New Dress Goods arriving every week. Some of the latest:

All-wool Zebiline, 44-in...79c; 50-in. $1.00
Barathea, 50-inch................. 1.00
Jacquards, 36-inch................ .50
New Flannelette, 27-inch.......... .10
New Book-fold Flannelette, 36-inch. .15

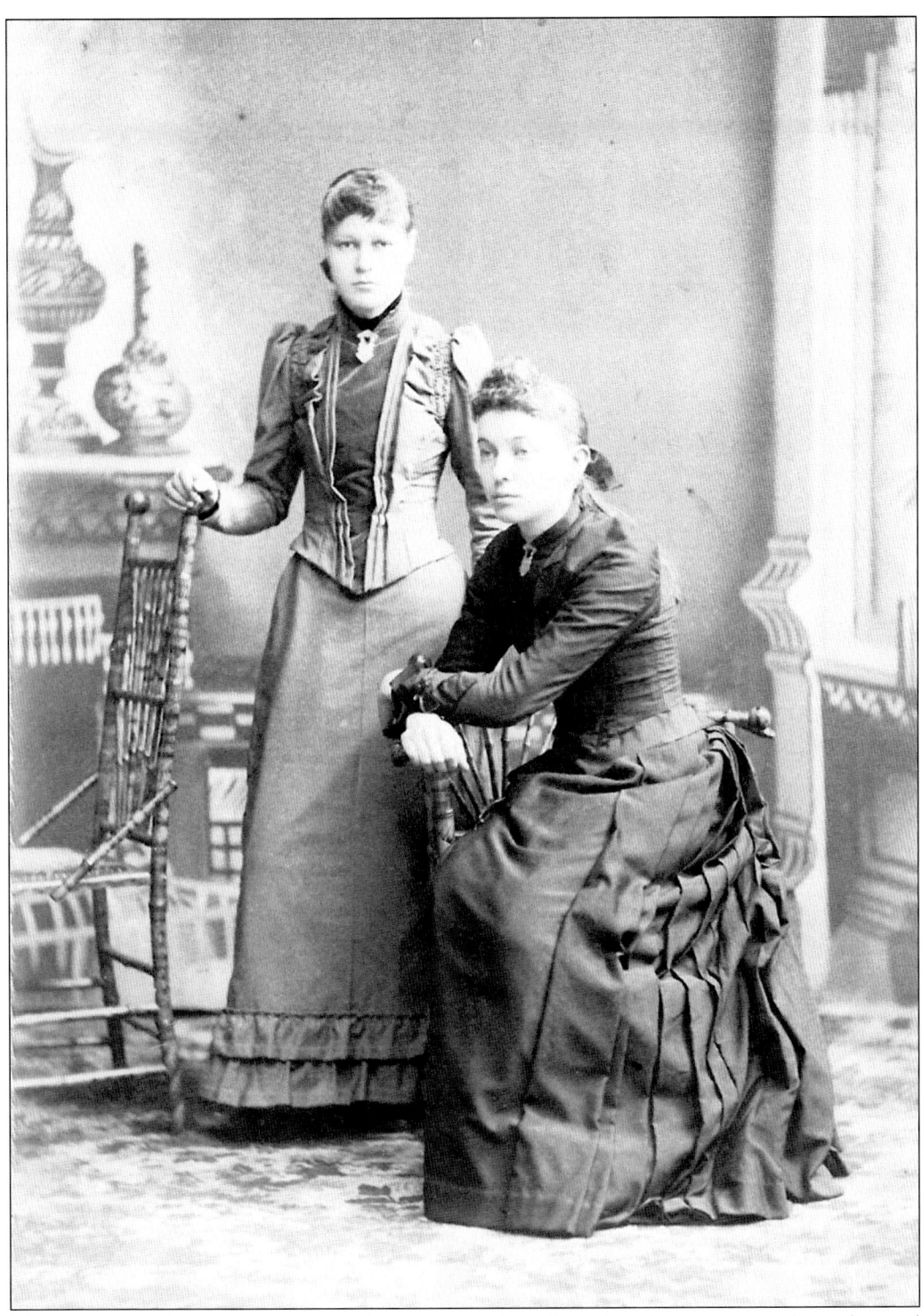

Mal (left) and Mary, two well-dressed young ladies from Woodstock, were sure to have shopped at the Woodstock Dry Goods store, which promised the latest fashion and a fair deal every week. (Author's collection.)

F. G. SCHUETT   C. H. SCHAAF

# Schuett & Schaaf

Automobiles

Farm Implements

Buggies and Road Wagons

WOODSTOCK              ILLINOIS

1909

Charles Schaaf, son of Michael and Kate Schaaf, went into business with F. G. Schuett in November 1902 in Woodstock. Their business was located at the site now occupied by the Woodstock Cinema on Main Street. They were dealers in agricultural implements, buggies, road wagons, surreys, and the newest fad—automobiles. Their sign read, "Dealers in Farm Machinery, Carriages, Gasoline Engines." They later added "Buick Dealer." They built up a very substantial business thanks to Charles's large number of acquaintances in the farming community. Schuett was elected alderman in 1899 and was chairman of the Woodstock City Council Finance Committee. Charles died at his home on South Street in 1919. (Courtesy of the McHenry County Historical Society.)

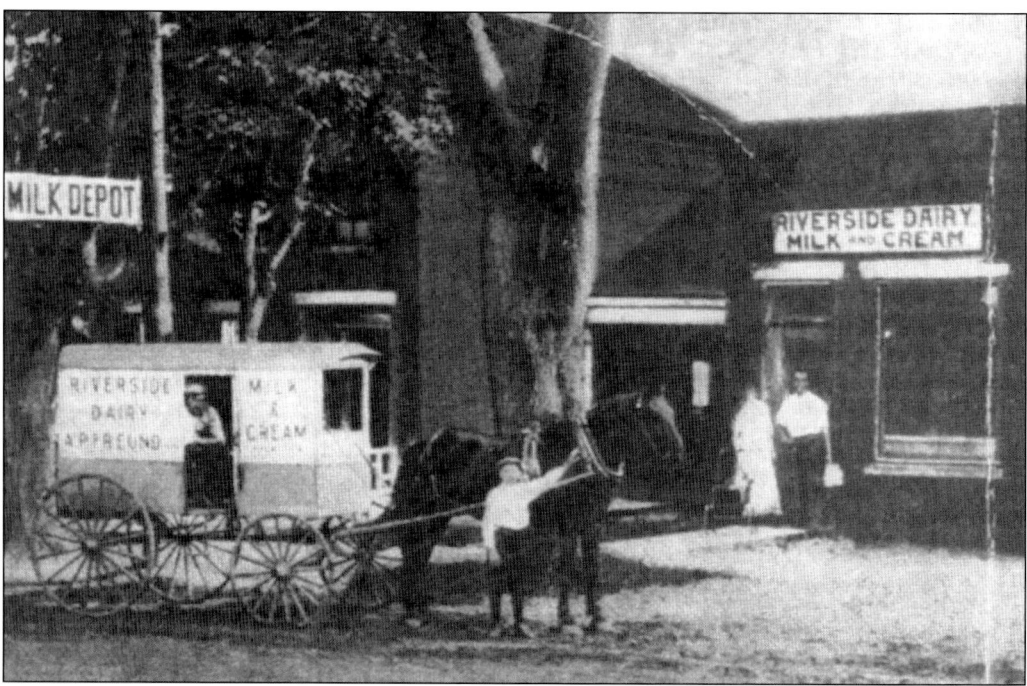

Before the advent of the automobile, milk was transported in horse-drawn wagons. The one pictured here in 1915 was owned by the Riverside Dairy. Horse-drawn milk wagons were used right up until World War II in the Chicago area. (Courtesy of the McHenry County Historical Society.)

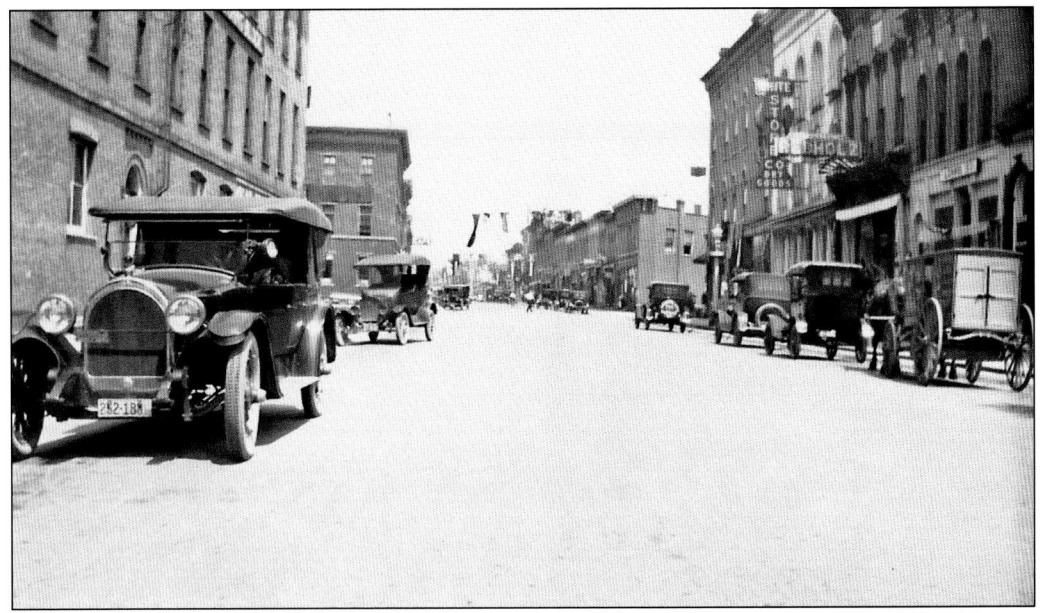

Automobiles began to appear on the streets and roads of McHenry County around the dawn of the 20th century. The automobile could even be said to have put some towns on the map. It also made McHenry County more accessible to the citizens of Chicago, who traveled west in their new automobiles to seek out summer homes. (Author's collection.)

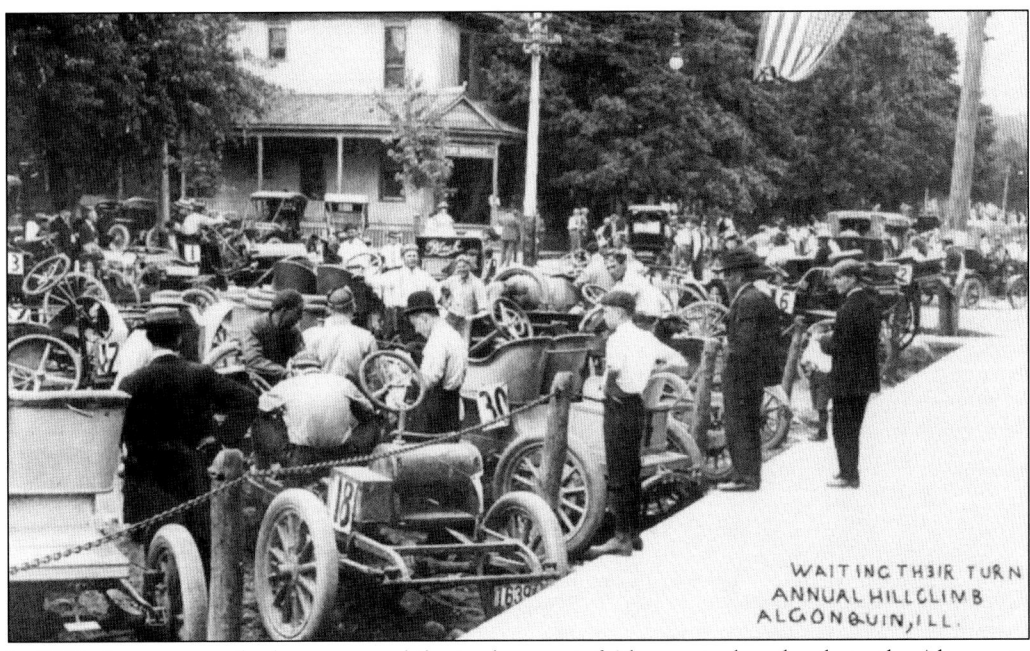

In 1906, there were only three automobiles in the town of Algonquin, but thanks to the Algonquin Hill Climb, focus was directed to both the "gem of the Fox River Valley" and the newfangled horseless carriage. By 1918, there were over 3,000 automobiles in the county. (Author's collection.)

A. Dwight Osborn, owner of an exclusive grocery business in Oak Park, moved to Woodstock in 1898 to open a hardware store. It was a very large store, consisting of two sales floors plus a basement for a total of 4,400 square feet. In addition to tools and hardware, Osborn's store also sold china and toys on the second floor. In the basement, Osborn ran the Woodstock Heating and Plumbing Company, which employed 12 mechanics. (Author's collection.)

Hoy's pharmacy, which had operated in Woodstock for almost 30 years by the dawn of the 20th century, was owned and operated by Luman T. Hoy. Hoy was also president of the *Woodstock Sentinel* and was appointed by Pres. Theodore Roosevelt as appraiser for the port of Chicago. (Author's collection.)

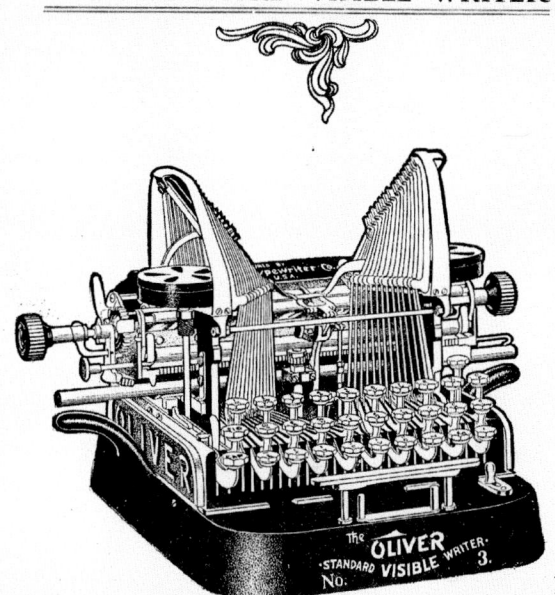

Thomas Oliver was born in Woodstock, Ontario, Canada, in 1852. He moved to Illinois as a young man after the death of his mother and later became a minister in the town of Epsworth, Iowa. Needing a more legible way of writing his sermons, he invented a mechanical means for putting words on paper. Although there were other typewriters at the time, the keys struck the paper on the back, therefore the typist could not see the words. Oliver's typewriter, patented in 1891, used a different method, something he called "Visible Print." In 1895, the Oliver Typewriting Company was incorporated and headquartered in Chicago. In 1896, manufacturing moved from Iowa to Woodstock, Illinois, when the city donated a vacant factory on the condition that the Oliver Typewriter Company remain there at least five years. In 1910, the Emerson Typewriter Company also moved to Woodstock. By 1922, about half the world's typewriters were made in Woodstock. (Author's collection.)

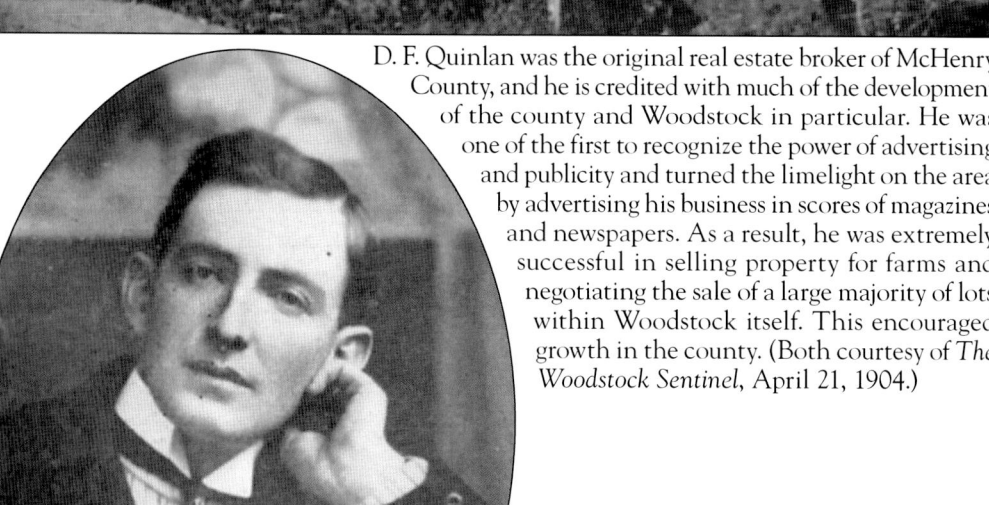

D. F. Quinlan was the original real estate broker of McHenry County, and he is credited with much of the development of the county and Woodstock in particular. He was one of the first to recognize the power of advertising and publicity and turned the limelight on the area by advertising his business in scores of magazines and newspapers. As a result, he was extremely successful in selling property for farms and negotiating the sale of a large majority of lots within Woodstock itself. This encouraged growth in the county. (Both courtesy of *The Woodstock Sentinel*, April 21, 1904.)

## Three

# THEN CAME THE DAIRYMEN

Fred Hatch's development of the tower silo marked a change in dairy farming in McHenry County. If properly stored, silage is frost proof, can stay fresh for several years, and is more digestible. Better nutrients meant the cow would give more milk. In 1884, a cow belonging to S. N. Wright was recorded as giving 44 pounds of milk per day. Because farmers built multiple silos, larger, more lucrative dairy herds were also now possible. A silo 20 feet high could hold 40 tons of silage. An acre of silage kept a cow for year. Prior to the 1880s, there were less than a dozen silos in the country, but the idea soon caught on. By 1926, there were three-quarters of a million silos in the country, and the number of dairy cows had increased from 11 million to 26 million. Dairy farming had become a very profitable enterprise.

Other notable developments also assisted the growth of the dairy industry. By the 1880s, over 3,000 refrigerated railcars were in service between Chicago and eastern cities. In 1878, Dr. Carl G. DeLaval of Sweden patented a cream separator, which proved much more efficient for separating butter fat from whole milk. He also marketed small hand separators so farmers could remove the butter fat and then feed the leftover skim milk to hogs. Between 1875 and 1880, the number of hogs in McHenry County increased from 17,500 to 27,500, making hog farming a viable secondary profit center for dairy farmers. All dairy producers benefited from a cheap, practical butterfat test perfected by Wisconsin chemist Stephen Babcock in 1890. The test measured the fat content of milk and provided an objective basis for payments to farmers by processing plants and dealers.

In 1875, there were 40,000 cows, both beef and dairy, in McHenry County. By 1914, McHenry County was in the center of the greatest dairy region in the world. The county contained more than 50,000 dairy cows alone, producing over 200,000 tons of milk annually. Thanks to advances in animal husbandry and dairy industry practices, the average annual yield per cow climbed from 3,050 pounds of milk in 1890 to 4,508 in 1950. Not only had supply increased but so had demand. By 1910, the average person was consuming 752 pounds of dairy products per year. The dairy farms of McHenry County were not only dotted with black and white faces, they were paved with gold.

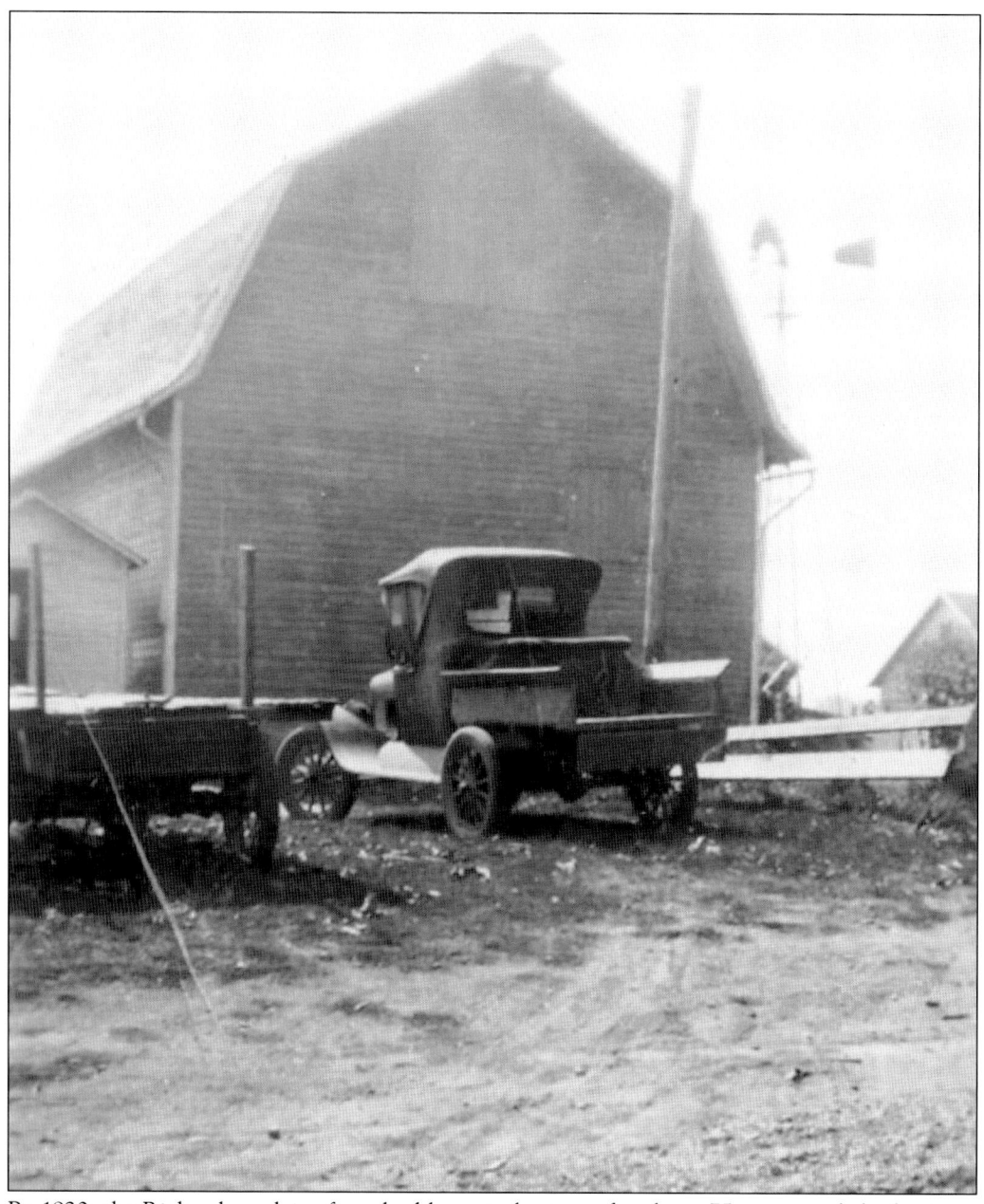
By 1920, the Richardson dairy farm had been in business for about 75 years, and the business of dairying was undergoing significant changes. By the dawn of the 20th century, both urban and rural groups wanted some control over the precious product that was unique among farm products: milk. Urban groups took an interest in milk production and regulation because it had become an important food staple. Rural groups responded to urban attempts to control production practices by organizing cooperatives for the benefit of the dairy farmers. Negotiations about who should control the making of milk were often heated and sometimes even led to strikes by the farmers, such as the milk wars in 1931 in central Illinois and the 1932–1933 strike by farmers in Wisconsin to protest the price that was being paid for their milk—1¢ per quart. Milk was sold to the consumer for 8¢ a quart. (Courtesy of the Richardson family.)

As more roads were built, milk transportation shifted from rail to truck. It soon became apparent that significant economies of scale could be had in processing milk. There was substantial consolidation of milk receiving stations, and milk plants grew in size and shrunk in numbers—like the Borden plant in Alden. The development of the interstate highway system and refrigerated trucks also influenced the dairy business. (Courtesy of the Richardson family.)

The Richardson family has operated its dairy farm in Spring Grove for six generations. Pictured on the right are Owen Richardson's grandparents around 1930. (Courtesy of the Richardson family.)

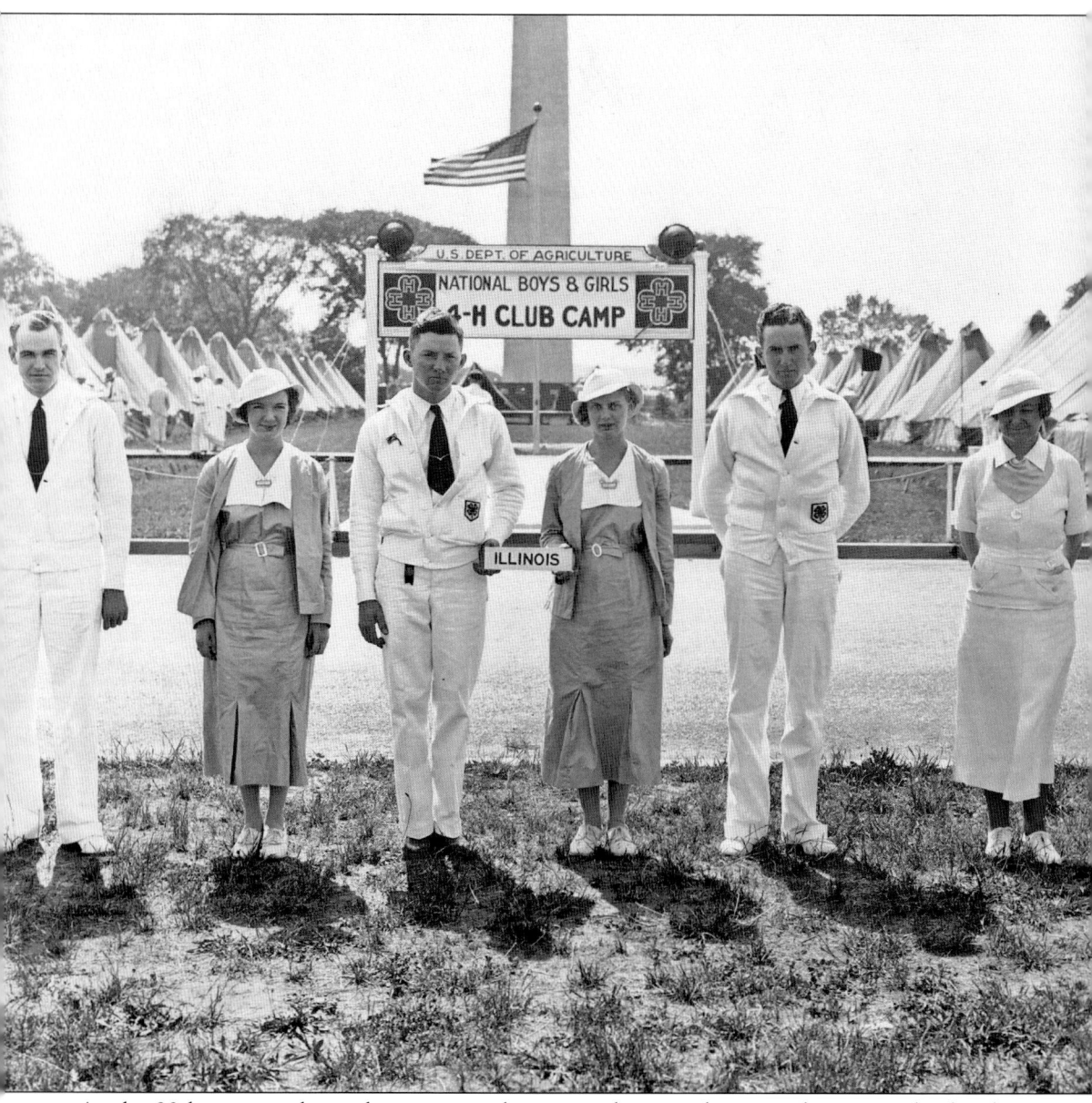

As the 20th century dawned, young people were eschewing their attachment to the family farm and moving to the city. At the same time, agricultural technology was changing and the U.S. Department of Agriculture (USDA) was looking for a way to get new technology onto the old family farm. In 1901, A. B. Graham, a school principal in Ohio, came up with an idea that would both promote the agricultural lifestyle to young people and convey needed acceptance and understanding of new technology to their parents. He began to promote vocational agriculture in schools by forming out-of-school clubs. With the assistance of the Ohio Agricultural Experiment Station and the Ohio State University, he formed a club for boys and girls in 1902. It is considered to be the founding of the 4-H club. This photograph is of a 4-H club camp that took place in Washington, D.C. Helen Harrison, later Helen Marlowe, age 17, from Ringwood, is third from the right. She represented girls from the state of Illinois. (Courtesy of the McHenry County Historical Society.)

The 4-H club celebrated its 50th anniversary in 1952. The federal government honored the event by issuing a commemorative stamp. This photograph is of Wendell Calhoun of McHenry County, who was the 4-H club congress winner for his dairy cows in the early 1950s. (Courtesy of the McHenry County Historical Society.)

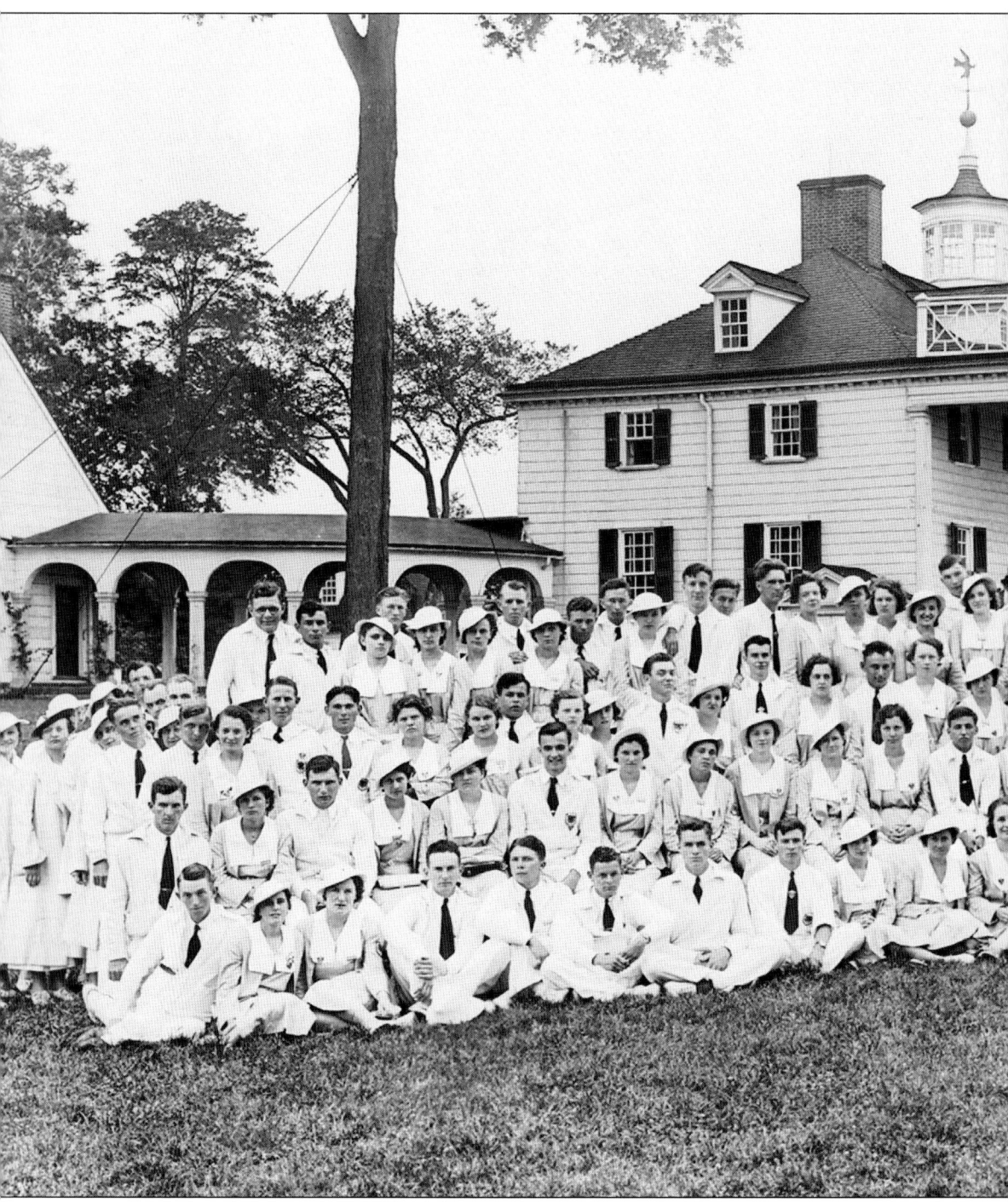

The National 4-H Congress, sponsored by the USDA, is an annual educational event that brings together 4-H delegates between the ages of 14 and 19 from across America to share cultural experiences and discuss important issues facing youth. This five-day conference is typically held during the weekend of Thanksgiving and has been hosted in Atlanta, Georgia, since 1998. Throughout the conferences, 4-H delegates attend workshops, participate in community service

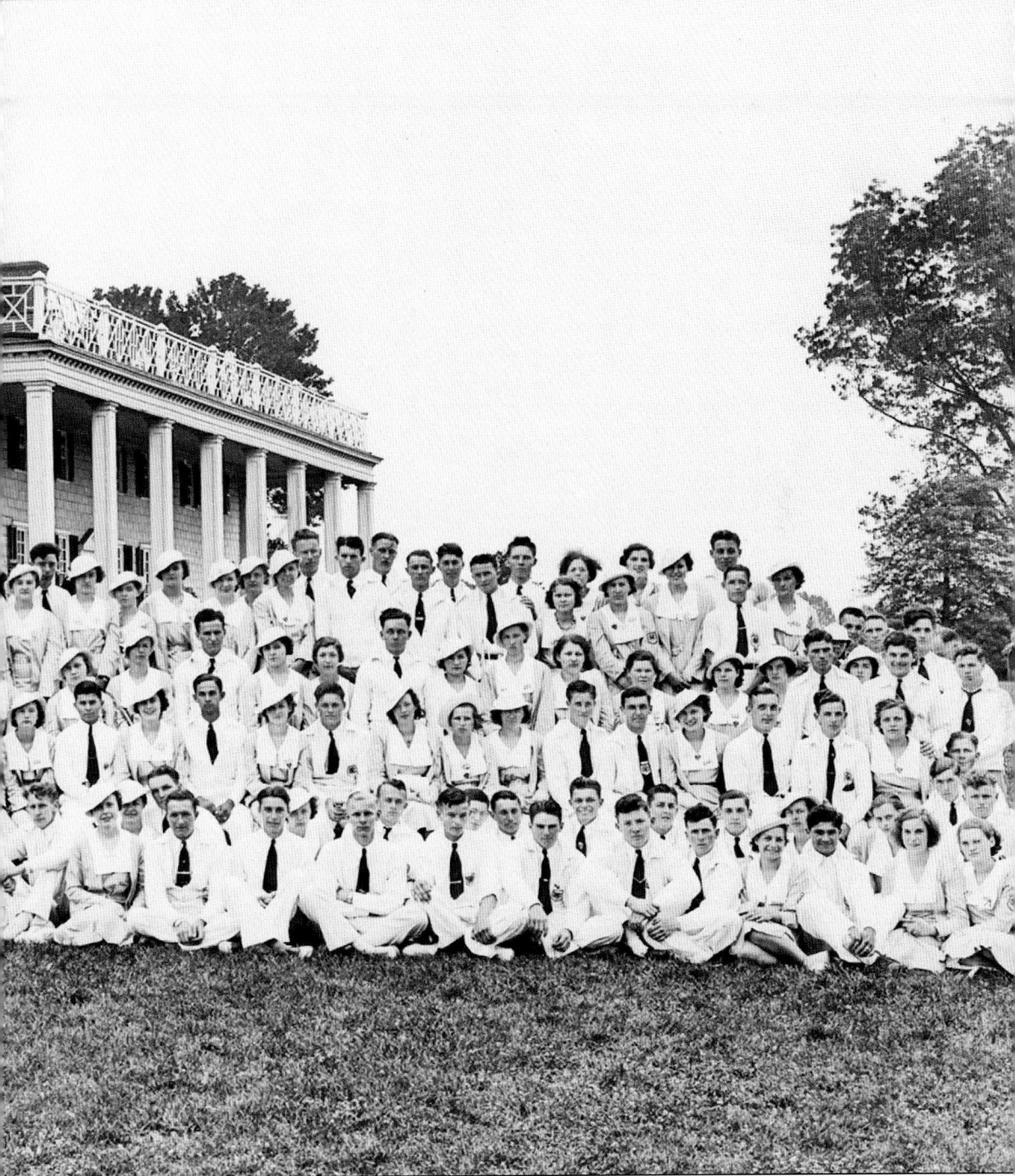

activities, and listen to speakers in an effort to develop compassion and increase social awareness. Other conferences are held by regional and state entities for youth, volunteer development, or professional development for staff. Pictured here is the 1935 conference at Mount Vernon. (Courtesy of the McHenry County Historical Society.)

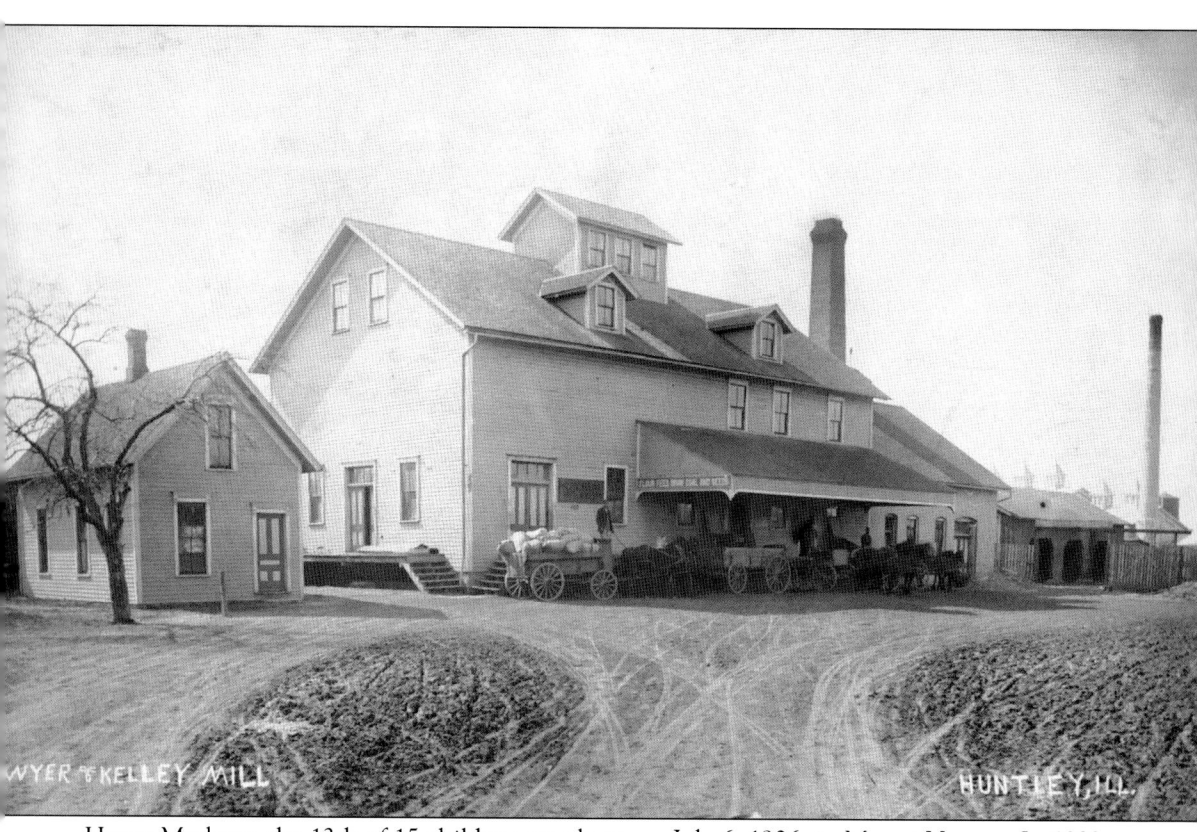

Henry Marlowe, the 13th of 15 children, was born on July 6, 1906, in Mount Vernon. In 1929, he founded the Winnebago 4-H club. Looking for a job, he hitched a ride to Huntley in 1931 and became the first vocational agricultural teacher in the school. He soon had 52 farmers enrolled in the Marlowe Dairy Management Service and began selling Wayne feed to farmers in the area. Because of the Depression, his teaching duties were reduced to a part-time position. In 1935, he married Helen Harrison, and in 1945, they bought the old Sawyer-Kelly Mill, which had been a flour mill powered by a steam engine, near the railroad tracks on Route 47 in Huntley. There they opened the Marlowe Feed and Hatchery. (Courtesy of the McHenry County Historical Society.)

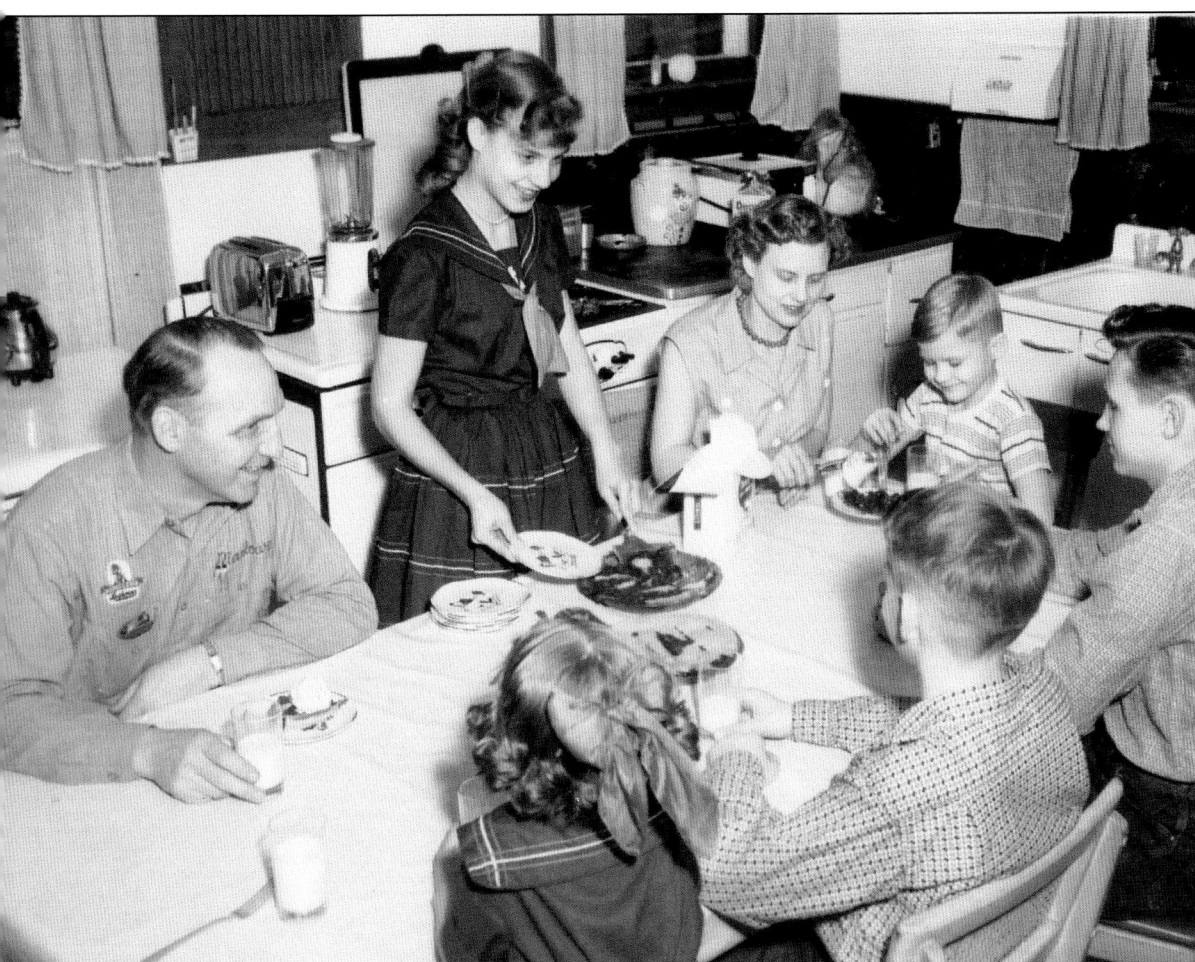

The Marlowe family, pictured here, included five children, Byron, Elizabeth, Lyle, Dean, and Faye. Parents Henry and Helen built their business by selling truckloads of feed to cattle owners in the area. The business also hatched about 800,000 eggs a year, providing laying chickens to local farmers. Henry was an early 4-H leader in the country, serving in that capacity for 26 years. He was also one of the founders of the McHenry County Fair and served as president for four years and director for 12. The Marlowes also had a farm of their own just north of Huntley. In 1973, at the celebration marking the 40th anniversary of the Marlowe Feed and Hatchery, Henry noted that of the 122 farmers in the area when he first arrived, only two were still farming on the same farms. (Courtesy of the McHenry County Historical Society.)

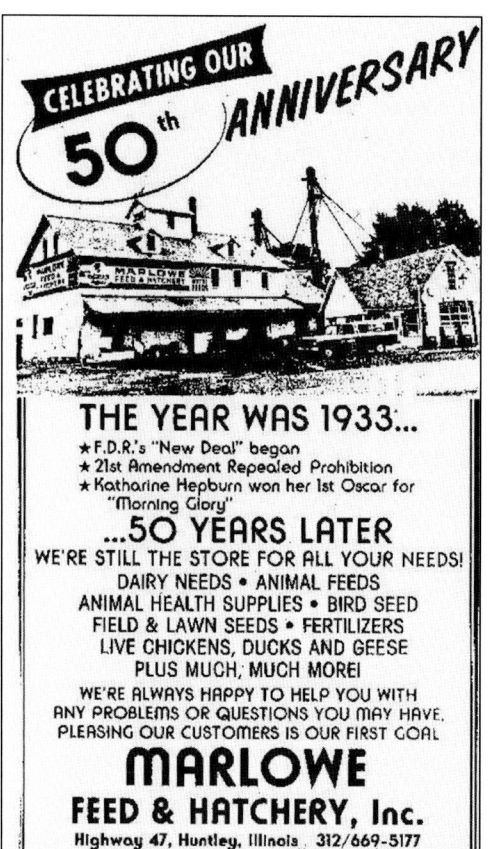

Henry Marlowe lived long enough to see the 50th anniversary of his business. He died on May 25, 1984. His wife, Helen, continued to run the business for over a decade. In that time, she recalled that her business was changing rapidly. Dairy farmers in the area were selling out to developers, and hobby farmers from urban areas were moving in. She is quoted as saying, "Livestock is too expensive to make a good return. Young people will not carry on the 24 hour, 7 days a week work that their parents did." (Courtesy of the McHenry County Historical Society.)

About the time the Marlowes were starting their feed business in Huntley, dairying was still very important to the economy of the farmers of McHenry County. Dairy cows were featured in the banner of the *McHenry County Farmer's News*, the official publication of the McHenry County Farm Bureau. (Courtesy of the McHenry County Farm Bureau.)

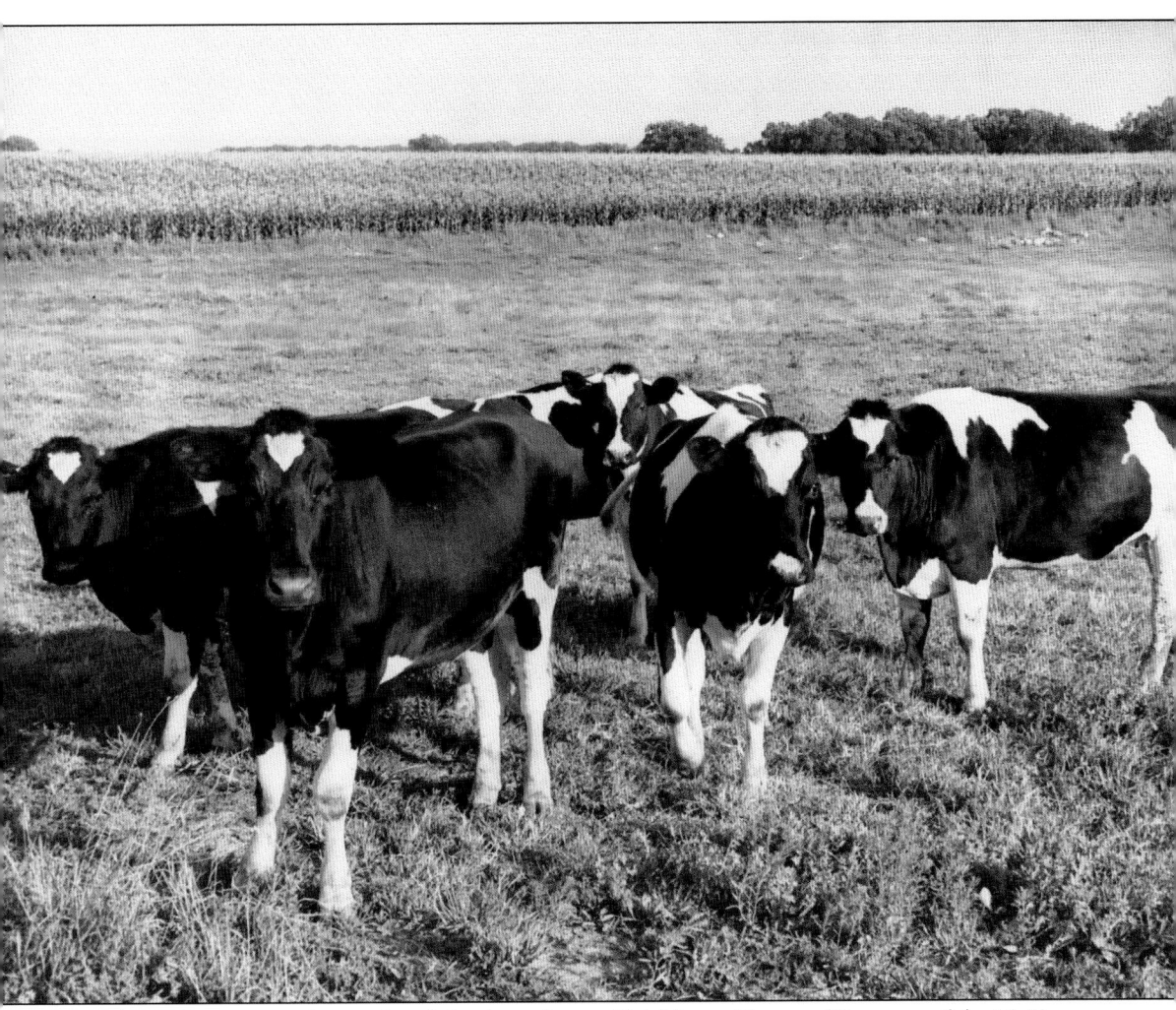
Holstein-Friesian cattle populated the dairy farms of McHenry County. (Courtesy of the McHenry County Historical Society, Dan Peasley Collection.)

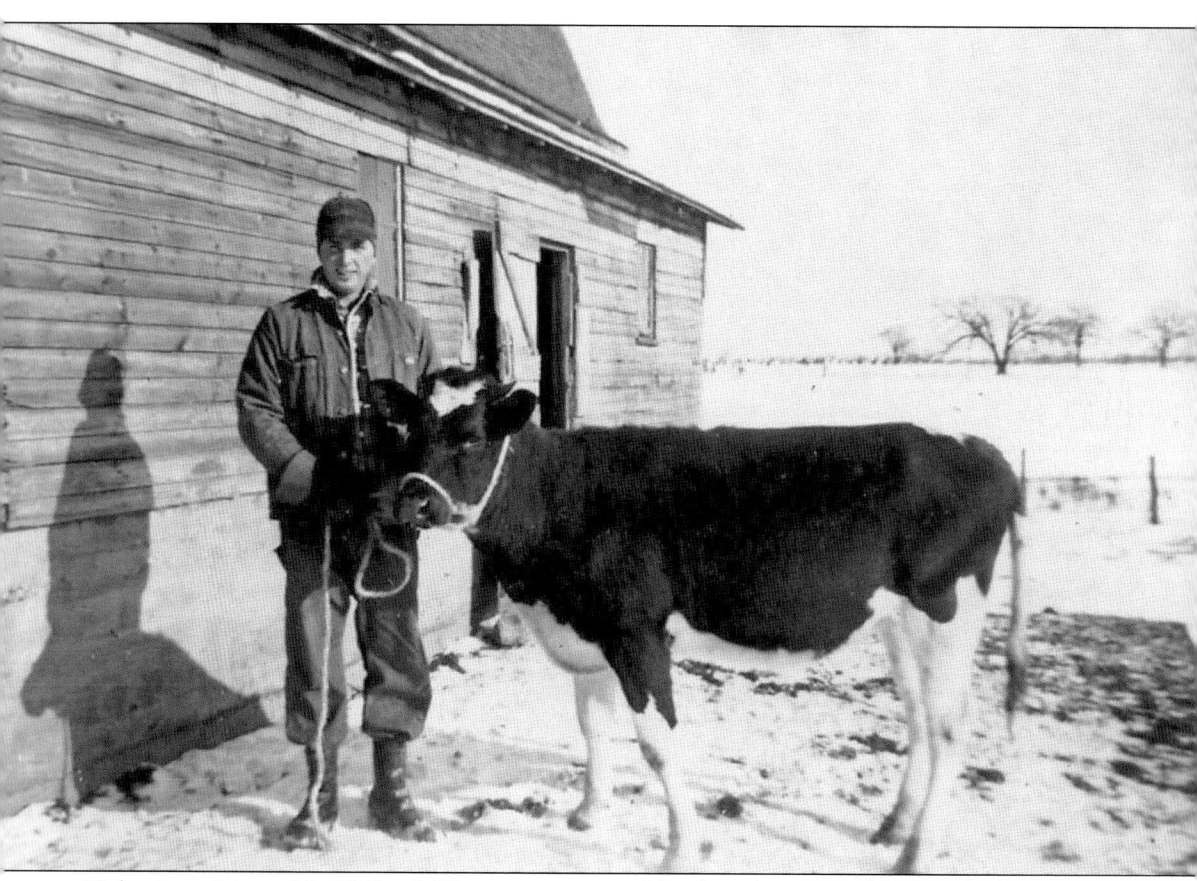

Holsteins originated in Holland. They are recognized by their distinctive black and white or red and white color markings and for their outstanding milk production. A healthy Holstein calf weighs 90 pounds or more at birth, and a mature one weighs about 1,500 pounds and stand 58 inches tall at the shoulder. Holstein heifers can be bred at 15 months of age, when they weigh about 800 pounds, but it is desirable to have Holstein females calve for the first time between 24 and 27 months of age. Gestation is approximately nine months, and the normal productive life of a Holstein is six years. Average production for Holsteins in 1987 was 17,408 pounds of milk, 632 pounds of butterfat, and 550 pounds of protein per year. For these reasons, Holsteins became the preferred cow for McHenry's dairy farmers. Owen Richardson is pictured above with one of the family's dairy animals. (Courtesy of the Richardson family.)

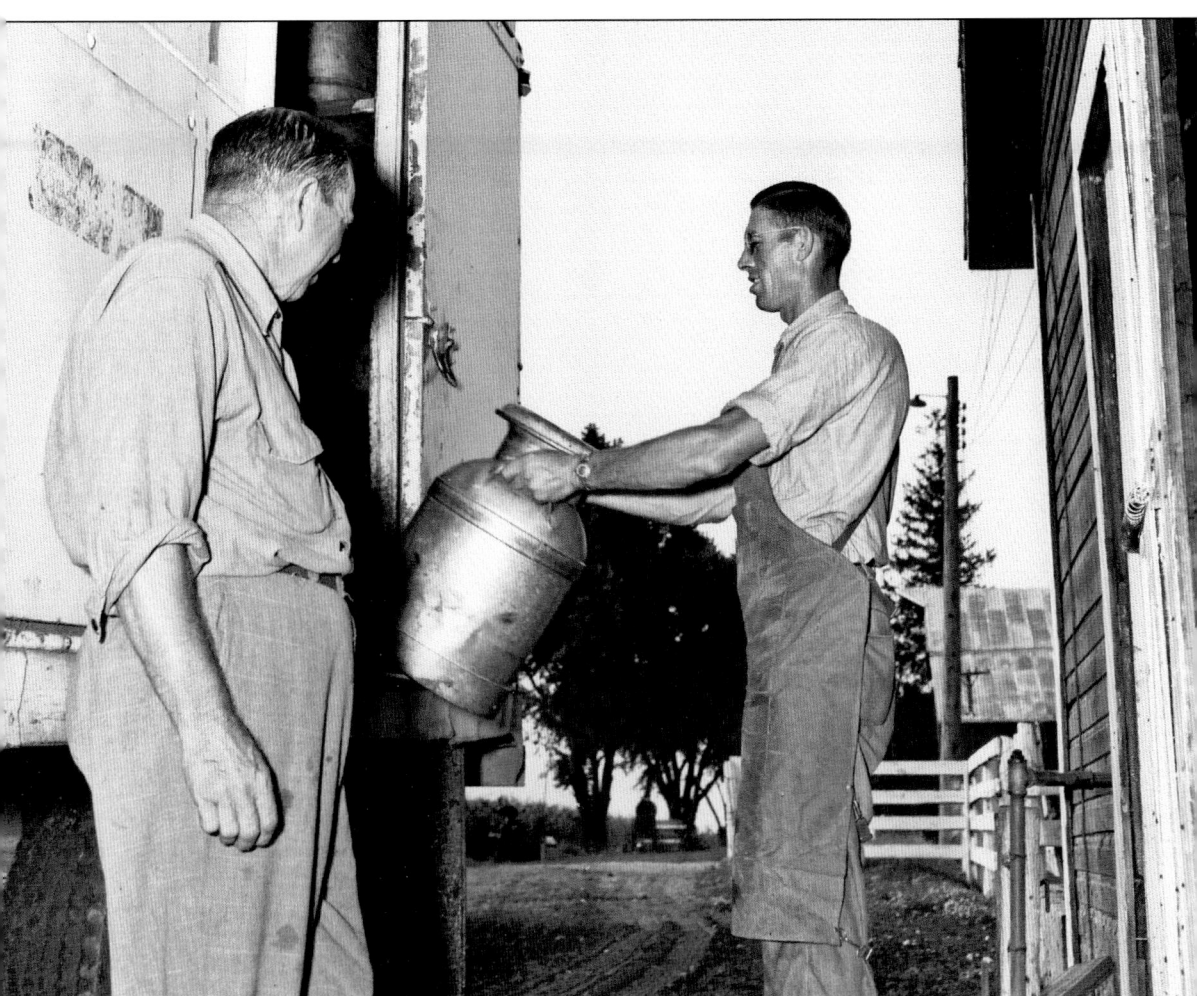

Dairy farming is very labor intensive. Roy Cope, a farmer from Richmond, is pictured above lifting heavy milk cans onto a truck driven by Merwin Christensen in August 1953. Cope had a large herd, milking 72 cows a day, and filled 30 cans a day. Dairy farmers need to milk their cows with absolute regularity at least twice a day. Some high-producing herds are milked up to four times a day to lessen the weight of large volumes of milk in the udder of the cow, which makes her uncomfortable. This daily milking routine goes on for about 300 to 320 days per year. If a cow is left unmilked just once, she is likely to reduce or even stop producing milk almost immediately and for the rest of the season, posing a significant loss for the farmer. (Courtesy of the McHenry County Historical Society.)

Earl M. Hughes was born on the family farm in Woodstock on September 6, 1907. He became one of the modern breed of farmers, who, rather than leave the farm, took it to the next level. In 1929, he received a bachelor's degree in agriculture from the University of Illinois and went to work on the family farm, where, like his father, he milked cows, raised chickens, fed the beef, and farrowed hogs. He also specialized in raising barley seeds and seed oats. But his career did not end there. He went on to get his doctorate degree from Cornell University, became a professor of agricultural economics at the University of Illinois, and in 1954 went on to become a consultant to the secretary of agriculture. In 1967, the Hughes Hybrids brand was formed to retail a new single-cross corn hybrid directly to farmers. In the 1990s, Hughes brand soybeans were developed. Hughes believed in keeping his focus local, marketing locally adapted corn, soybean, and alfalfa products to area farmers. Hughes is pictured in August 1969 on his farm in Woodstock. (Courtesy of the McHenry County Historical Society.)

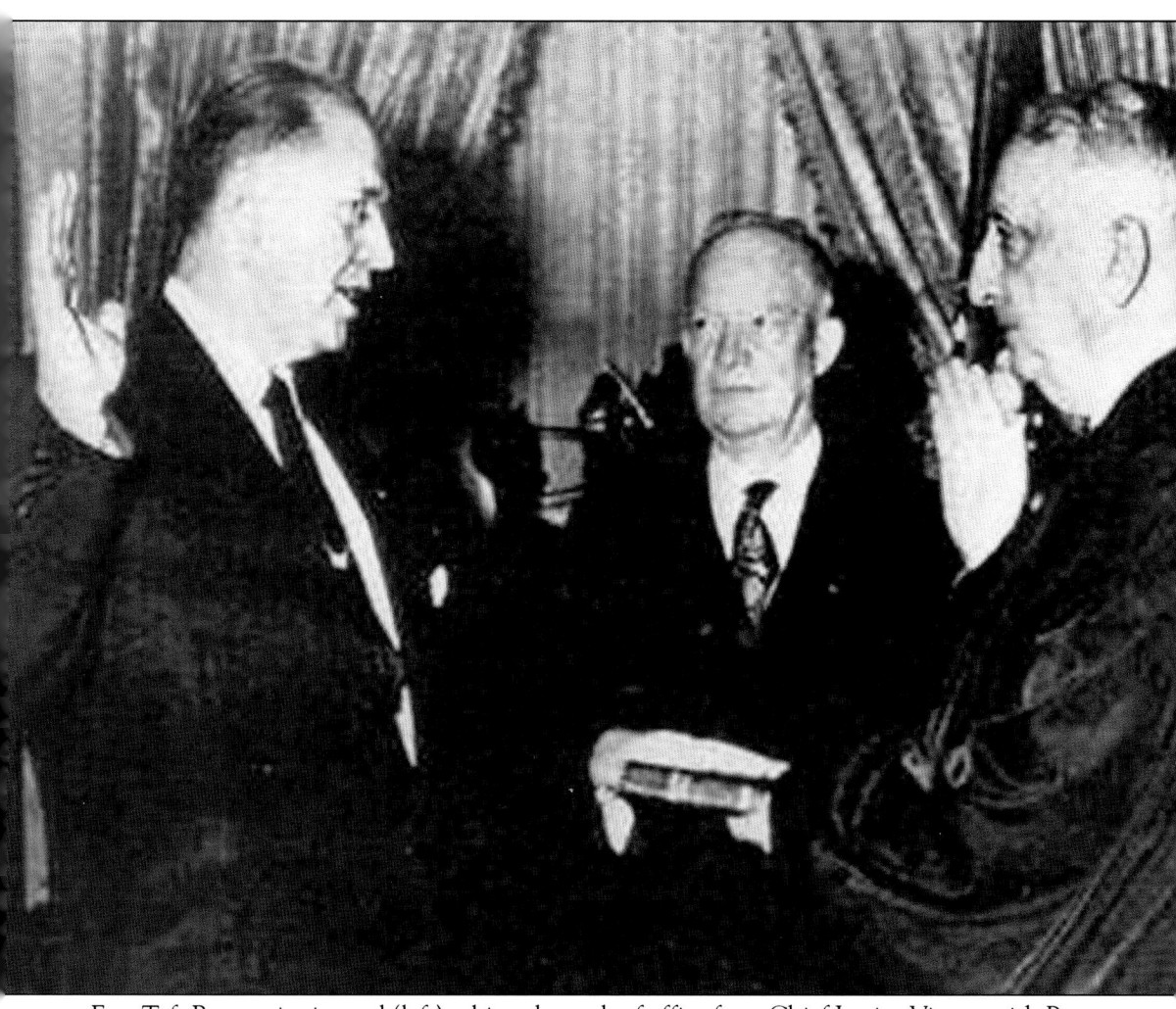
Ezra Taft Benson is pictured (left) taking the oath of office from Chief Justice Vinson with Pres. Dwight D. Eisenhower looking on. (Courtesy of the McHenry County Historical Society.)

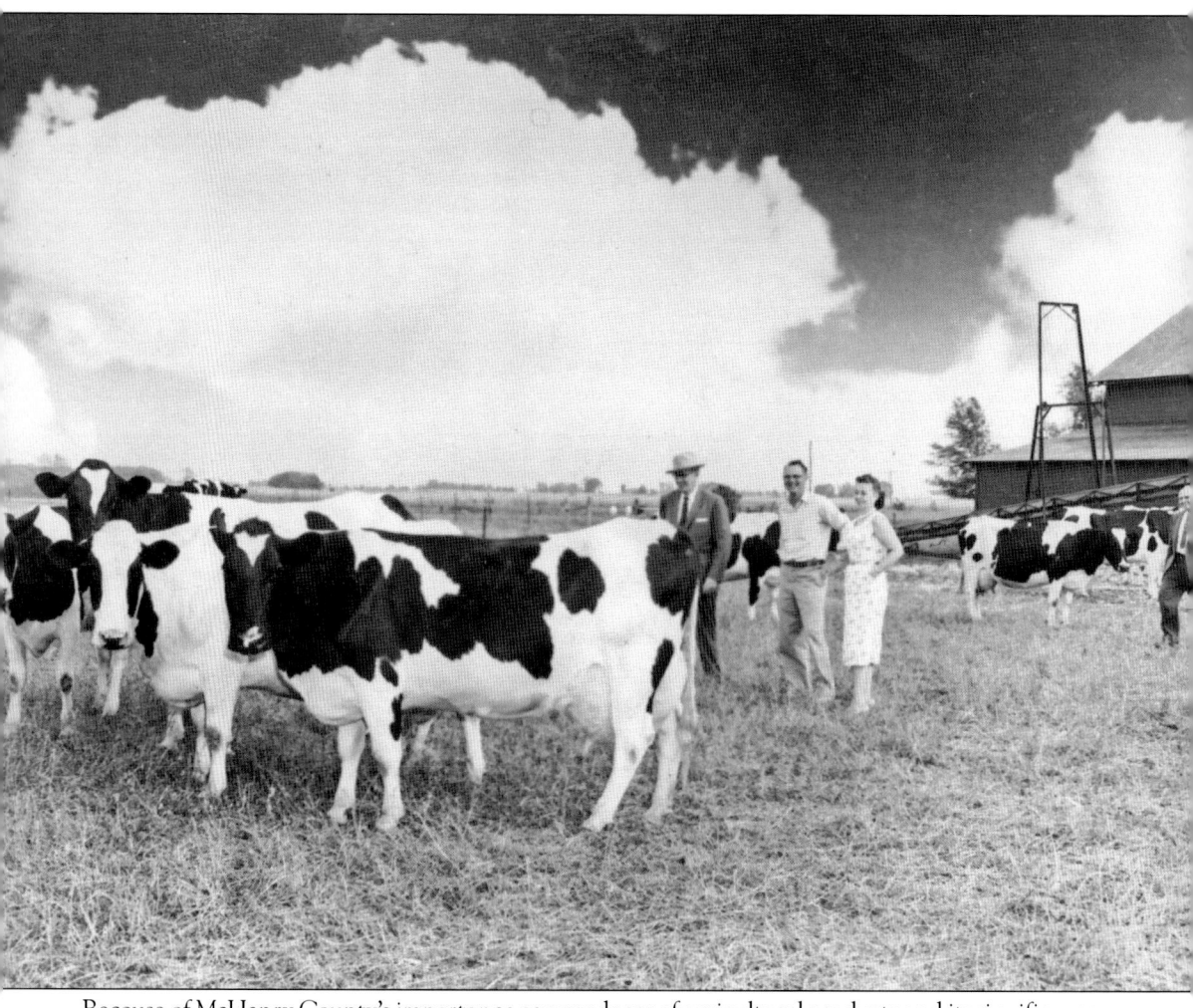

Because of McHenry County's importance as a producer of agricultural products and its significance to the dairy industry in particular, Secretary of Agriculture Ezra Taft Benson was a frequent visitor to the county. He is pictured here visiting Ward and Betty Plane's dairy farm in Huntley in 1955. (Courtesy of the McHenry County Historical Society.)

Pictured above is part of the Hughes dairy herd. Although grazing provided the bulk of the nutrients for dairy cattle, their diets were also supplemented by grain, usually corn and sometimes oats and soybeans. In addition, attention was paid to levels of various minerals in their diets, such as zinc and calcium, the addition of which improved the quality of their production as well as their health. On Rose Hill Farm, the feed included nuggets of molasses, which made a tasty treat for both cows and kids alike. But perhaps one of the most important things that a healthy, high-producing dairy cow needs is plenty of water because without sufficient water, there can be no milk. (Courtesy of McHenry County Historical Society.)

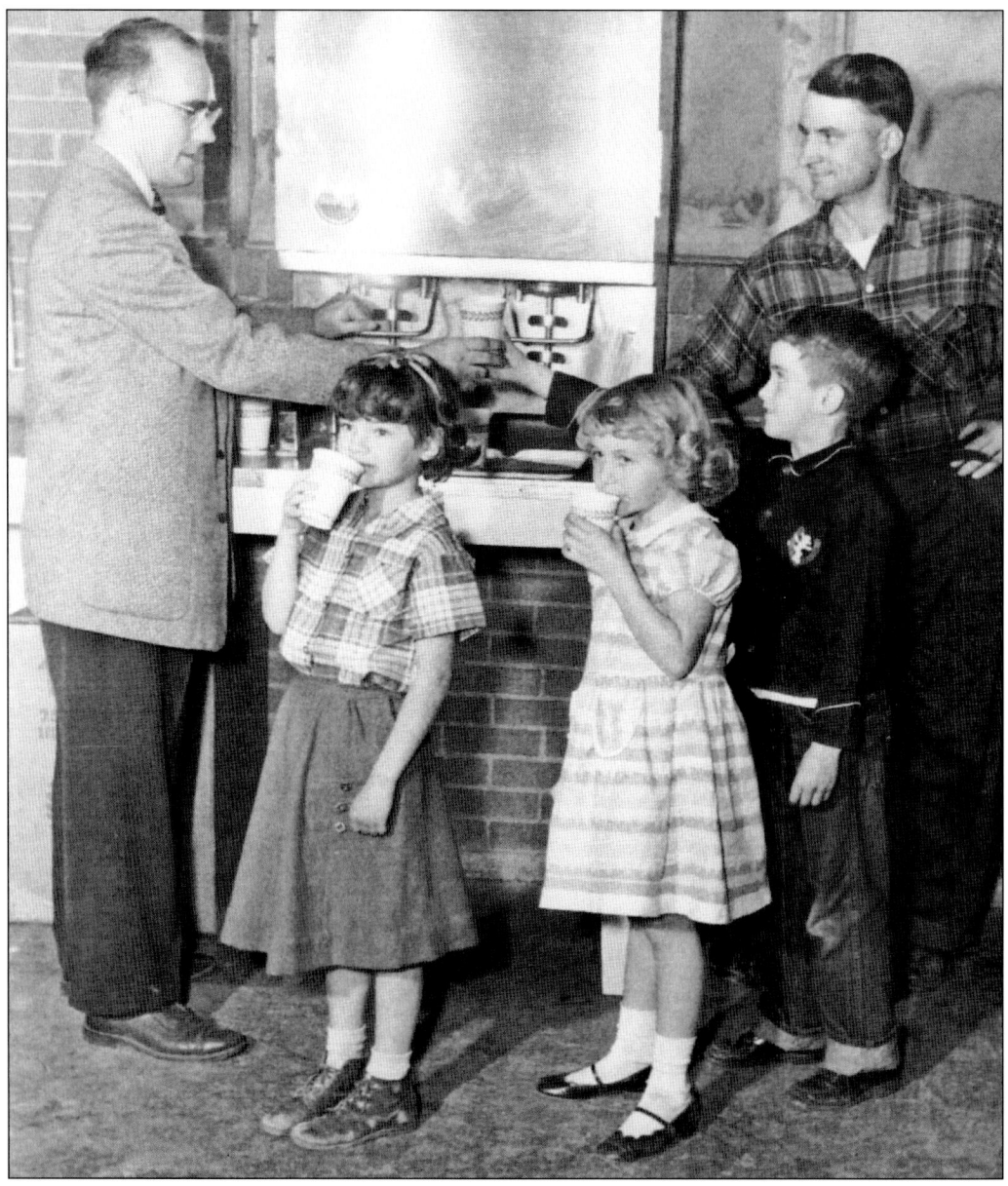

There is a saying that one can never have too much of a good thing. When it came to the bounty provided by McHenry's dairy farmers, that was not necessarily the case. By 1954, there were huge surpluses of milk and 360 million pounds of butter in government warehouses. Finding ways to make more milk available to more people became one of Ezra Taft Benson's priorities. The first bulk milk dispensing machine was approved by the Chicago Board of Health on February 19, 1955. Expanding markets for milk through schools was an obvious if not complete solution. The first machine, made by Mr. Robot, Inc., was placed in Woodstock High School in 1955. Four milk vending machines were also put into the agriculture building in Washington, D.C. They dispensed half a pint of milk for 10¢. Benson wanted the machines to be installed in all government offices. Dale Noe (right), farm bureau president and McHenry County Dairy Promotion chairman, is pictured above. (Courtesy of the McHenry County Historical Society.)

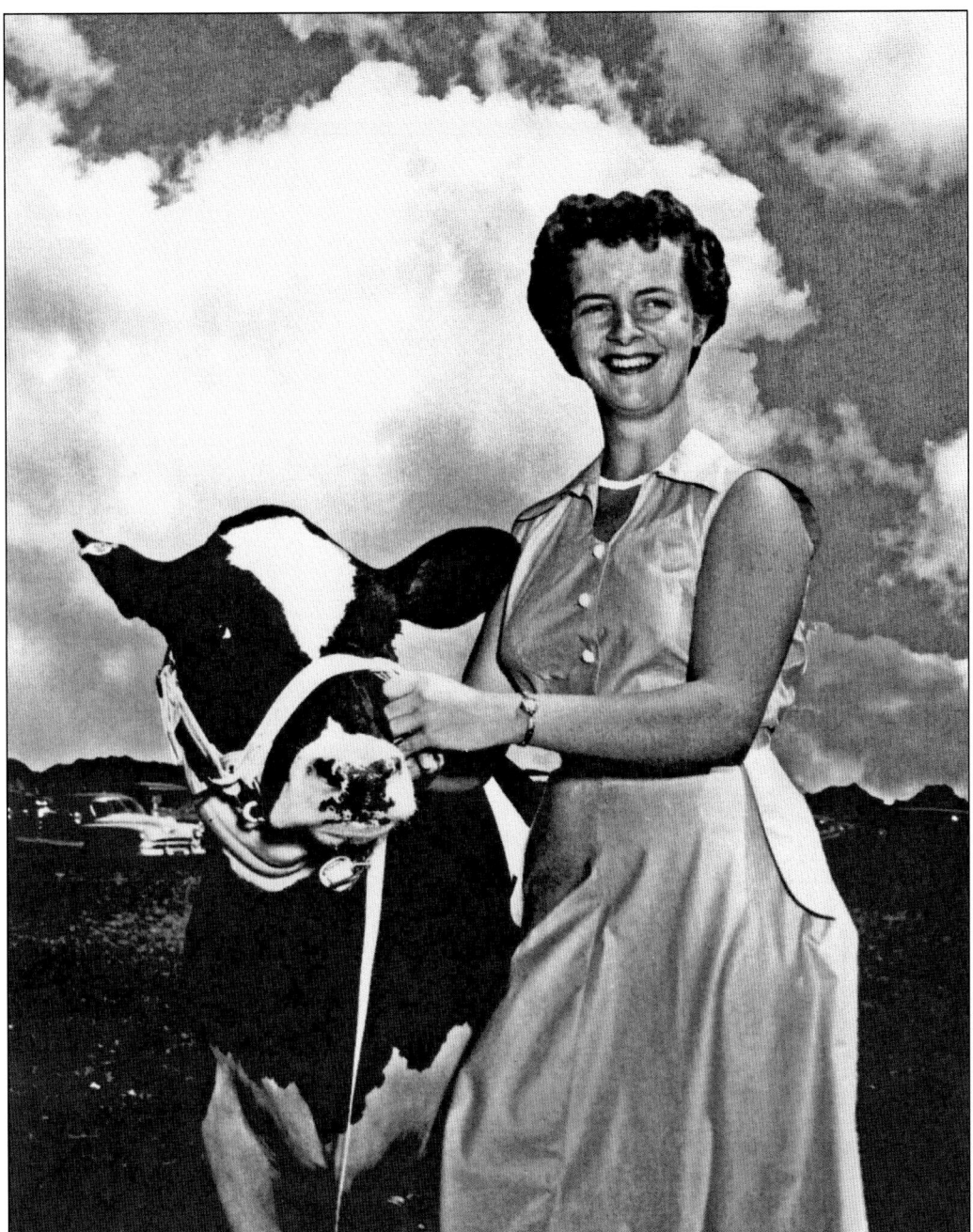
Milk was already being heavily marketed in the early 1950s. The idea was simple: in order to get people to drink more milk, they needed to romance the product. Milk was not just a beverage anymore. It was not just a part of good nutrition. Marketing campaigns for milk evoked youth, health, and the country lifestyle of fresh air, open skies, and uncluttered vistas. The government, schools, even doctors got on board the milk promotion bandwagon. What better way to promote a healthy, youthful product than with a healthy, youthful, pretty girl. Miss McHenry County of 1952, Patricia McFarlin, from Harvard, poses here, conveniently with a Holstein. (Courtesy of the McHenry County Historical Society.)

The use of pretty girls to sell more milk went on for many years. Patricia Hogan Parsley served as McHenry County's dairy princess in 1961 and 1962. In the photograph, she is talking with Charles B. Shuman, president of the American Farm Bureau Federation (AFBF), in December 1962. The history of the Illinois and county farm bureau dates back to 1916. However, the idea was centuries old, based on the belief that farmers working together could accomplish more. Shuman retired as president of the AFBF in 1971. (Courtesy of the McHenry County Historical Society.)

Marilyn Lindall was the McHenry County Dairy Princess in 1954 and 1955. (Courtesy of the McHenry County Historical Society.)

## McHENRY COUNTY Farmer's News
**Official Publication of McHenry County Farm Bureau**

VOLUME 10 — NO. 8     TUESDAY, JUNE 23, 1964     Woodstock, Illinois

James Curran
207 S. Curran
Mc Henry, Ill

# Dairy Council Marks Milestone June 30th

## Banquet Set At Harvard Church

Ten years of boosting dairy products on a united and coordinated basis will be celebrated at the tenth anniversary banquet of the McHenry County Dairy Promotion Council on Tuesday night, June 30.

All former McHenry County Dairy Princesses will be invited back for this gala affair, and most — if not all — are expected to attend.

The Dairy Banquet is scheduled for 7:30 P.M., June 30 at the Harvard Methodist church. The church is located on the north side of Harvard on U. S. Route 14.

### State Princess Coming

Miss Cheryl Smith, reigning Illinois Dairy Princess, will be one of the special guests. Cheryl is from Oswego, daughter of Mr. and Mrs. J. George Smith and a niece of Virgil Smith, one of the three founders of the Dairy Promotion Council when he was sec-

**EIGHT CANDIDATES**—all daughters of McHenry County dairy farmers—are seeking the McHenry County Dairy Princess crown this year. The winner will be crowned Tuesday night, June 30, at Harvard Methodist Church, site of the annual Dairy Banquet. From left: Judy Burke, Marengo; Pam Korslin, Harvard; Cathy Ryan, Harvard; Jane Peterson, Hebron; Rosalynn Rehorst, reigning County Dairy Princess; Susan Plane, Huntley; Sandi Larson, Wonder Lake; Connie Rudsinski, Union, and Shirley Schultz, Woodstock. (Don Peasley Photo)

## Alexander To Talk Aug. 29

An earlier-than-usual date for the annual meeting of the McHenry County Farm Bureau has been set.

The 52nd annual meeting will be held Saturday, August 29 at the Woodstock Community high school instead of in late September, the regular date for several years.

Reason for the speeded-up date is to have members act on a proposal to put into effect a dues increase effective September 1.

### Propose Dues Increase

The IAA will raise its dues to County Farm Bureaus $2 a member effective September 1, 1964. In addition, an increase above $2 will be discussed to meet increased needs of the McHenry County Farm Bureau, Dale Noe, president, said this week.

Reasons ranging from the demands for expanded service to the requirement to have funds to pay increased operating costs are back of the board's proposal.

## Dairy Council Marks Ten

In June 1964, eight candidates, all daughters of McHenry County dairy farmers, competed for the title of dairy princess. The winner was crowned at a banquet celebrating the 10th anniversary of the McHenry Dairy Promotion Council in Harvard. Cheryl Smith, Illinois Dairy Princess, was a special guest. (Courtesy of *McHenry County Farmer's News*.)

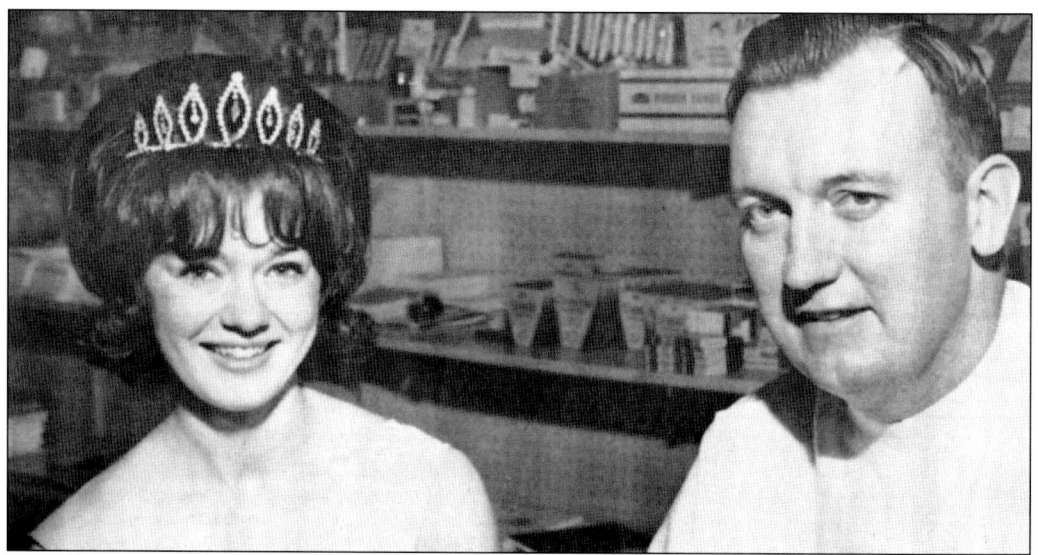

Dairy princess Andrea Simpson had a lot of opportunity to wear her crown. As the ambassador of the dairy business, she was often seen promoting not only dairy interests but also local businesses. In this photograph from the March 1966 *McHenry County Farmer's News*, she is seen with Don Heldenberg, assistant manager of the Piggly Wiggly in Woodstock, during an in-store promotion to increase milk sales. (Courtesy of *McHenry County Farmer's News*.)

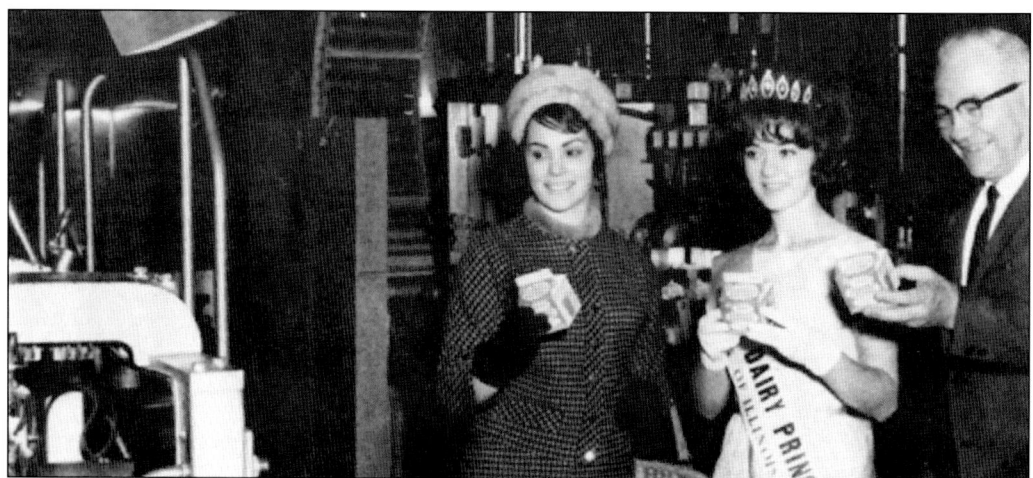

In another March 1966 *McHenry County Farmer's News* photograph, Russell Smith, manager of the Borden plant, demonstrates to Simpson and her aunt the new automated equipment that packages the Borden mascot cow Elsie's strawberry shakes. (Courtesy of *McHenry County Farmer's News*.)

It was not just pretty girls who were used to promote dairy products. Talk radio also had a presence in promoting the importance of agriculture. Green Pastures Farm, near Woodstock, is one of McHenry County's oldest active farms, although it has gone through some changes over the years. Half a century ago, it belonged to Lloyd Burlingham, farmer and agricultural commentator. Burlingham was schooled at Iowa State College and the University of Missouri. He also worked with the USDA as an editor of farm publications. In the 1940s and 1950s, he broadcast a daily radio show from his farm on Vermont Road on Chicago stations WLS and WGN. By 1952, he was in his 10th year of agricultural achievement awards broadcasts at NBC. Burlingham was also president of radio station WBEL in Beloit, Wisconsin, which he owned and operated. He died in 1971. (Courtesy of the McHenry County Historical Society.)

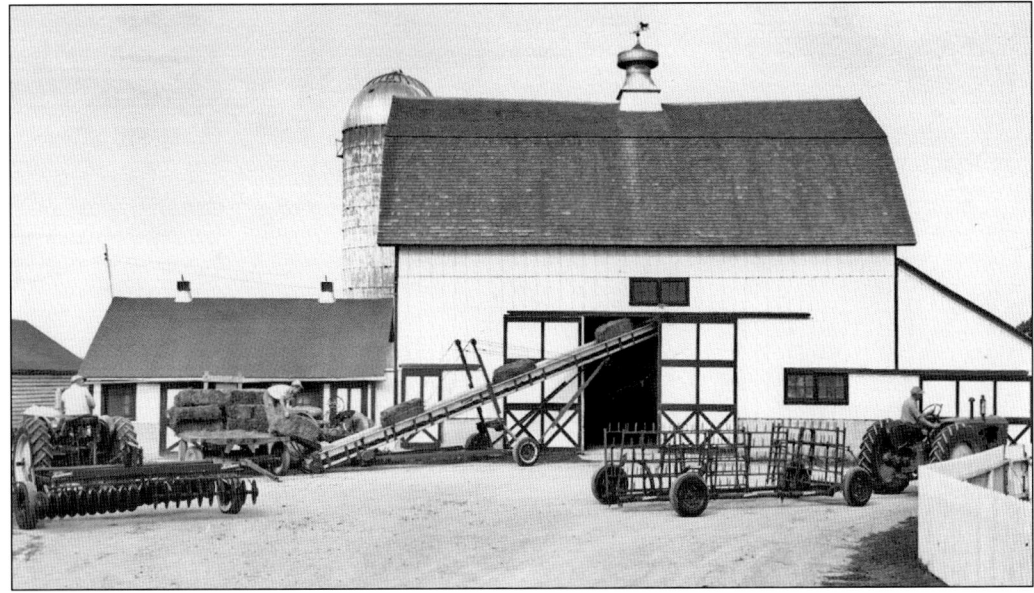

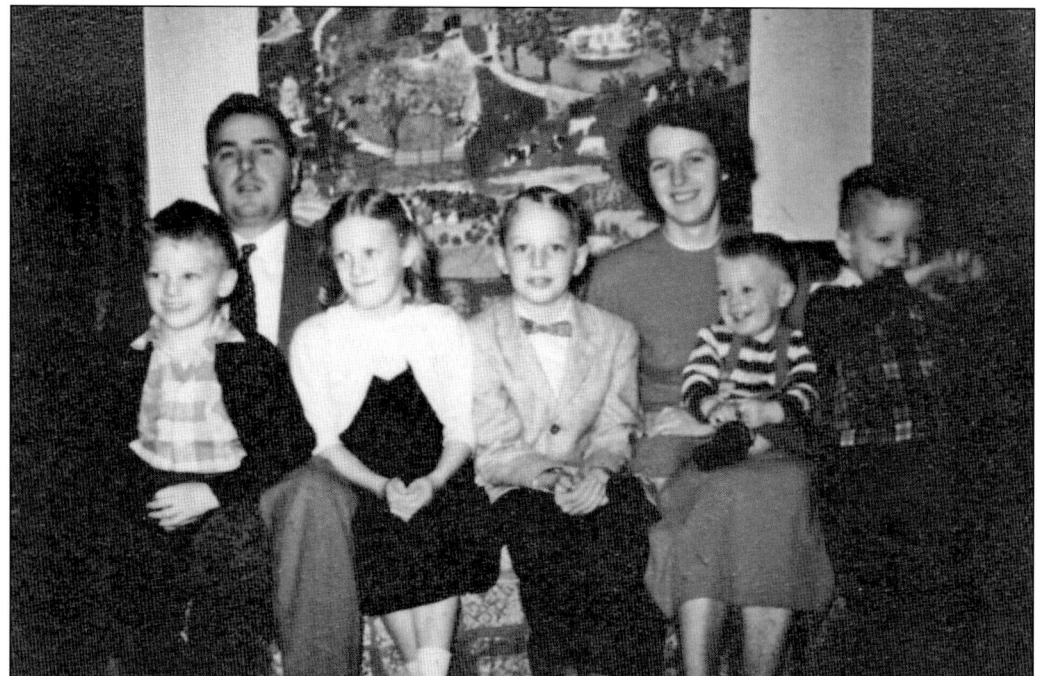
The Richardson family has been farming the same land now for six generations. Pictured here are the Richardsons with their children in 1958. (Courtesy of the Richardson family.)

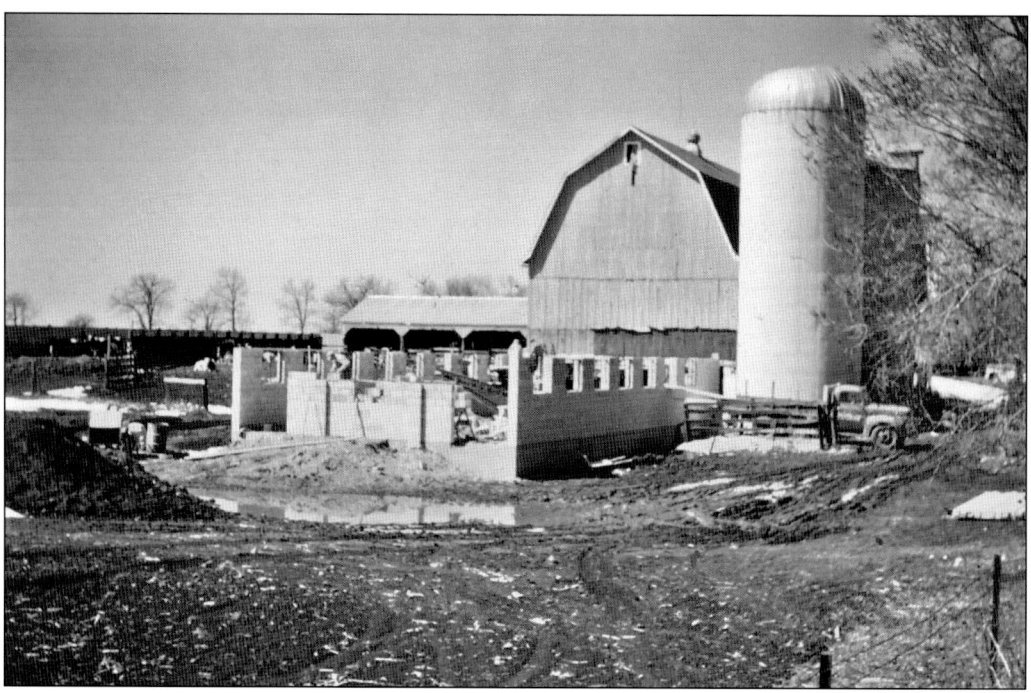
Farming was still a very viable business in the late 1950s. The Richardsons are shown here building a new barn. (Courtesy of the Richardson family.)

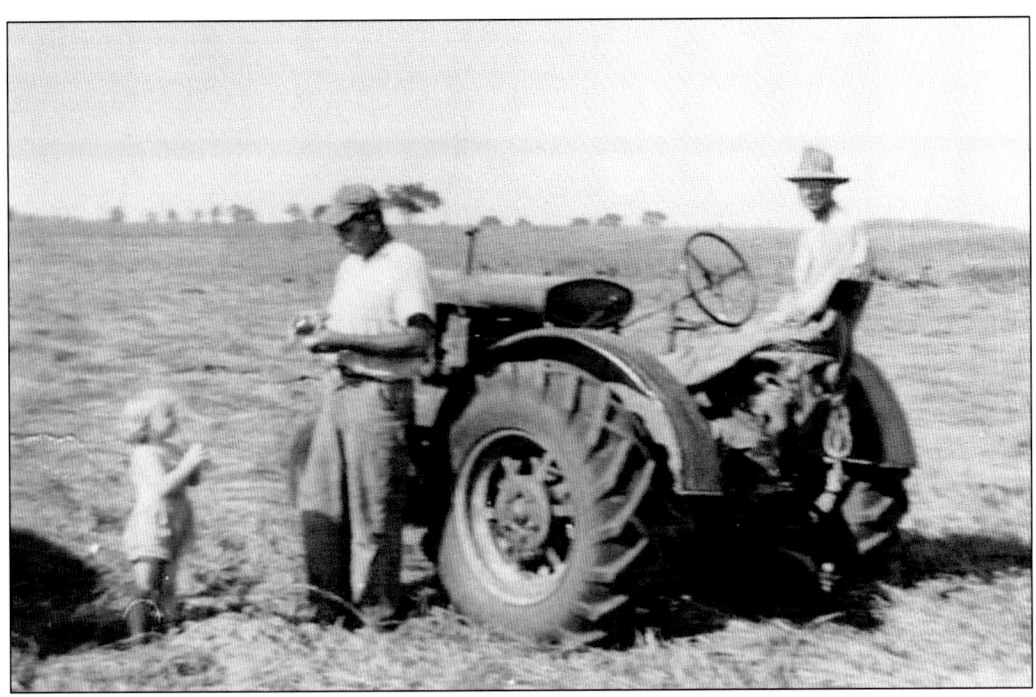

In order to stay competitive and profitable, farmers had to add the cost of equipment to their overhead. By 1938, the Farmall type general-purpose tractors were widely available, and despite the ongoing Depression, tractor sales increased rapidly. Farmers traded in their horses and mules for the more powerful tractors, which were strong enough to pull a combine. The peak year for tractor production was 1951, when almost 600,000 tractors were sold. Upgrading equipment and keeping up with the latest technology had become a fact of farm life, as companies like John Deere and International Harvester improved on the power of their machines and added new bells and whistles, such as enclosed heated or air-conditioned cabs. It was not until 1954, however, that the number of tractors exceeded the number of horses and mules on America's farms. Owen Richardson is shown with the family's tractor below and driving a tractor above. (Courtesy of the Richardson family.)

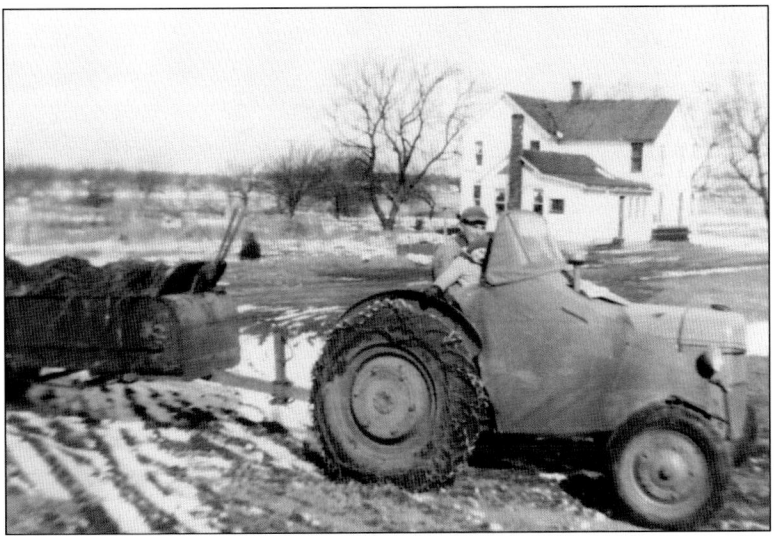

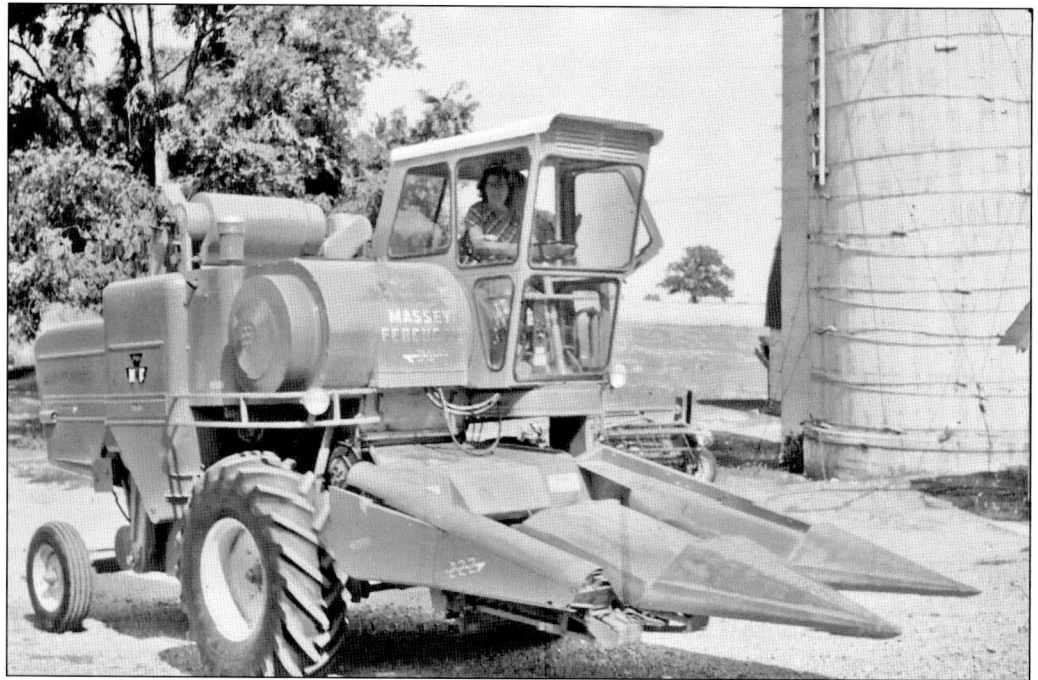

By the 1960s, more dairy farmers were turning to producing grain, which was more profitable and less labor intensive than dairying. The combine harvester, invented in 1838, became another farm necessity. The combine harvests crops, such as corn, wheat, oats, rye, barley, and the increasingly popular soybeans. It allows a farmer to complete three processes with just one pass of the machine over a field. Combines cost around $20,000, and a decent tractor can set a farmer back over $100,000. (Courtesy of the Richardson family.)

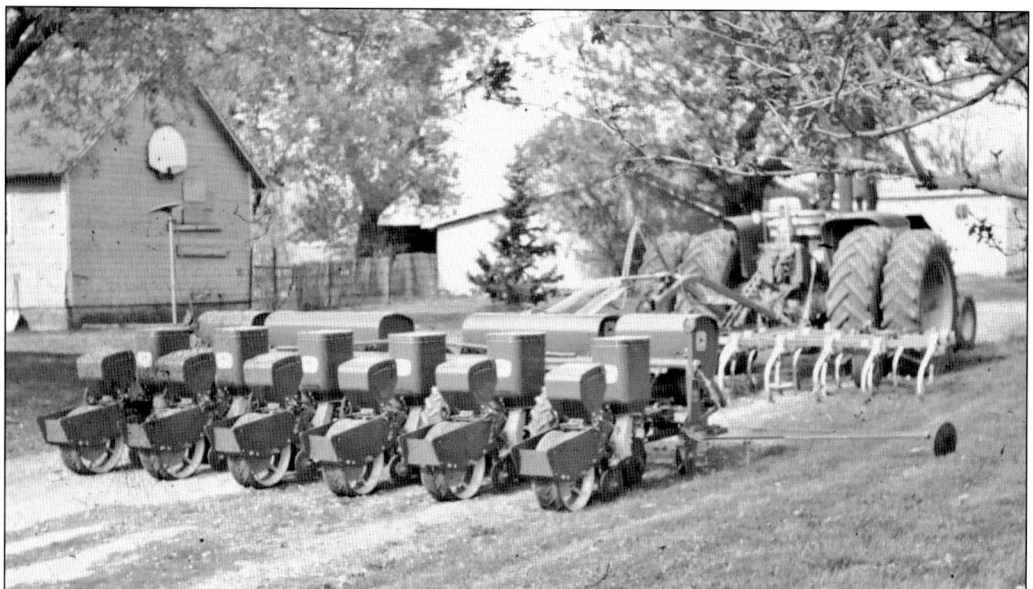

In 1890, it took 40 hours of labor to produce 100 bushels of corn using a two-row planter. By the 1940s, it took only 10 to 14 hours to produce 100 bushels of corn using a four-row planter. Pictured is the Richardson's new six-row planter in 1965. (Courtesy of the Richardson family.)

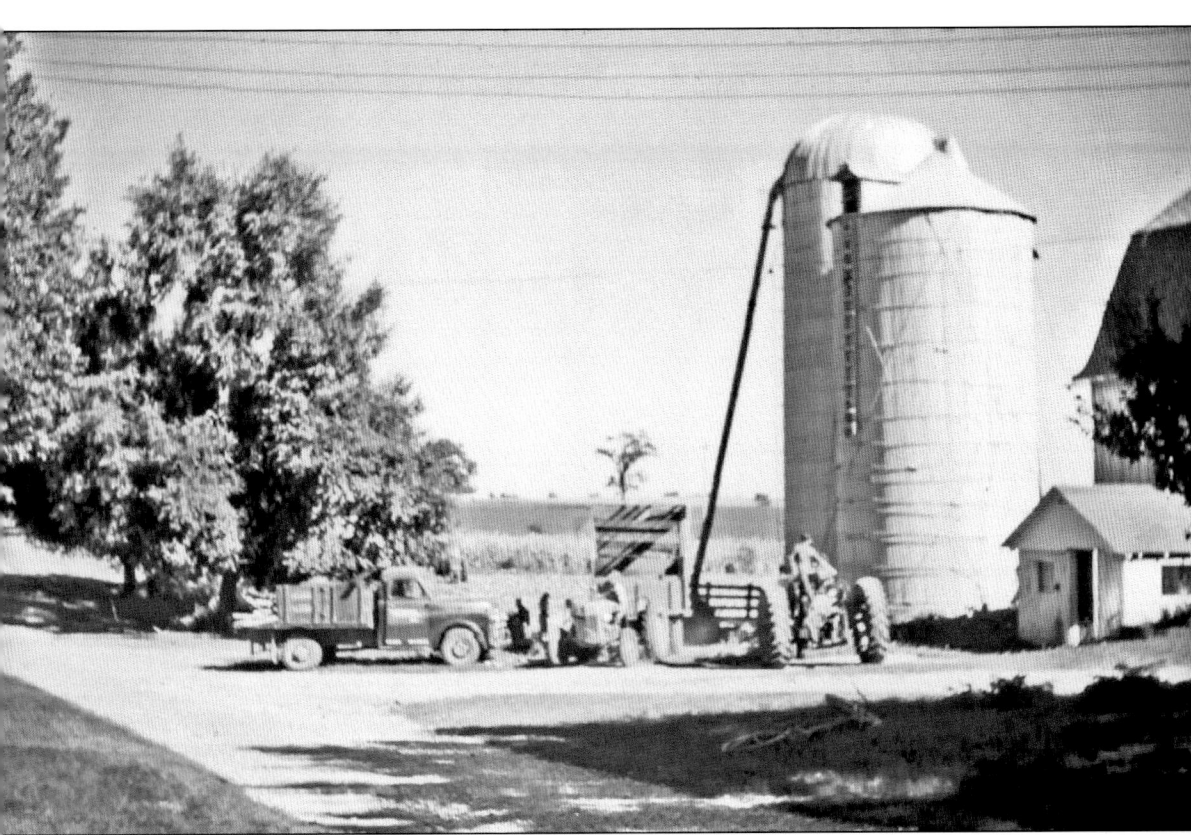

Farmers continue to use silos to provide for their dairy herds through the winter months. Proper filing of the silo was important because it determined the nutritional value of the silage. For instance, corn must be picked at just the right time and is often mixed with clover, peas, oats, or even sunflowers to maintain succulence. Much also depends on the climate and the season, and every crop is different. A farmer needs to know when is the best time to harvest whatever he plans to use as silage. The picture shows the Richardsons filing a silo in the late 1950s. (Courtesy of the Richardson family.)

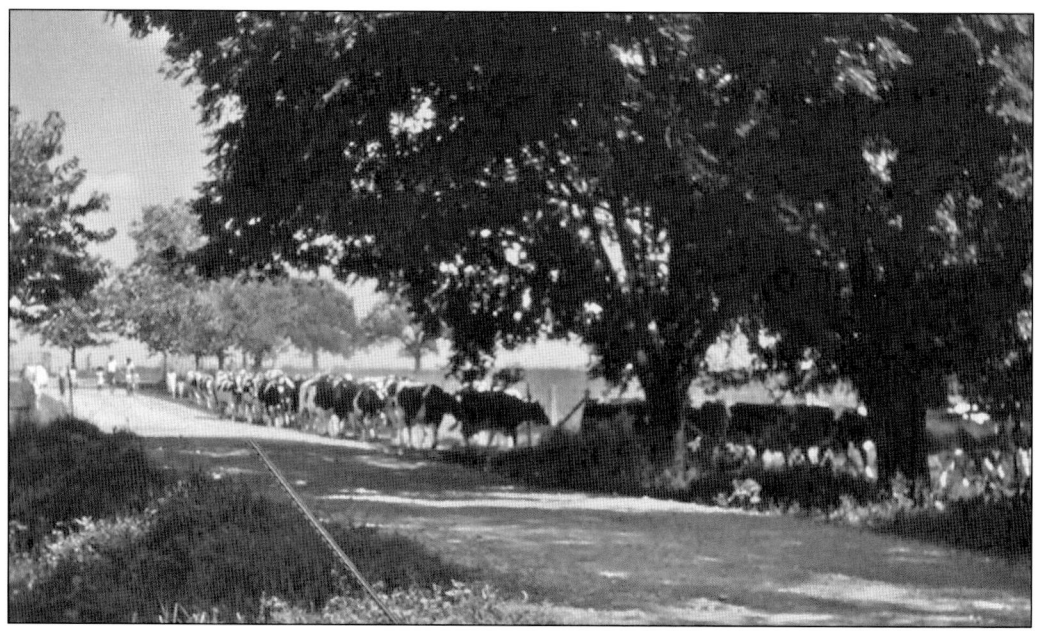

The Richardsons continued to keep a heard of dairy cattle until the mid-1960s. The picture above shows the cows being brought in from the pasture for milking and feeding the herd in the barn. Today, especially in the dairy capital of the country, which is now California, most dairy cows do not leave their stalls. They are kept in milking barns and rarely see the light of day, never mind fresh pasture. Some of the larger milking barns milk 30,000 head of dairy cattle a day. (Both courtesy of the Richardson family.)

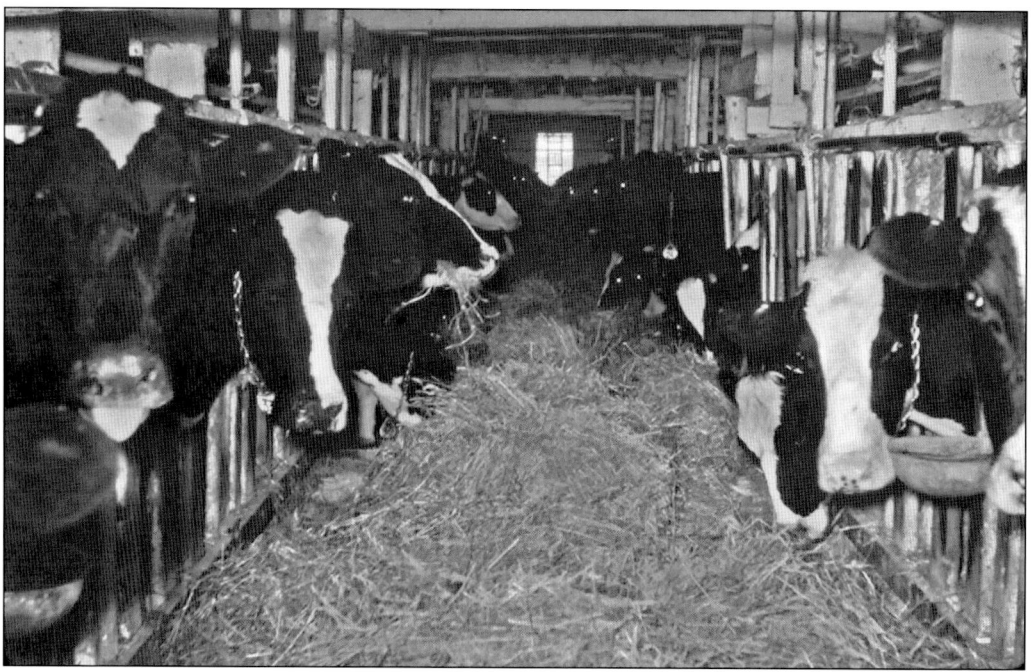

On Saturday, September 25, Owen Richardson auctioned his highly regarded herd of 115 dairy cattle for a price of about $225 a head. Richardson's reason for selling the cows was simple. He could not get the help he needed to milk the heard, so he could not keep them. He was not alone. In 1965, 16 dairy herds were sold at auction in the Spring Grove area. (Courtesy of the Richardson family.)

Still some dairy herds remained in the county. The Harvard Milk Days Festival, which takes place in Harvard the first week of June, is the longest-running festival in Illinois. It started in 1942. Norma Garrett of Harvard was the first milk queen in 1945. Harmilda the fiberglass cow is the still the city's mascot. Pictured above is Judd Davis greeting Pres. Gerald Ford's daughter Susan at the 1975 Harvard Milk Days Festival. (Courtesy of the McHenry County Historical Society.)

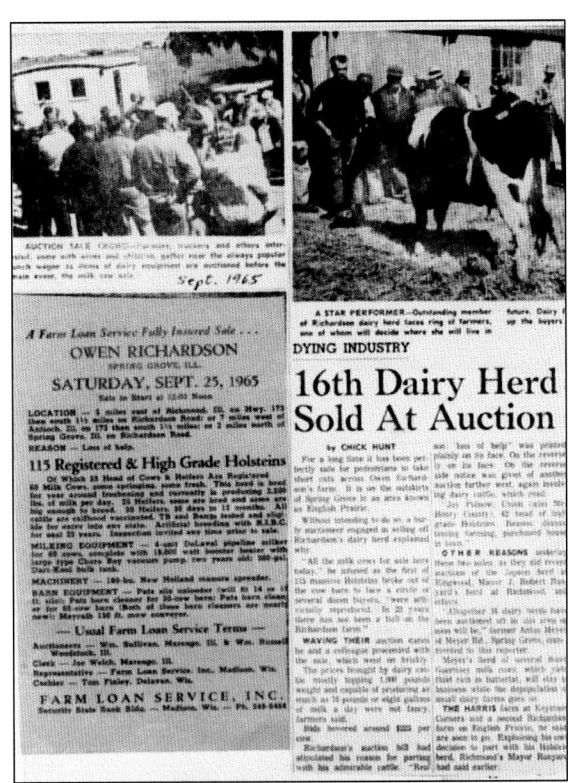

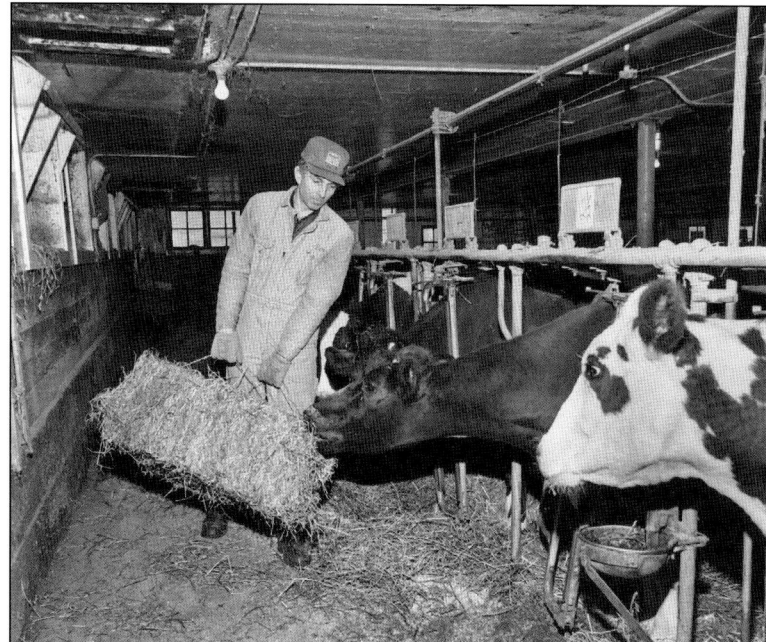

Earl M. Hughes's eldest son, Robert Hughes, and his wife, Genevieve, have been running their farm west of Woodstock since 1962. The farm was once owned by International Harvestor chief executive officer A. E. Mckinstry. They still live in the original farmhouse, which was built in 1867. (Courtesy of the McHenry County Historical Society.)

Over the years, the Hughes have had beef cows, hogs, and dairy cows on the farm. The dairy cows left in 1995. The Hughes now concentrate on their seed businesses, Yieldirect and OMG, which develops non-genetically-modified seeds. When asked if the family plans to stay on the farm, Genevieve pointed out that they "just put a new roof on the barn and that they were in the farm business and not the land development business." (Courtesy of the McHenry County Historical Society.)

After the Richardson cows departed, the pigs arrived. Hogs proved to be a more profitable product for many former dairy farmers for a while. In 1984, revenue from cattle in Illinois was only $685 million, but from hogs it was $1.08 billion. Despite that, the number of farms with any kind of livestock continued to dwindle. In 1975, there were 10,000 dairy farms in Illinois. By 1984, the number of dairy farms was down to 5,900. In the early 1990s, there were only 140 left in McHenry County. In 2009, according to University of Illinois Extension dairy specialist Prof. Mike Hutjens, there are only 32 or so in the county and only 102,000 dairy cows in the state, compared to a quarter of a million 30 years ago. Hog farms have not faired any better. In 1975, there were 49,000 farms producing hogs. In 1984, that number was down to 23,000. Factory farms with thousands of head of cattle or hogs replaced many family farms. (Both courtesy of the Richardson family.)

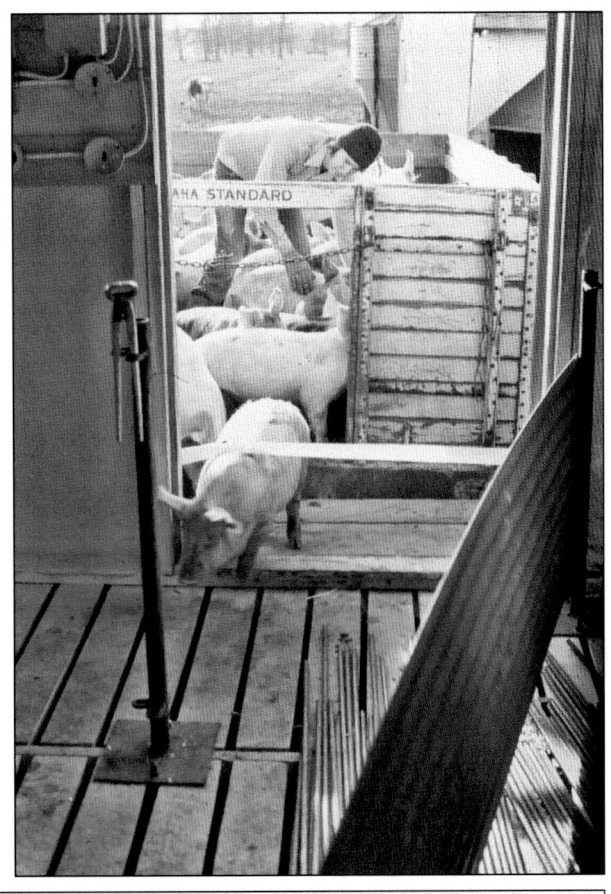

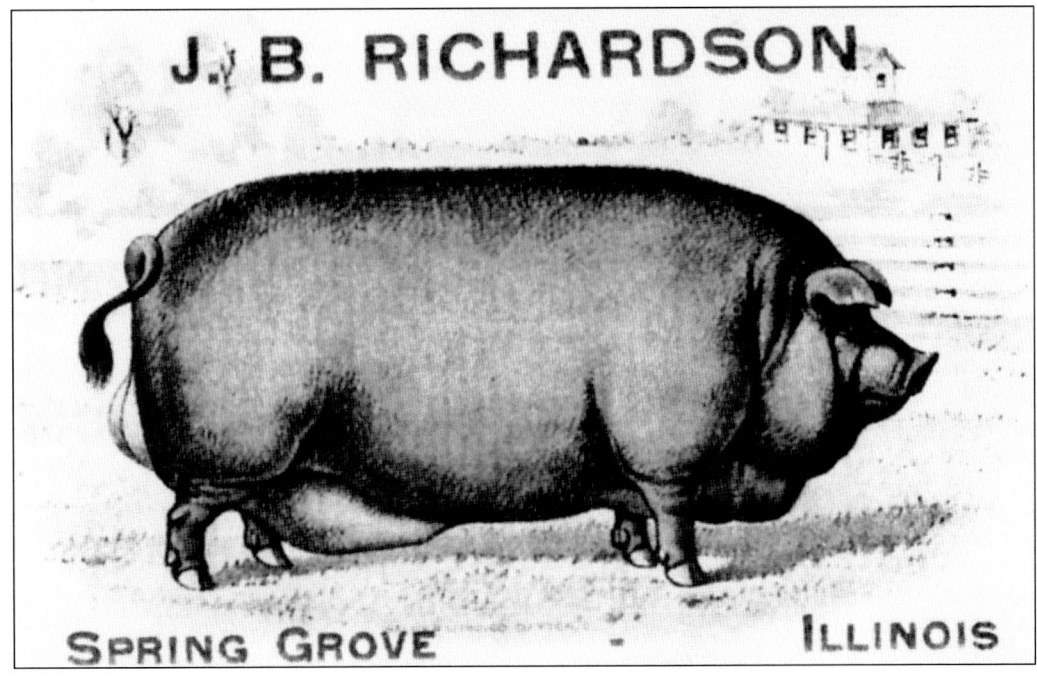

Walter (left) and Rose Schuett had a dairy farm just outside Woodstock near where the Dufield house still stands. In 1954, Walter was named dairy farmer of the year. They are shown here sharing a glass of their favorite beverage with secretary of agriculture Ezra Benson at the AFBF convention in Chicago in June 1954. Not long after, the Schuett's dairy farm was converted into WalRose Manor, a housing estate. It was a harbinger for the beginning of the end for McHenry County's family farms. (Courtesy of the McHenry County Historical Society.)

*Four*

# THEN CAME THE DEVELOPERS

Even those living in McHenry County for less than 10 years have noticed that local farms are disappearing at an accelerating rate. Dairy farms have been particularly hard hit by changing economic times. There are now less than three dozen of them in the county.

What happened? First, demand fell. Kids stopped drinking milk and started drinking soda. Between the 1950s and 1998, the per capita consumption of milk fell 35 percent. Between 1950 and 1970, the numbers of dairy farms fell by 80 percent.

Even though improved technology allowed production of both crops and livestock to reach higher levels than ever before, running the family farm became a more expensive proposition, as capital costs went sky high. Rising labor costs combined with decreasing availability of laborers was also instrumental in the disappearance of dairy farms. Many farmers started to rethink their plans for the future use of their land.

Illinois has been losing farmland since just after World War ll. According to the Illinois Agricultural Statistics Service, the state lost 3.9 million acres of farmland in the 50 years between 1950 and 2000. Illinois Department of Revenue figures show a loss of almost 600,000 acres of land assessed as farmland from 1981 to 1996 alone. Nearly a third of that farmland was lost in Cook, DuPage, Kane, Lake, McHenry, and Will Counties. Of course the land was not gone; it was converted into subdivisions and strip malls.

McHenry County had 84,000 people in 1960. By 2008, it was 318,000, an increase of over 300 percent. Somewhere in that surge of population was a tipping point. McHenry County, once the dairy princess of the Republican Party, became the darling of big developers. In 1989, Richardson brothers Robert and George petitioned the Village of Spring Grove so that their farm could be protected under a state program that prohibited designated "ag areas" from being developed or rezoned for 10 years. Municipalities located within a mile and a half of a proposed agricultural site had the right to veto the request, and they did. It was the first time a McHenry County farm owner's petition had been denied. Now those farmers who want to stay on their land are locked in a constant battle with those who want them to leave it.

Author Arabella Anderson, documenting the disappearance of McHenry County's farms before they are all gone, is shown taking a picture of a farm on Route 47 in Huntley. Even though it was dilapidated, with broken windows and weathered wood, it was obvious that it was once a very prosperous farm. When taking pictures, she and coauthor Glynnis Walker sometimes arrived just before the wreckers came or before the barns were engulfed in flames. (Photograph by Glynnis Walker.)

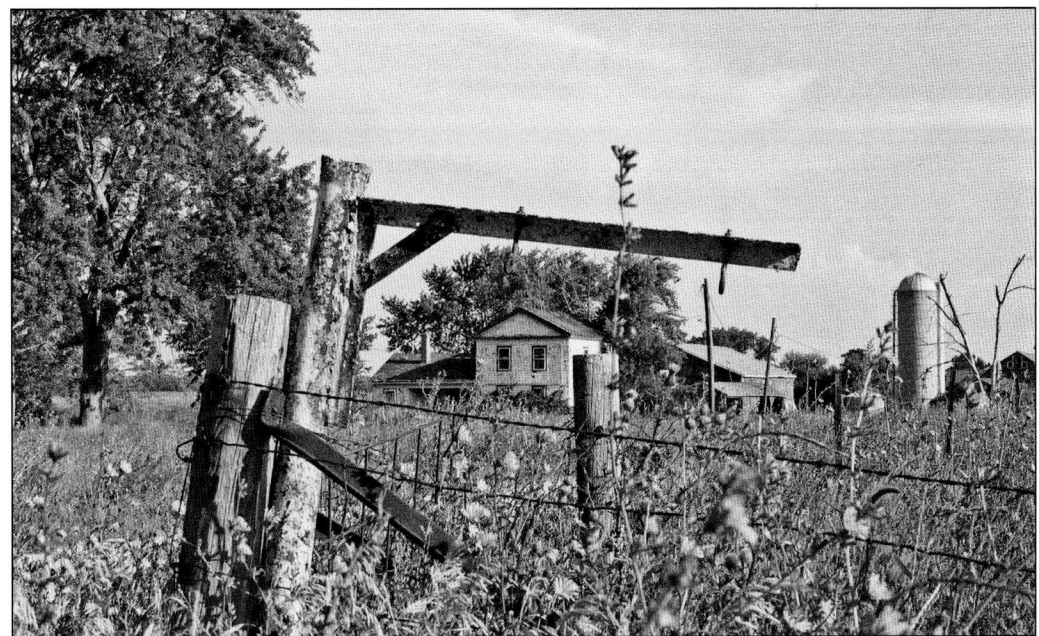

This farm used to be at the corner of Country Club and Bull Valley Roads. The dairy herd was large, and the cows would come over the fence to visit if people dropped by to say hello. Author Glynnis Walker grew up on a dairy farm and has always had a fondness for the peaceful creatures. One day, the pasture was full of farm equipment for sale. The cows were gone. (Photograph by Arabella Anderson.)

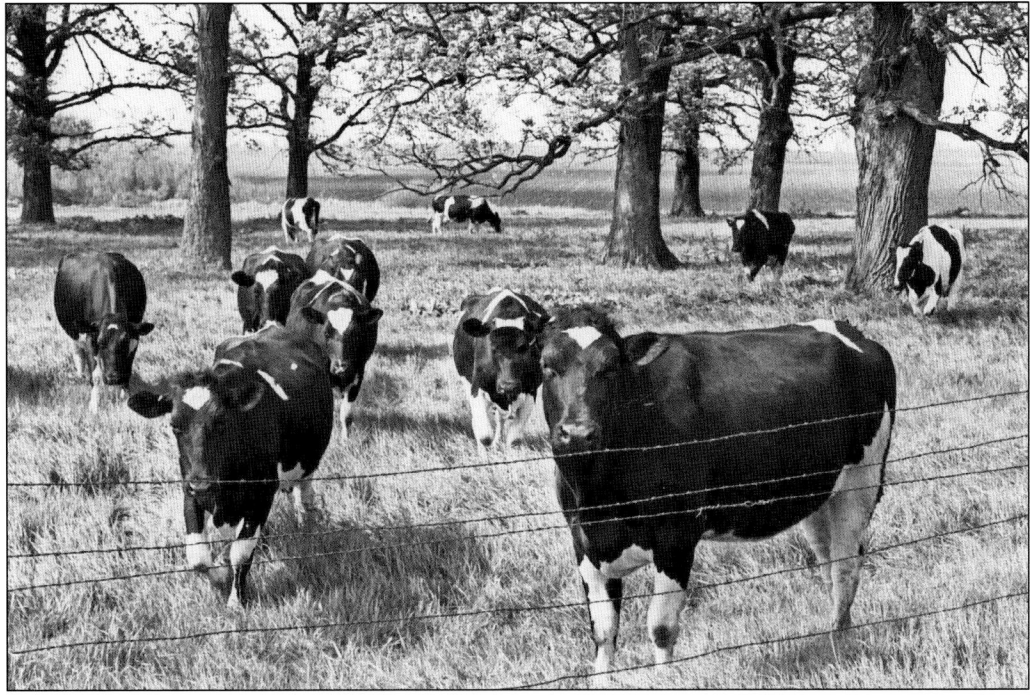

Pictured here are some of the Holsteins that used to live on the farm mentioned in the previous caption. (Courtesy of the McHenry County Historical Society, Don Peasley Collection.)

Not long after these pictures were taken, the wreckers came. The house went first and then the silos. The land that was a farm sits empty in 2009. It is owned by the Village of Bull Valley. (Photographs by Arabella Anderson.)

James D. Curran had an 80-acre dairy farm in McHenry County for more than 58 years. In 1947, he was named to the Purebred Dairy Cattle Association National Honor Roll for his dairy herd. He was a past president of the farm bureau, active in 4-H, and served on the McHenry County board. He and his wife, Magdalena, were married for over 50 years and had four daughters and one son. He died in December 1993. He is pictured here, second from left. (Courtesy of the McHenry County Historical Society, Don Peasley Collection.)

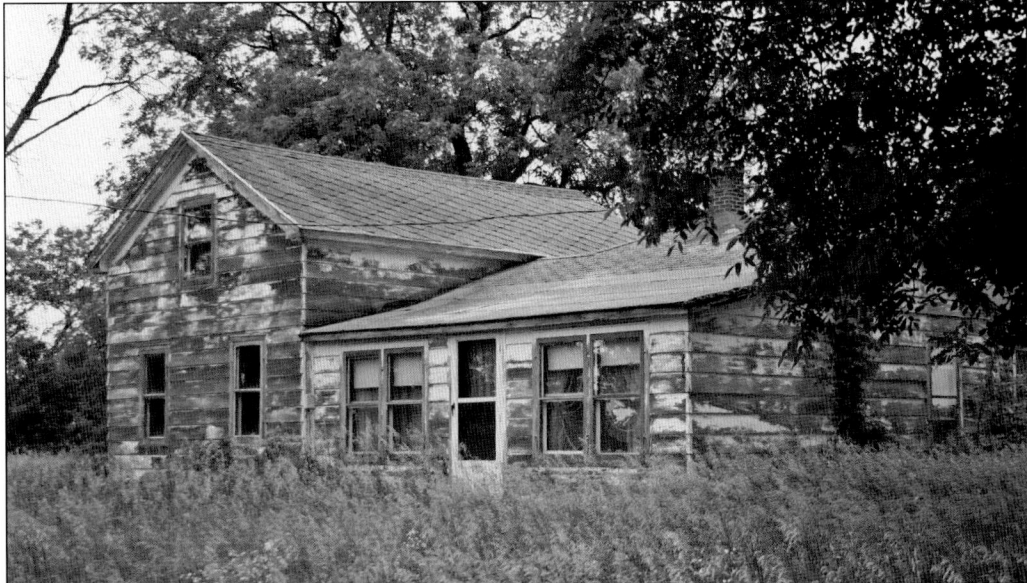

The farmhouse that James Curran shared with his wife, Magdalena, still stands, abandoned and derelict. (Photograph by Arabella Anderson.)

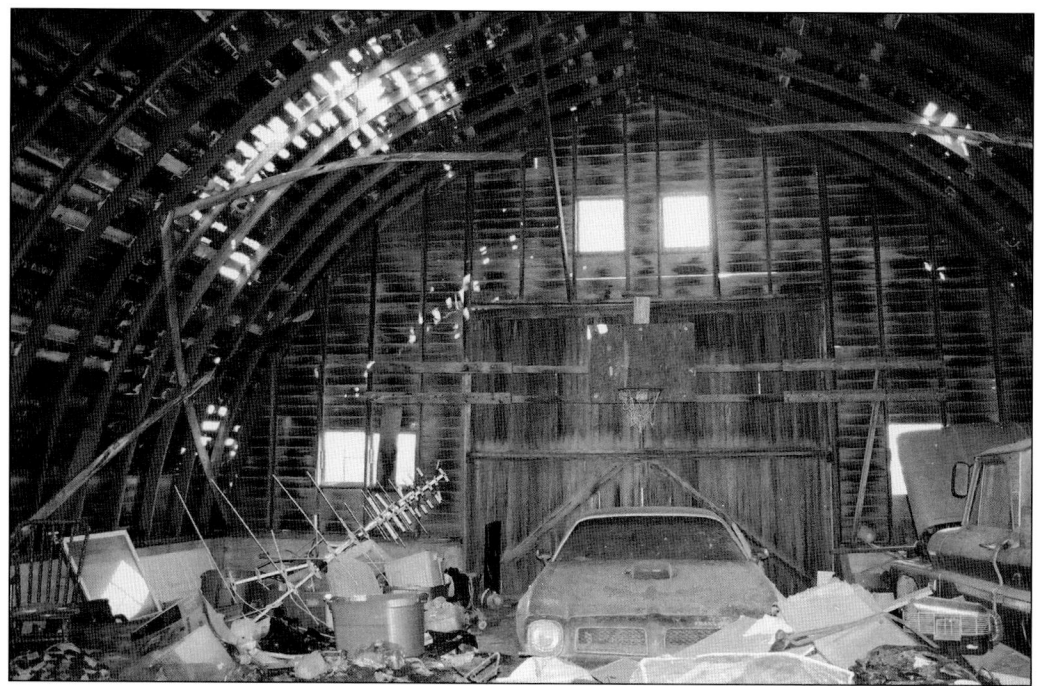
This is the interior of James D. Curran's barn. (Photograph by Arabella Anderson.)

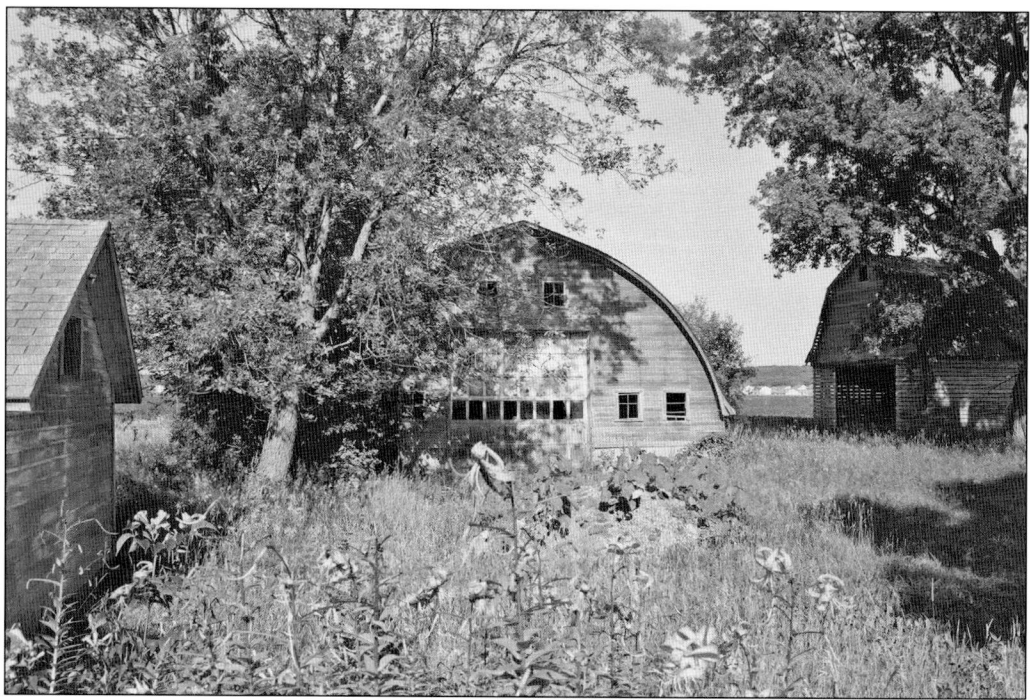
The prairie is gradually taking back the Curran barn. Behind it, the line of new houses shows that the developers are fighting the prairie for control of the farm. (Photograph by Arabella Anderson.)

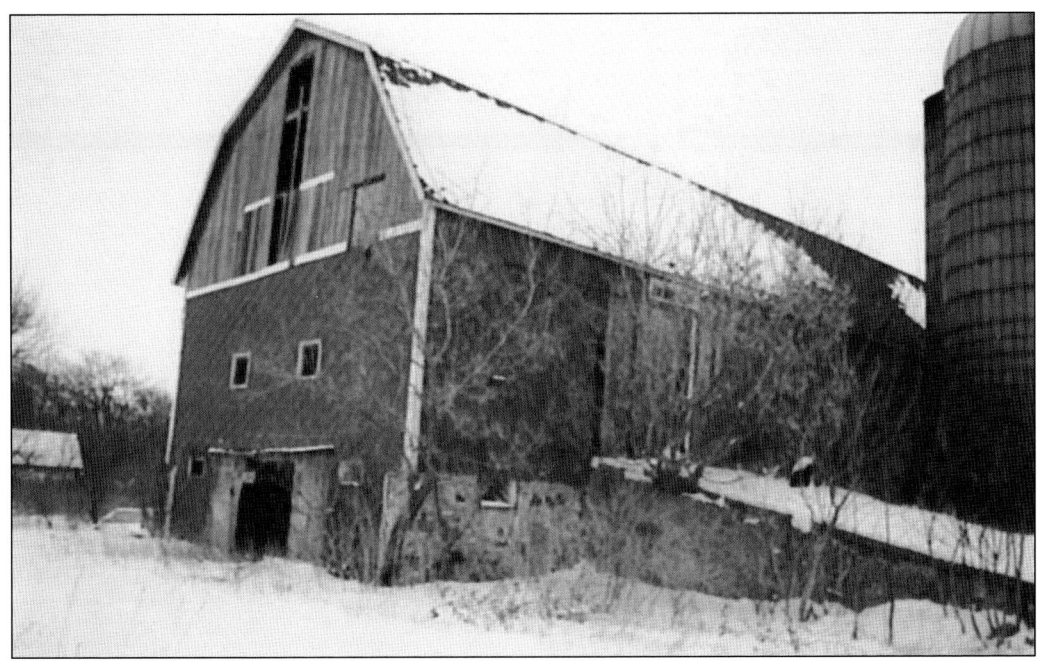

Built around the dawn of the 20th century, the beautiful Bohl peg barn was a landmark structure on Route 14 in Crystal Lake. It was demolished in April 1997, and the license plates, antique signs, and other artifacts that were inside were not saved. Although Florence Bohl wanted the Emmanuel Lutheran Church to have her farm, she made a number of handwritten codicils to her will. In one, she gave her goddaughter her Wellington piano and bench, old Victor talking machines and records, and any slides or pictures she may have wanted from the house. (Both courtesy of the Emmanuel Lutheran Church.)

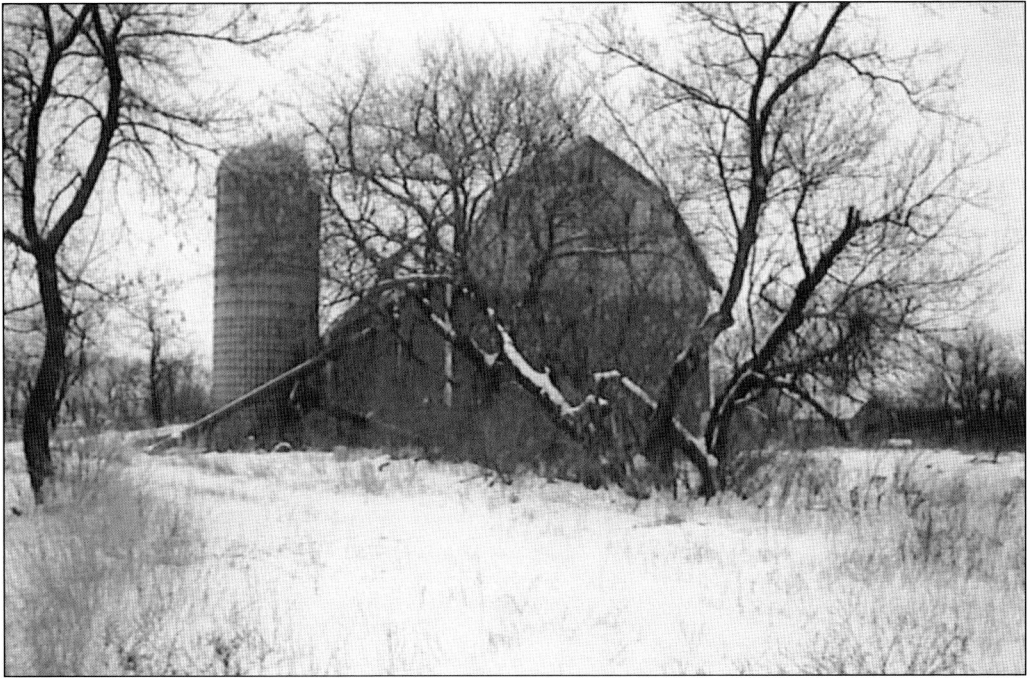

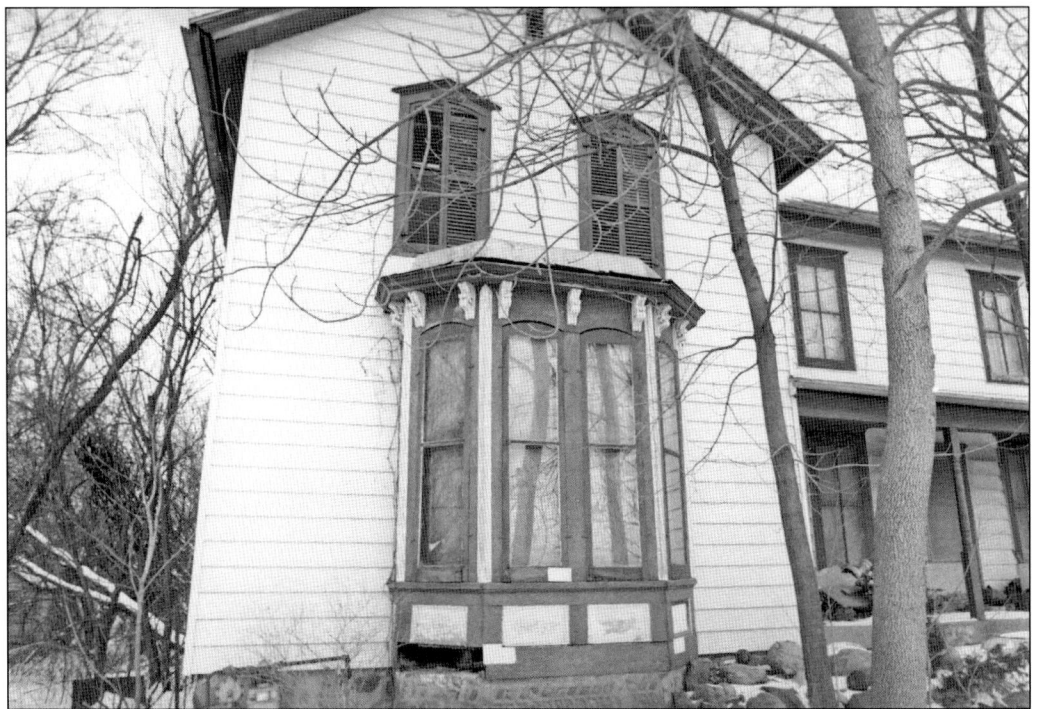

Florence Bohl made a provision of $1,000 for her pets at the time of her death. She also wrote that she wanted her "house and barn and farm buildings be preserved because of their age and beauty and be made to good use and not be demolished." Bohl's animals were saved. Her house and its contents, however, were bulldozed into a 25-foot pile of debris six months after her death. (Courtesy of the McHenry County Historical Society.)

Bohl also made a stipulation that her land never be sold, but the church sold it in a blockbuster $14.7 million dollar deal to developers, who replaced the beautiful, old buildings with a brand new strip mall. The Bohl Marketplace features, among other stores, a Target and a Barnes and Noble. (Photograph by Arabella Anderson.)

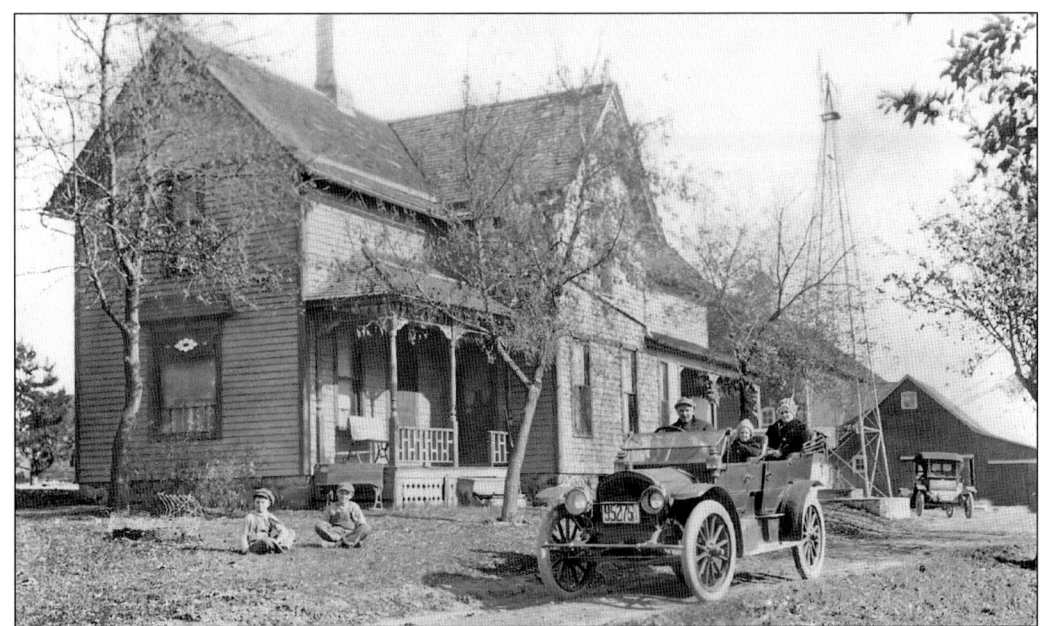

Charles Conley was born in 1863 on this farm about two miles north of Huntley on the east side of Route 47. He married Margaret Higgins of St. Charles in 1889 and had six children, Harold, Clifford, Marcella, Roy, Marian, and Agnes. Margaret died in 1927, Conley died in 1945, and the farm was passed on to Roy. (Courtesy of the McHenry County Historical Society.)

In 2008, all that remained of the Conley farm was part of the silo and the artisan well. Like much of the land on Route 47, this once-fertile farmland is waiting to be developed. (Photograph by Arabella Anderson.)

This farmhouse, located on Route 47 south of the old Conley farm, had two staircases and six bedrooms. The steps on the stairs were tread-worn, evidence of the passage of many feet. A family, perhaps several generations of one, lived their lives in this house and farmed this land. (Photograph by Arabella Anderson.)

The house was deserted for years, with the land waiting to be developed. The farm was a good size, about 80 acres, and the barn and outbuildings were large and numerous. (Photograph by Arabella Anderson.)

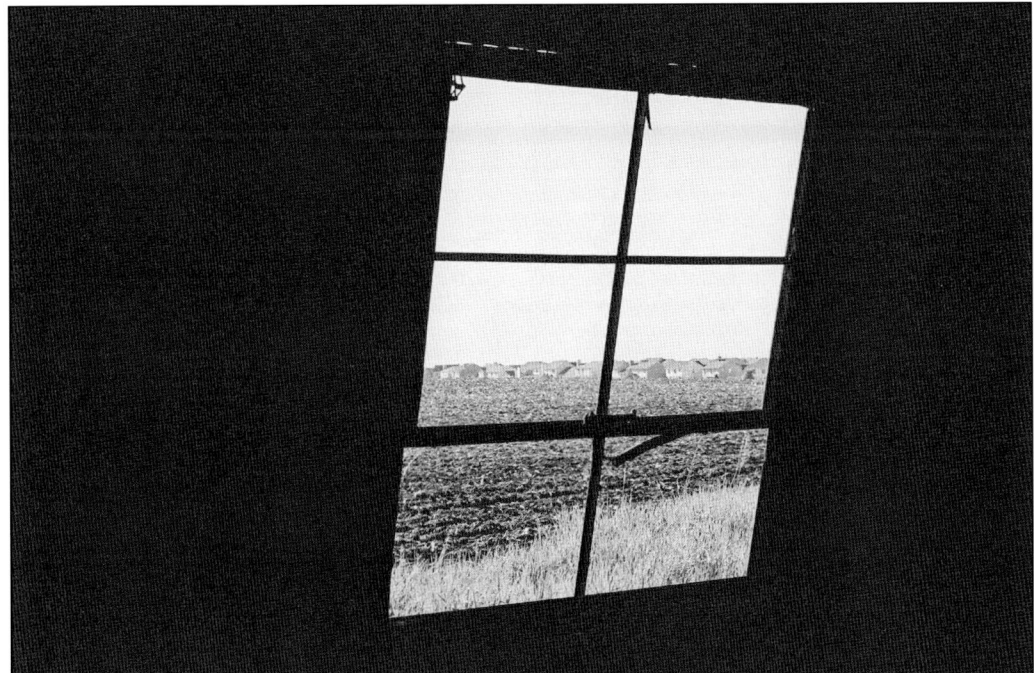

The authors visited this farm twice, struck by its stark beauty and the knowledge that it too was lost. The many new houses behind it—visible from looking out the upstairs window—meant that it would not be long before this farm too passed into memory. On the second visit, the bulldozer had already gone to work. (Photograph by Arabella Anderson.)

In a matter of hours, decades of McHenry County farm history became a heap of rubble. The fence, where author Arabella Anderson sat while taking pictures of the farm on the first visit, was all that remained during the second. (Photograph by Arabella Anderson.)

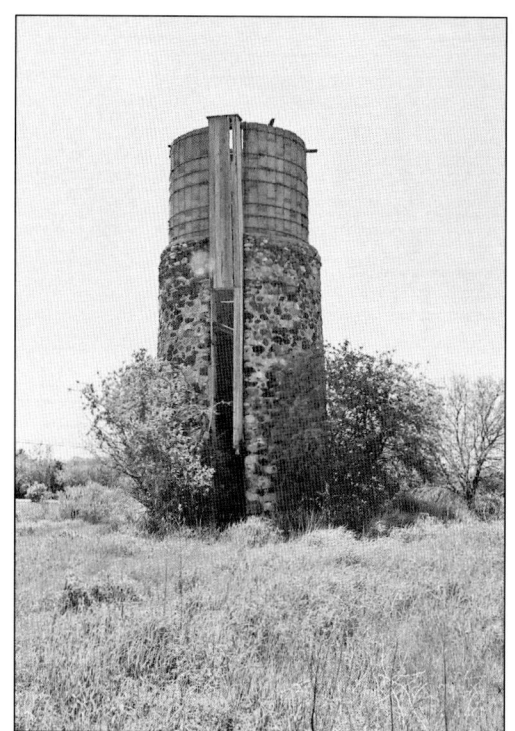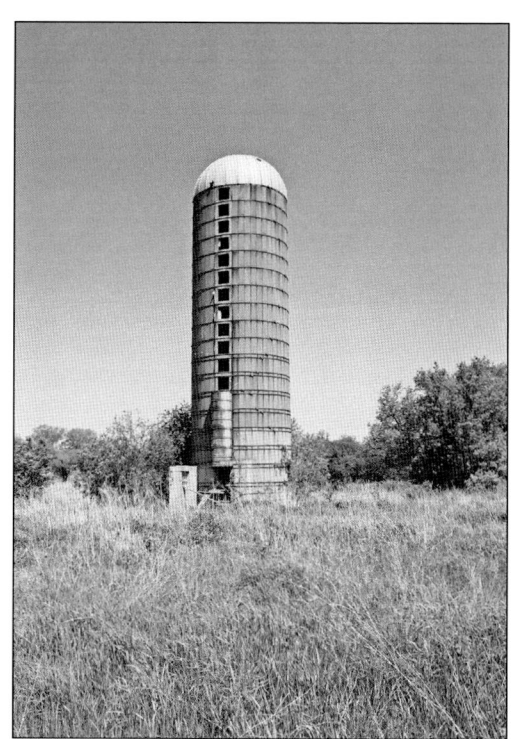

All over McHenry County, remnants of Fred Hatch's revolutionary idea, which made the dairy industry boom, sit as silent sentinels of the lost farms. (Photographs by Arabella Anderson.)

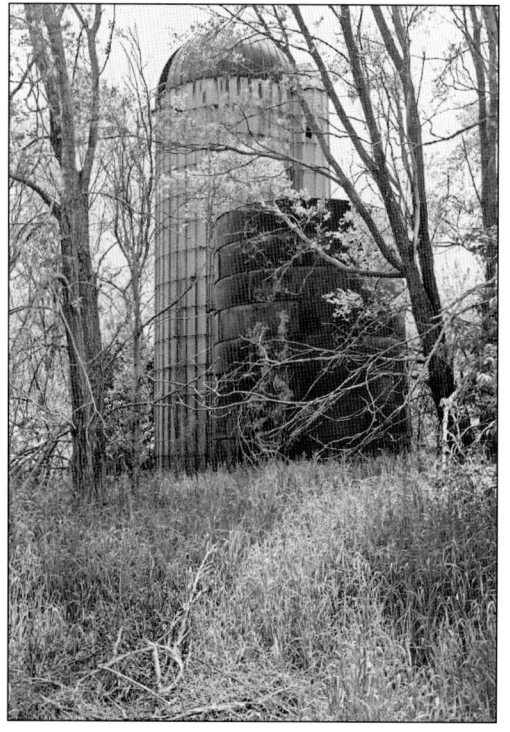

The Randall Road commercial corridor was once farmland. Above is all that remains of the large and once-prosperous Pederson farm. The abandoned farmhouse is pictured below. (Photographs by Arabella Anderson.)

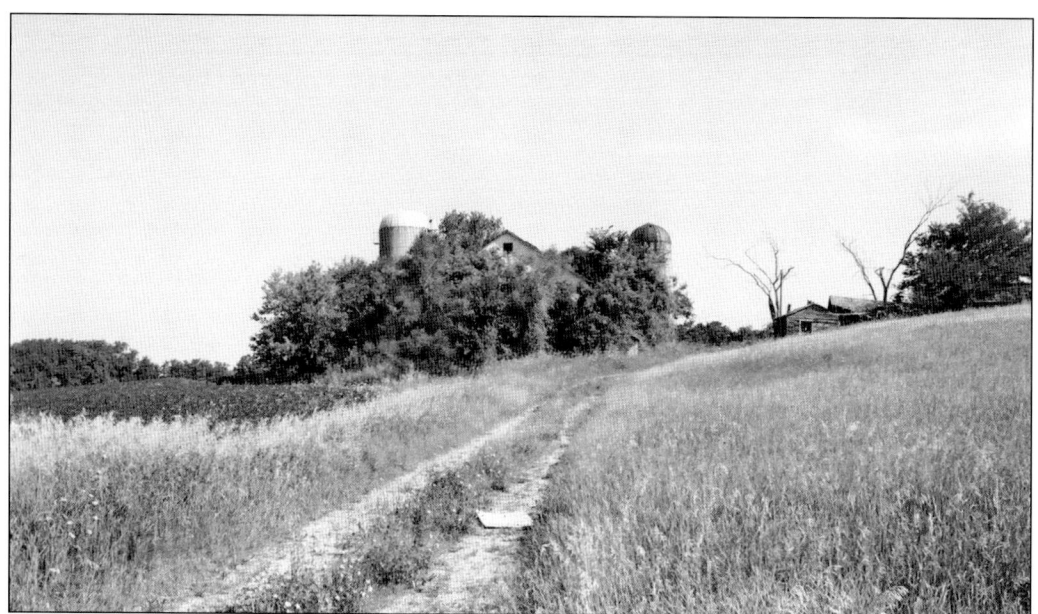

Harry Fosdick moved to Greenwood Township with his wife, Pattie, in 1835. The prosperous Fosdick farm had a large, yellow brick farmhouse, with high ceilings, basement walls 18 inches thick, and many outbuildings. The Fosdicks grew into a large, well-to-do family. Every June, they got together for a huge outdoor family picnic with as many as 90 guests. A sumptuous feast was enjoyed by all, which always ended with large servings of homemade ice cream. (Photograph by Arabella Anderson.)

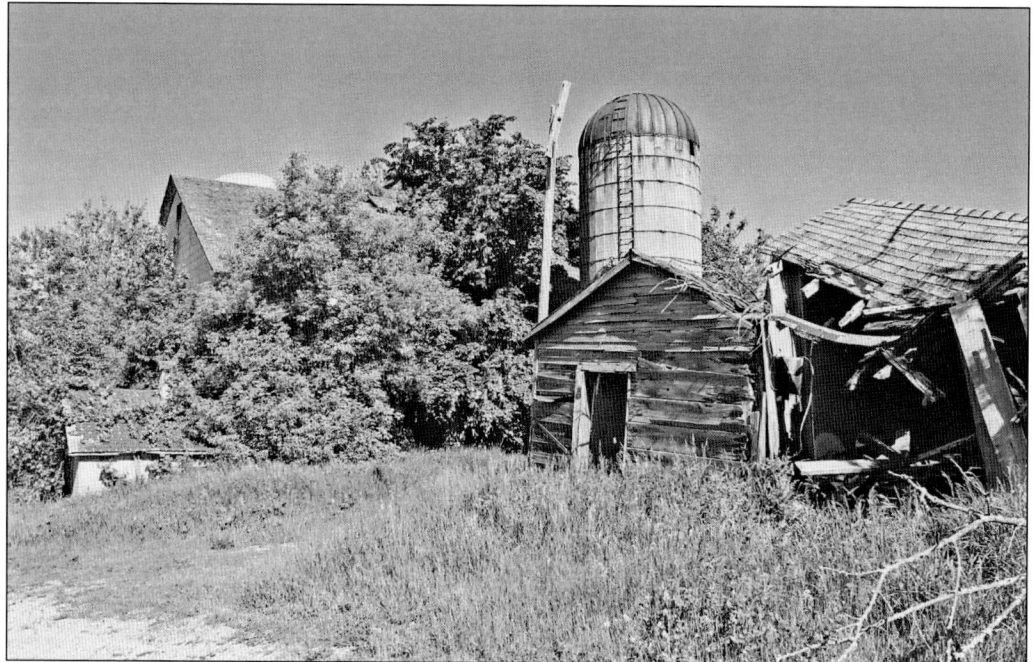

This farm, which sat majestically on a hill on Route 120 outside Woodstock, was empty for many years. The barn caved in and large trees were growing through its roof. (Photograph by Arabella Anderson.)

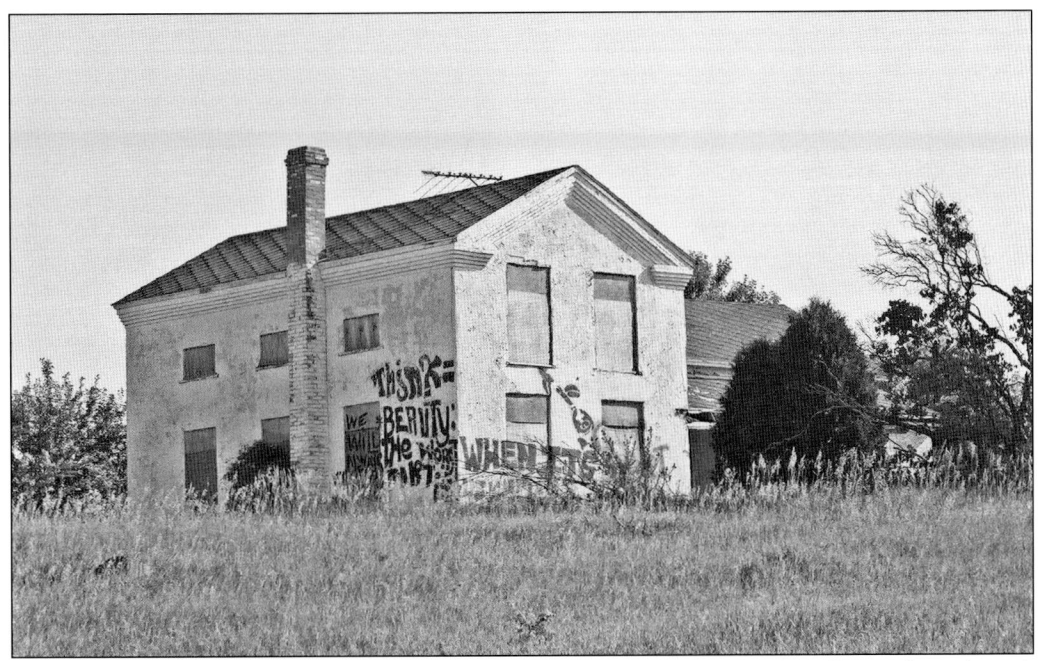

The house, which was at one point stuccoed, bore multiple incidences of graffiti, and weeds took over from the crops. (Photograph by Arabella Anderson.)

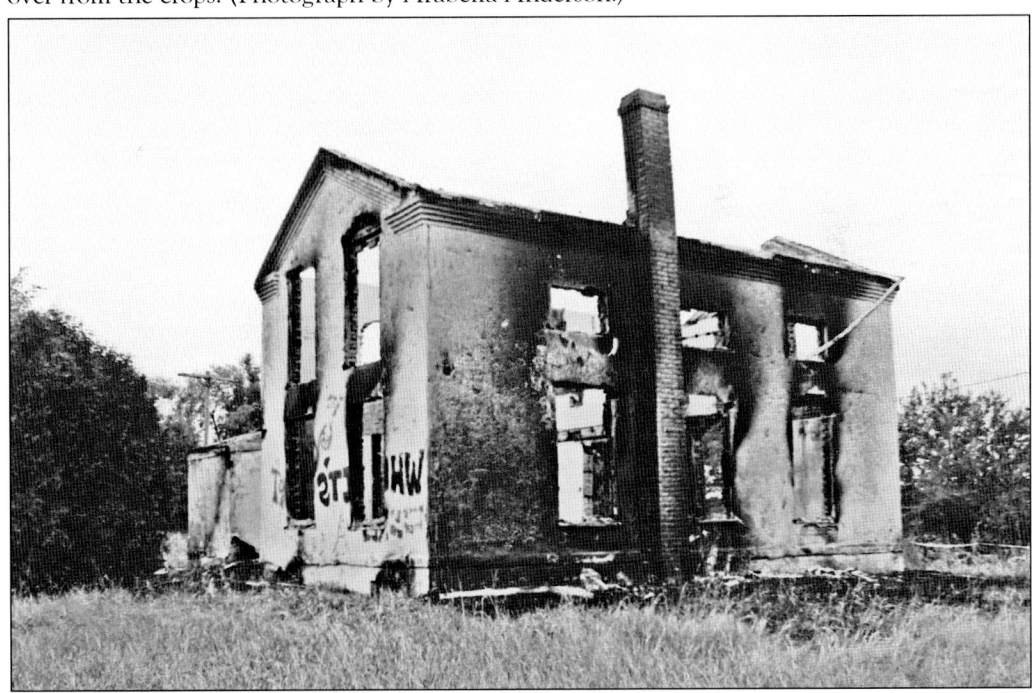

On the night of September 26, 2009, Harry and Pattie Fosdick's once-beautiful farmhouse caught fire. The next morning, when author Arabella Anderson took these pictures, the wooden beams were still smoldering and the yellow bricks were hot and charred. All that remained of one of Greenwood's finest farms were some sooty walls and staring, empty windows. (Photograph by Arabella Anderson.)

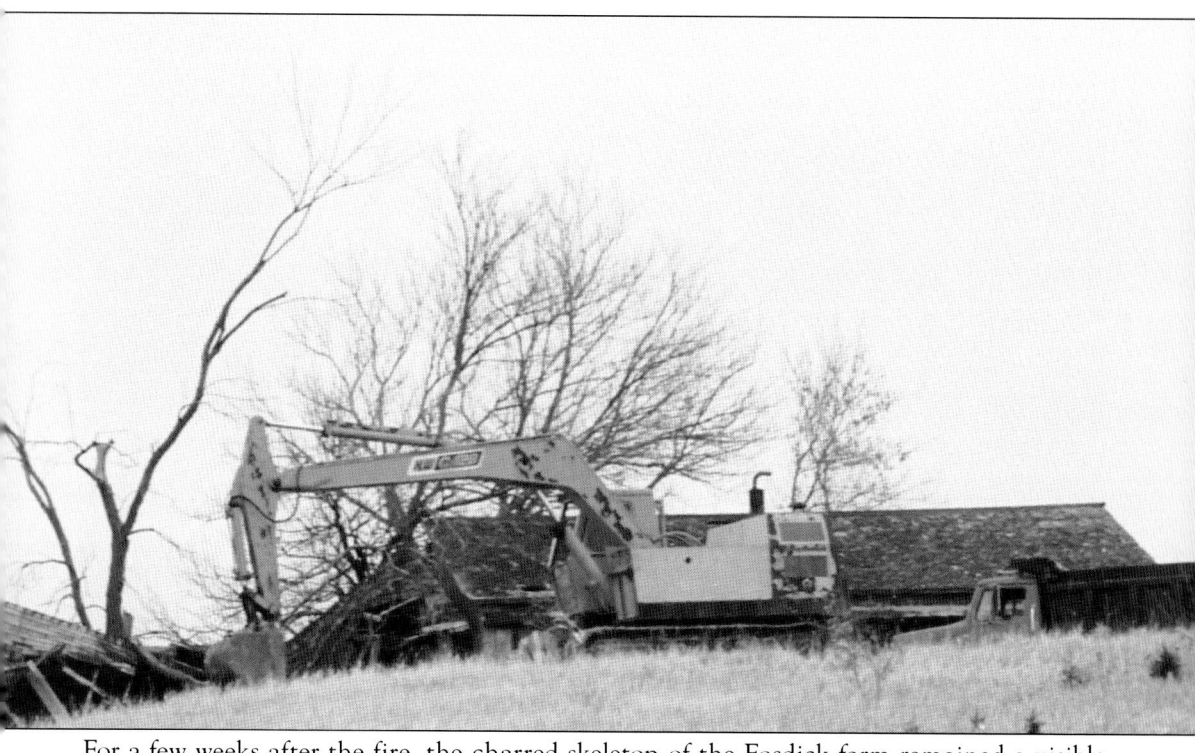

For a few weeks after the fire, the charred skeleton of the Fosdick farm remained a visible testament to the fate of family farms everywhere. Then one morning the bulldozer came and what was once a magnificent and productive farm became a heap of rubble. The land that once grew crops and provided dairy products now sits vacant, waiting to be developed. (Photograph by Arabella Anderson.)

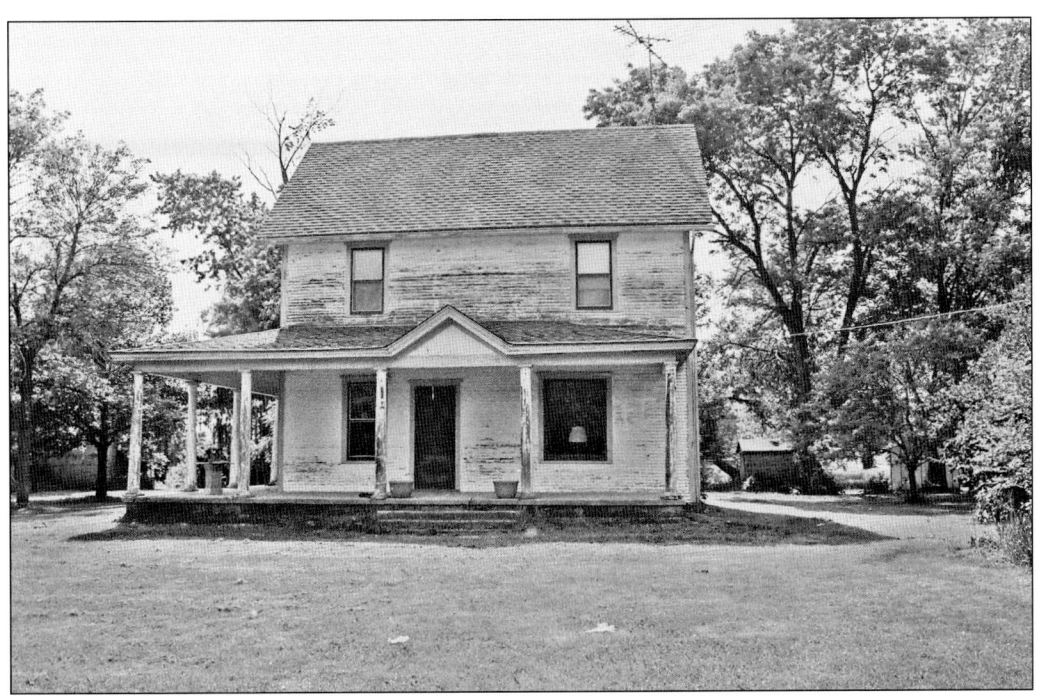

This farm on Franklinville Road is still occupied, but not by farmers. When the railroad did not come through this part of McHenry County but passed through Woodstock and Harvard instead, the town of Franklinville disappeared. Now the farms along Franklinville Road are following suit. The farmhouse is still sturdy, but the barn has been battered by a series of storms and is in a serious state of disrepair. (Photographs by Arabella Anderson.)

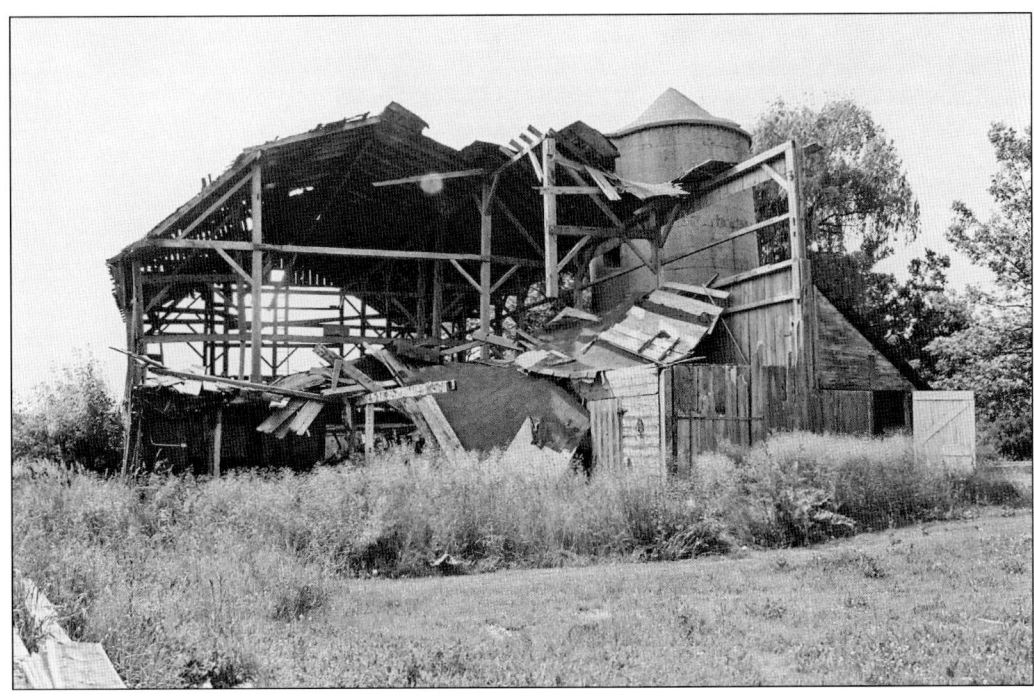

There are still some farms in McHenry County of course. Michael Walkup occupies the house on Walkup Avenue. His is one of a few small farms that produce vegetables or organic meat for a growing audience who wants to know where their food comes from. On January 2, 2010, there was a serious fire at the house, but Michael is hoping to rebuild. (Photograph by Arabella Anderson.)

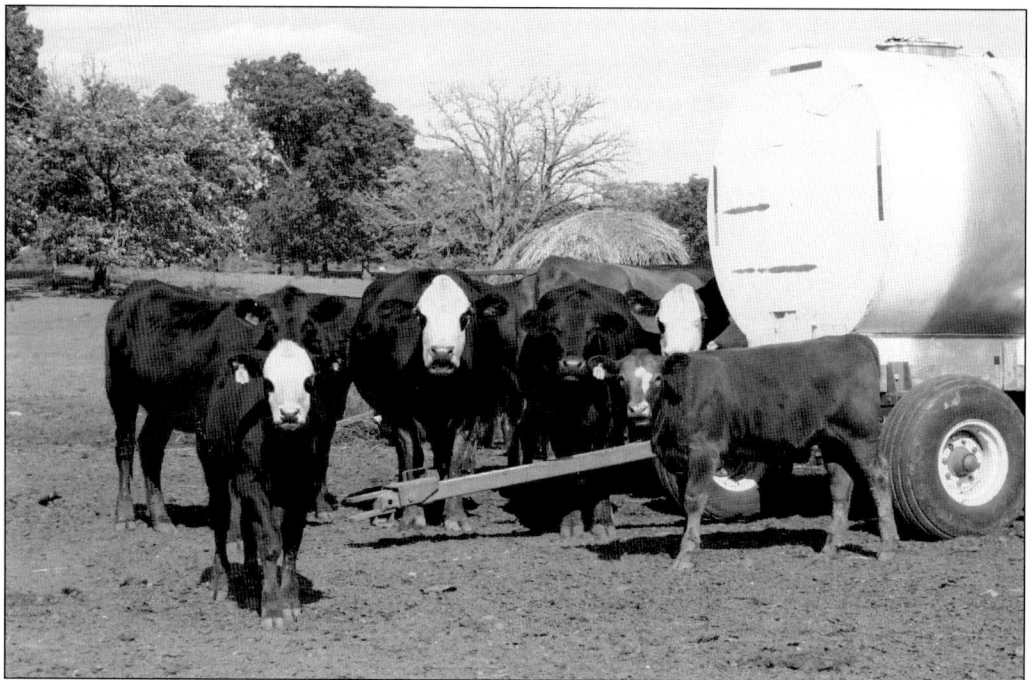

The black and white faces of dairy cattle have been replaced by beef cows that can be turned over in a single season. (Photograph by Arabella Anderson.)

Grain crops are still grown, but more and more, the corn has to fight the houses for the land. (Photograph by Arabella Anderson.)

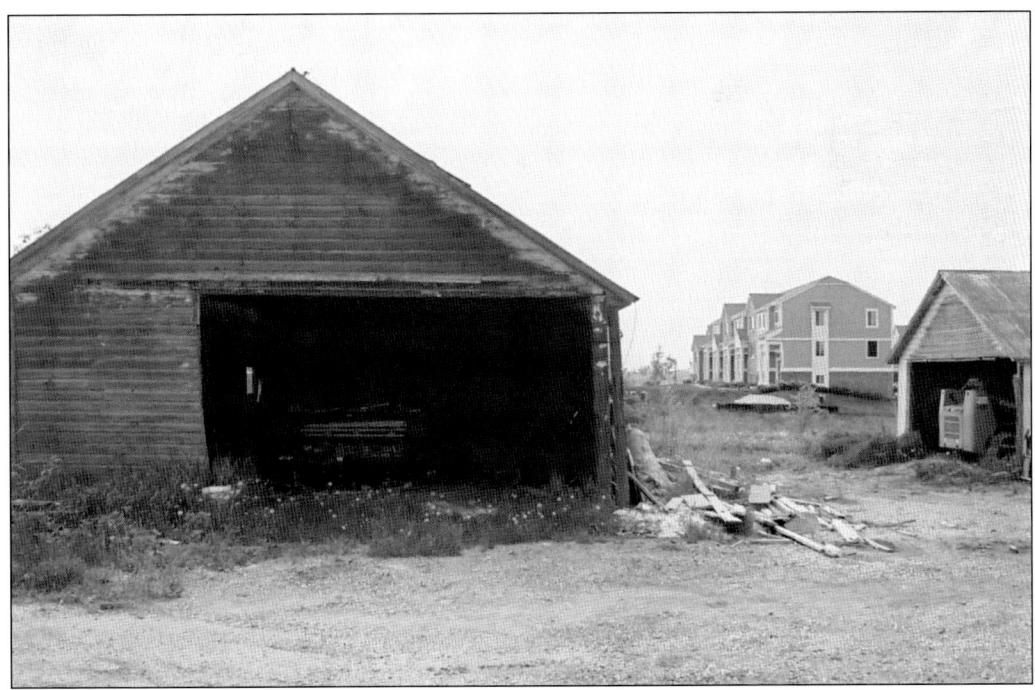
Sometimes the developers do not even bother to tear down the farm buildings before erecting the new houses. (Photograph by Arabella Anderson.)

The Richardson farm on English Prairie has the largest corn maze in the world. (Both courtesy of the Richardson family.)

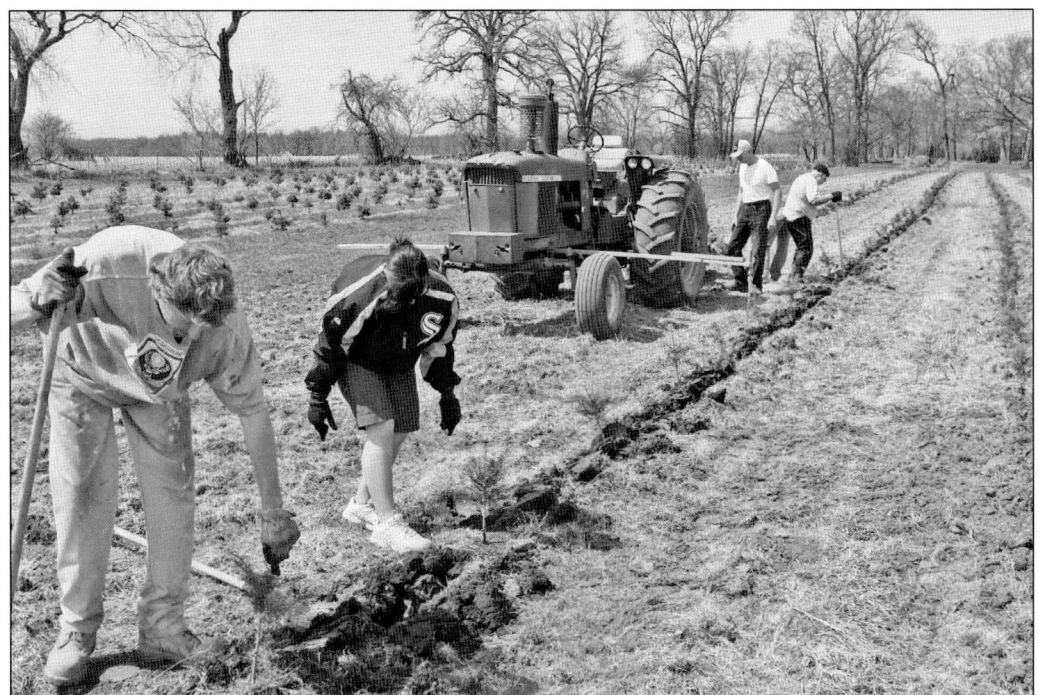

The Richardson family has gone from being dairy farmers to tree farming and capitalizing on agritourism in the county in an effort to keep their farm operating. They hope that some of their children will stay on the farm, but it is a daily battle to make the farm profitable and to fend off the developers. (Both courtesy of the Richardson family.)

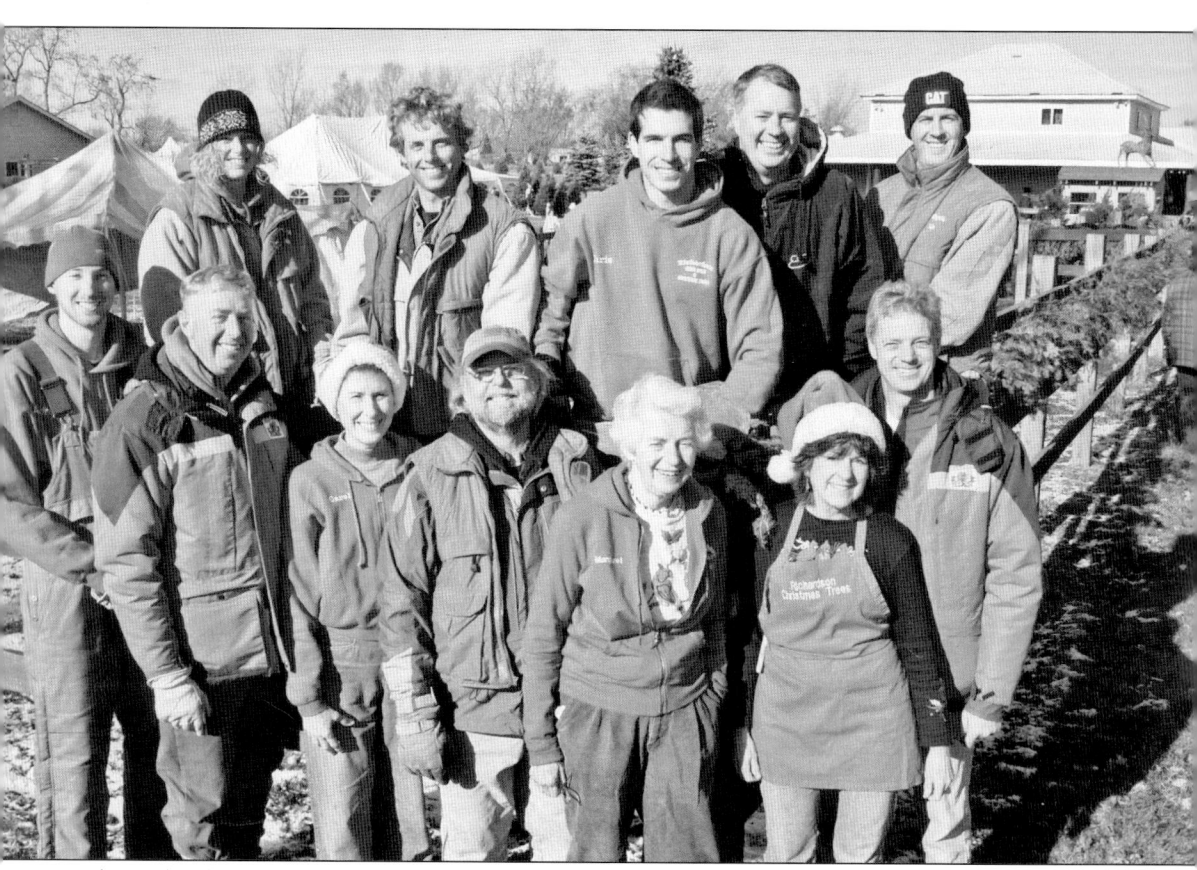

The Richardson family has adapted to changing times. They are now growing Christmas trees—over 50,000 a year. (Courtesy of the Richardson family.)

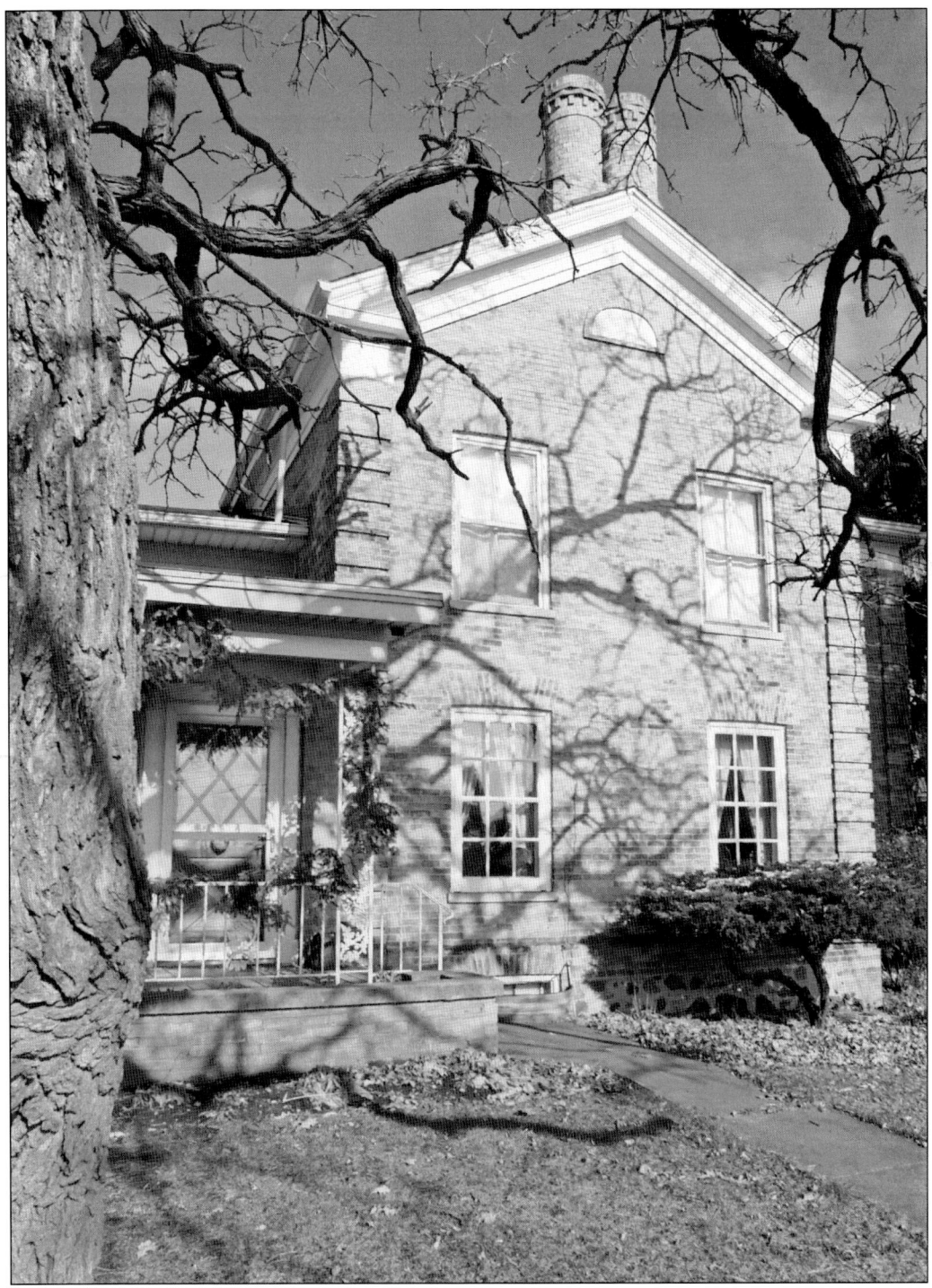

The house that Robert and Frank Richardson built in 1846 is still occupied by the family. Ryan Richardson will eventually take over running the farm, which will make him the seventh generation of the family still on the land. Perhaps some farms will survive after all. (Courtesy of the Richardson family.)

# Discover Thousands of Local History Books Featuring Millions of Vintage Images

Arcadia Publishing, the leading local history publisher in the United States, is committed to making history accessible and meaningful through publishing books that celebrate and preserve the heritage of America's people and places.

Find more books like this at
**www.arcadiapublishing.com**

Search for your hometown history, your old stomping grounds, and even your favorite sports team.

Consistent with our mission to preserve history on a local level, this book was printed in South Carolina on American-made paper and manufactured entirely in the United States. Products carrying the accredited Forest Stewardship Council (FSC) label are printed on 100 percent FSC-certified paper.